10

THREE ALEXANDER CALDERS

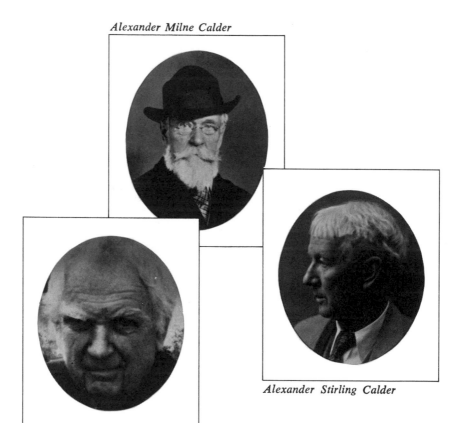

Alexander Milne Calder

Alexander Stirling Calder

Alexander Calder

THREE ALEXANDER
CALDERS

a family memoir by

MARGARET CALDER HAYES

•

Introduction by Malcolm Cowley

PAUL S. ERIKSSON
publisher
MIDDLEBURY • VERMONT

Library of Congress Cataloging in Publication Data
Hayes, Margaret Calder, 1896-
 Three Alexander Calders.

 Bibliography: p.
 Includes index.
 1. Calder, Alexander Milne, 1846-1923. 2. Calder, Alexander Stirling, 1870-1945. 3. Calder, Alexander, 1898-1976. 4. Sculptors—United States—Biography 5. Hayes, Margaret Calder, 1896- 6. United States —Biography I. Title.
NB 237.C29H39 1977 709'.2'2 [B] 7779244
ISBN 0-8397-8017-6

ACKNOWLEDGMENTS

For original photographs or photographic copies of pictures of the family and of the artists' work grateful acknowledgment is made to Nanette Sexton, Peter Carter, Muriel Cowley, Donald Freeman, Walter J. Russell, James Stipovich, Antonio Violich and DeWitt Ward.

The photograph of THREE MEN HIGH (Part IV) by Marvin Schwartz is reprinted, with permission, from Calder's Circus,© Jean Lipman, with Nancy Foot, editors. New York: E. P. Dutton with Whitney Museum of American Art, 1972.

Part title motifs are by Alexander Calder.

*To the Calder Women
those partners in the creative team
without whose care, companionship,
and dedication the three Alexanders
could not have wrought as they did.*

CONTENTS

ILLUSTRATIONS

PREFACE

When my husband Kenneth and I were clearing out the basement of "Grandma's House" in Roxbury, Connecticut in 1962, we found an old bag of letters destined for the dump. Glancing through them, I saw many were from my brother Sandy, some from Mother's friend, the author Jimmy Stern, and many from Alice Ray, who had gone to live in India. Some were even from me.

Many months went by before I explored further. As the Calders seldom dated letters beyond "Tuesday the 17th," the envelopes, if any, were also important. Many were faded and hard to read, so I decided to type them all and see what story they told. I found more letters from Sandy among my own treasures, so the typing took several years. There were also boxes of photographs and several albums, begun by Mother but never finished. I already had all of Father's photographs left with me when Mother changed her mind about living in Berkeley. I am a true Calder in the matter of cataloging and filing but when the Index of American Sculpture asked for photos of all Father's work for their archives, I felt I owed it to him to comply. A valiant friend helped me over that hurdle by sorting them and setting up a file in an exemplary brandy carton.

After discussing the letters with various art historians who felt they were a unique first-hand account of the formative years of an artist of major importance, I thought of including all of Sandy's letters. But to do so would have made the volume so bulky with appeal to such a small audience that I selected those I thought would be of the greatest interest to a broader public.

Sandy encouraged me, authorized me to write his biography and told me to write what I chose. Immediately the question of the month of

his birth arose. Our whole family, including Grandfather, whose birth-day was August 23 had always celebrated it on August 22, but in 1942, when Sandy wrote to the Philadelphia City Hall for a birth certificate, it came back July 22! A recheck produced the same results. Sandy was inclined to accept the city records but I find it hard to believe that both Mother and Father could mistake the birthday of their second child and only son. Mother was flabbergasted at the idea. Sandy's daughter, Mary, and I think the clerk just flipped open the wrong month when the birth was first recorded. At any rate, Sandy solved the problem by having two birthdays and I adhere to the old August 22, 1898.

Meanwhile, another book about *CALDER* came out each year. All were about Sandy, the arrived artist. None about his childhood and youth, except his own *Autobiography with Pictures,* a joyous, sponta-neous account of life as he remembered it.

But how did I remember *him?* Could my memories throw any light on how this lovable, chubby tease of a little brother became, according to the art critic Alfred Frankenstein, "the most influential American artist who ever lived"?

A friend advised me to put down everything I could remember and in so doing I was struck by how unusual it is to have a succession of three generations of sculptors, each distinguished in his time, ascending to Sandy, a truly unique character. So I decided to include all three.

In dealing with *The Three Alexanders,* I found it impossible to do justice to Mother, Nanette Lederer Calder, who, subordinating her own talent and longings, played an important role in the development of both Father and Sandy. Happily, my granddaughter, (Mother's name-sake) Nanette Sexton, now a teaching fellow at Harvard, is launched on a study of Mother, which she plans to illustrate with color photos of Mother's paintings. Nanette has contributed many of the photographs for this volume and given me much sage advice, for which I thank her.

Altogether this saga has been written four times from different angles. I owe fervent thanks to those many friends who gave me advice, counsel, help, encouragement from the first gentleman who told me to put down everything, which turned out to be more than 800 pages, to Malcolm Cowley who showed me how to handle letters and later when there were only 500 pages counselled cutting them; to Kay House, who helped me get started; to Elisabeth and Cush McGiffert, who listened to the weekly output with seeming interest; to W. H. Janson, the late Mark Schorer, Charles McLaughlin, Richard Boyle, George Gurney, Marjorie

Day, Phil Lilienthal, Margaret Shedd, Greta Mitchell, Joan and Erik Erikson, Joel Witkin, Margy and Martin Meyerson; Winifred Rogin who edited the 500-page version word for word, comma by comma, and claimed she enjoyed it immensely; Eva Hayes who typed this final version, and those many others who were interested and encouraged me to continue.

The 1976 Retrospective at the Whitney Museum called for changes, and to my aid came James Johnson Sweeney, Sandy's lifelong friend and critic, who also knew Mother and Father.

Then suddenly after two weeks of festivities and homages, came Sandy's death, necessitating, besides heartache, more changes. Here Kay Caldwell introduced me to Wanda Corn who introduced me to Muriel Bell who has helped me over this last hurdle. And of course, there is Sandy, whose last Retrospective Exhibition so enchanted Paul Eriksson that he undertook to publish this volume after reading only 47 pages!

Lucky is he who has found his work—and lucky are we that Sandy's produced so much joy and pleasure for us all.

INTRODUCTION

We are all grateful to Margaret Calder Hayes for what she tells us about her unusual family, with its three generations of sculptors, and especially for what she has to say about her famous brother Sandy. There are other books about Alexander Calder, the most revealing of which, in its candid but laconic fashion, is his own *Autobiography with Pictures*. Sandy gives us the outline of the story, but here Sister Peggy fleshes out many of the important episodes. She does not explain his extraordinary talent—who could do that?—but she presents the background in which it was able to develop.

In the beginning that background was the warm family life of the Calders. The father, A. Stirling, was an idealist, somewhat withdrawn, wholly impractical, creating symbolic figures while brooding on the cruelty of nature. The mother, born Nanette Lederer, was a portrait painter when she had leisure to paint; at other times she presided over a somewhat makeshift household. The Calders had to "make do," especially after they were forced to move West by the father's illness; sometimes they used orange crates instead of storebought furniture. Back in Philadelphia was the grandfather, Alexander Milne Calder, a monumental realist whose masterpiece was the huge statue of William Penn that crowns the City Hall. The grandmother was a Scottish Presbyterian, a virtuous old dragon who claimed that each of her six sons was the result of rape; only two of the sons dared to marry. Peggy and Sandy were the only Calders of the third generation.

As children they were close companions, a little cut off from the rest of the world by relative poverty, by frequent changes of residence, and by the feeling of their neighbors that artists and their families were not like other people. Peggy, two years older and more athletic, pro-

tected her brother in the early years when, it would seem, he needed protection. He went to school in Buster Brown suits that his mother made for him awkwardly, and he was sometimes bullied by his classmates. Instead of complaining, he went home and "made things": toys for Peggy, copper jewelry for her doll, Princess Thomasine, and things that moved on wheels. By the age of eight he had a Noah's Ark of wooden animals, the precursor of his famous circus. By ten, he had his own workshop in the cellar. Much of his later career was foreshadowed in those early years.

He was, however, a late bloomer. From Peggy's book, as from the *Autobiography,* we find that there were five turning points in his adult life. The first was in the summer of 1922, when he was in the black gang of a steamer bound for San Francisco. He used to sleep on deck, on a coil of rope. Early one morning off the west coast of Guatemala, he saw the beginning of a fiery red sunrise on one side and the moon, "looking like a silver coin," on the other. That vision was to change the character of his later work; "it left me," he says, "with a lasting impression of the solar system." A second turning point was in 1923, after a year spent mostly in logging camps near Aberdeen, Washington, where Peggy was living with her laughter-loving, generous-hearted husband. Sandy grew tired of moving from job to job and asked the advice of an engineer, a former business connection of his father's. The engineer advised him to do what he wanted to do—"Not like me," he must have said. "I wanted to be an architect." Sandy decided on the spot that he really wanted to be a painter. He went back to New York at the age of twenty-five and enrolled in the Art Students League.

A third turning point was in 1926, when he went to Paris practically without connections there and gained a reputation among modern artists by giving performances of his toy circus. A fourth was in the summer of 1930, when he first visited the studio of a famous non-objective painter, Piet Mondrian. It was "a very exciting room," Sandy reports. "Light came in from the left and from the right, and on the solid wall between the windows there were experimental stunts with colored rectangles of paper tacked on. . . . I suggested to Mondrian that perhaps it would be fun to make these rectangles oscillate."

"No, it is not necessary," Mondrian said with a very serious face. "My painting is already very fast."

But Sandy went back to his studio with the notion that the colors

really should move, and that notion, he thinks, was the genesis of his mobiles. Soon afterward came the fifth of the turning points, which was his marriage to Louisa James on January 17, 1931. Louisa was completely different from Sandy in many ways and she was the perfect mate for him. Their marriage, so to speak, was the incorporation of a new firm that was responsible for the production of his later work. Of course it was Sandy's work from beginning to end—except when Louisa made hooked rugs from his designs—but she otherwise played her part by falling in with his ventures, by contributing her modest income (from a Cushing grandmother, Peggy tells us), and by generally maintaining the conditions that made the work possible. People spoke of "Sandy and Louisa" as if they were a joint personality.

Some day a book will be written about the Calders' siege and conquest of Paris, which preceded by several years their conquest of New York. Sister Peggy was six thousand miles away, in California, and cannot give a direct account of what happened, but her book includes scores of letters from Sandy. Some are the letters of a young artist eager to get ahead. "What I need is an unbroken stay in Europe for some time," he wrote shortly before his marriage. "It's absolutely essential to stay, and put oneself across for all one's got, to get anywhere as far as Paris is concerned. And as it is the merchandising center for Art, besides other features, it's here I want to be." With the help of new friends, Sandy's first Paris show was mounted in the spring of 1931, three months after his wedding in Concord, Massachusetts. "My show starting in 6 days," he wrote, "I naturally have a few things on my mind. I think it will go over very well among the artists, some dozens of whom have seen the things and are very enthusiastic. . . . I got Fernand Léger to write a very nice preface." Nothing was sold at that first Paris show—or at the second in 1932, which included the new "mobiles"—but both were widely praised, with no more jeers than were expected. Sandy was the only American to be accepted as an equal, and as a boon companion, by the whole Paris group of innovators: Léger, Arp, Miró, Pascin, Mondrian, Masson, Tanguy, and the others.

But why did they accept him into their various circles while turning their backs on others? Of course his work in itself, continually inventive, playful, and enchanting, was his ticket of admission, but his letters suggest that he and Louisa had other claims to being welcomed. They were generous, they were personable (Louisa was a beauty), and

they entertained in a simple, unreckoning fashion; artists met artists at the Calders', laughed, danced, and had a glorious time. They were both of them natural and unassuming. I suspect that Sandy was regarded as that traditional figure in France, the Noble Savage, one who disregards social conventions and judges everything by his instinctive standards. Always he found simple answers to complicated questions (or complicated answers to simple questions, as, for example, how to close a door. The Civilized Man would get up and close it. Sandy would devise a mechanism of strings running over pulleys and leading to the latch, which would be a new form of latch, devised and hammered out of brass wire by himself).

He could be laconic in French or English, except when making puns in both languages. Much of the time, I suspect, he didn't think in words as most people do; instead he thought in geometrical shapes, in colors, and in mechanical lines of force. The result was a curious dissociation of materials from their conventional uses and of objects from their conventional surroundings. Like an observant visitor from another culture, he kept finding new combinations of whatever was nearest, simplest, and commonly discarded: tin cans, packing boxes, feathers, worn-out axles, and bits of broken glass. He inspected junkyards. When Peggy asked him for advice about a new pair of andirons, he suggested, "Go to a junkyard and try to find two objects which will serve, even if you have to cut part away. And if they are *not* a pair, that would be more amusing. REALLY *sans blague!* The real idea in modern furnishing is *economy,* and if you can substitute an old piece of *junk* and make it serve as well as something more costly, you win."

The Noble Savage—if we borrow that French notion of Sandy— had his own fixed system of values. Wife, children, parents, friends— freedom, justice, invention, playfulness, naturalness—those persons and qualities were absolute goods to be achieved or defended; whereas moping, idleness, pretense, and cheating were absolute evils. He never questioned those standards, some of which may have been acquired from his Scottish ancestors. He was canny, too, for all his appearance of unworldliness. He had a tenacious memory, and people who failed or cheated him once were not often given an opportunity to cheat him again. It hasn't often been noted in books, not even this one, that he was faithful to one woman, as she to him. I wonder about the silence on that subject. Has marital fidelity become a mildly scandalous topic

in this adulterous society? Sandy teased, but he didn't flirt. He made ribald jokes, not suggestive ones. He liked to draw the outlines of opulent breasts or buttocks in copper wire, or with his blunt hands in the air; at parties he liked to goose dignified ladies; his hands went roaming, but not his eyes. There is a look in the eyes to which women or men often respond; it says, "I'm on the prowl." Sandy never had that look, and accordingly young women didn't flirt with him at the uproarious parties I attended. Louisa played her accordion and we danced.

I never saw any trace in him of the manic-depressive cycle that afflicts many artists and, one suspects, most of our imaginative writers. He worked intensely, often for long hours, but he liked working. After hours he enjoyed himself in company; he was never somber. Once he was asked by a reporter whether he ever experienced sadness. "No," he said, "when I start to feel that way, I go to sleep. I conserve energy that way." He was famous for sleeping at the table after dinner. Massive in a red flannel shirt, a seated Buddha, he would let his head droop forward and half-close his eyes; then suddenly he would interject a remark, often a ribald pun, that showed he had been listening to what was said. Sandy, Sandy, with his crooked smile, his bear hugs, and those half-closed hazel eyes that missed very little. . . . There is so much I remember about him, so much that makes me feel the pain of his absence.

And his sister Peggy?—In many ways that dear woman resembles him, especially in naturalness and generousness and fidelity to family. In her eighties now, she still has an eager and coltish quality. Her life has been devoted to good causes, as notably the preservation of San Francisco Bay and the surrounding area, and, in recent years, the memory of her engaging husband and her brother. She treasures the toys that Sandy made for her when they were children, not to mention a wealth of his later "objects"; her house in Berkeley might serve as a Calder museum. She herself is not an artist in paint or metal or words, and her book on Sandy and the other Calders is not so much written as lived. I like and respect it all the more for that.

MALCOLM COWLEY

Sunrise Over Guatemala

PART I

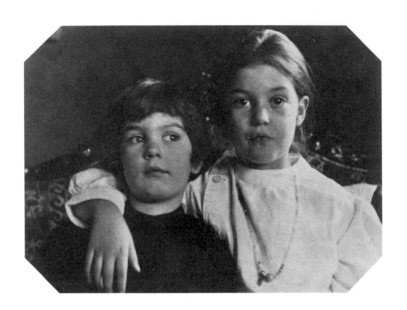

1

July, 1976
Saché

Dear Peg
I will have a show at Perls in October before the one at the Whitney
—so things will be very hectic. We go late in September.

Love to you all,
Sandy

As I prepared to join the festivities, I wondered if this Retrospective at the Whitney would be anything like that of 1964 at the Guggenheim, recalling with pleasure how one had left behind the grimy street with its smelly cars and buses and with the swinging of the door had entered a joyous world of light, color, and motion.

Overhead from the dome of that snail-shell building had hung a huge white mobile, *Ghost.* Below it on the entrance level was the only ominous note, a black stabile, *Guillotine for Eight.* That exhibition had been arranged in chronological groupings, with the earliest at the top level, reached by elevator. As we began our descent down the ramp, we were also descending through the years of Sandy's development.

First were the pen-and-ink drawings. It was hard to find standing room before the next station, which held the Circus. Then came wood carvings, mostly animals with fantastic names: *Flattest Cat, Two-headed Cat, Bending Dangerously.* A few realistic oil paintings were followed by several abstract oils; then wire sculpture and portraits; jewelry (here again standing room was scarce); small bronzes; and early, motor-driven mobiles.

Across the open space *Wire Sculpture by Calder,* the sign made for his first wire exhibition in 1928, and *Red Face,* which woggled an

eye and spewed forth a mobile, hung to the outer edge of the ramp. Several mobiles were hung near the edge, to be touched gently in passing. There were wall mobiles and mobiles mounted on stabiles; there was a whole case of small mobiles that did not move because they were enclosed, but elsewhere the galleries sparkled and danced with the color and movement of the viewers, as well as of the objects whose variety and playfulness bore witness to the lively imagination, vitality, and versatility of their maker. Art students, critics, and just plain people stood in rapt study before a Constellation, or huddled over the cases in which Sandy's books *Three Young Rats* and *Fables of La Fontaine* were displayed.

I was standing in delighted contemplation of a rug made by Louisa, Sandy's wife, when someone grabbed my arm and Sandy asked, "Well, what do you think?" I stammered, not finding words to express my astonishment and excitement, and let out a long "Ohhh," as we rounded the corner to find a large, sulphur-yellow tapestry with one big vermilion sun and a white moon.

"Nelson Rockefeller has just bought that one for Happy," he volunteered. "Come along and choose a couple of prints and I'll sign them for you."

We looked at them together. "In that one, Sandy, the forms dance in space without strings, just floating." He signed it for me.

"You have copies of all the books?"

"Yes, and *Three Young Rats* is beautifully inscribed, but you must have been in a more ribald mood when you signed *The Ancient Mariner* for my birthday in 1947."

With Much Affection
to
Peggy & Kenneth
HAYES
& ALL THEIR Offspring
from Louisa, Sandra, Mary
& Sandy Calder
12/12/44

THREE YOUNG RATS *is
beautifully inscribed.*
Photo: Colin McRae

'Come along and choose a couple of prints and I'll sign them for you.'

Photo: Hugo Mulas

These memories were still vivid now, twelve years later, as I entered the Whitney Museum to find this Retrospective began on the second floor. When the elevator doors opened we found ourselves facing *Universe,* a 33-x-55-foot white panel, which provided both frame and background for: a black circle that swung slowly back and forth with a rhythmic tick-tock; three gaily colored shapes that oscillated about one another; to the front and left a pole of petal-like shapes turning slowly; a black disc bisected by a red one, moving gently to the right; and below and toward the back, a large black helix winding endlessly from a black box slightly left of center to another one on the right.

The purr of the motors concealed behind the white panel was interrupted by the indignant voice of a fellow passenger who evidently expected something rather different at a Retrospective Exhibition.

"What the hell do you call that? Do you call it Art?"

"Well," a mollifying voice began, only to be interrupted.

"These three crazy cats playing tag! And that worm!"

The other voice was mirthful as it finally managed to interject, "Well, it's fun, whatever it is. Like patting your head and rubbing your stomach at the same time. That's not a worm, it's . . ."

"Well, what is it?"

"A lariat being whirled, or whatever you wish."

"I say it's a worm."

And the arguing couple moved to the Circus room.

The sound of Sandy's voice announcing something drew me along. It was a film of parts of his miniature marionette Circus, with Sandy announcing an event in regular ringmaster style. Nearby, the Circus itself was displayed under a huge glass dome.

"Now I ask you, I suppose you call this Art too! I call it toys and they are cute, but tell me what is Art about them?"

"You'll have to admit they are amusing, anyway. Look at the belly dancer!"

They rounded the corner while I stood, indulging my delight in the characters, animals, and apparatus. Imagine tying all those little knots in the net for the trapeze! In memory, I saw Sandy as a young boy, his head bent between his knees, totally and patiently absorbed by the demanding intricacies of his project. I saw, too, the small circus that had come to Croton-on-Hudson in 1911, setting up under a tent near the railroad station. It was only a one-ring affair, with

clowns, an elephant or two, and the usual fat horses, which loped around the ring while the lovely lady in pink tights alternately leapt off and on and stood on her head. The hardness of the plank seating was more than made up for by the delightful nearness and intimacy of it all.

The final act was not the usual chariot race, unmanageable in such a small space, but "Uncle Tom." Eliza ran across the ice, made up of flat, round pieces of wood, painted white and mounted so they rocked underfoot as she ran. Bloodhounds bayed. The audience cheered when she outdistanced her pursuers and booed when they almost caught her.

The next morning Sandy and I sneaked out early to watch the circus pack up, to be discovered too quickly by an irate Mother, who ordered us home in no uncertain terms! Later, we spent hours constructing and re-creating various acts, using sawhorses and broomsticks. But there were no other children in Croton to join in the play, homework called, and our circus was abandoned.

At the Whitney I looked up at the museum walls covered with pen-and-ink line drawings of circus scenes: trapeze artists swinging forth to catch one another, acrobats engaged in every imaginable stunt, jugglers, slack-wire artists, animal shows, and clowns galore. The action expressed in those thin black lines! How did Sandy create content, solidity, and motion with that single line? As I rounded the corner I heard a woman asking the unanswerable question, "What is Art, anyway?" and found pen-and-ink portraits, and wire portraits dating from 1926. There was no mistaking the subjects, so faithful were the likenesses—caricatures, to be sure, but never mean, only amusing. How unerringly he had bent the wire to portray the subjects' salient features. Jimmy Durante's nose was in double outline. Well I remembered the furor over Calvin Coolidge, whose features were so readily adapted to Sandy's fun-making.

The transition from pen-and-ink lines to the wire portraits and sculpture seemed natural and painless. In a wall cabinet were his oft-exhibited *Sow, Horse,* and of course his *Hostess.* There she was, with lorgnette and bracelets, her high heels tipping her forward as she minced along. The whole created by a single wire.

"I think best in wire," Sandy once told me, and I remembered how after a big storm in Pasadena in 1908, which necessitated extensive repairs to telephone and electric wires, the eight-year-old

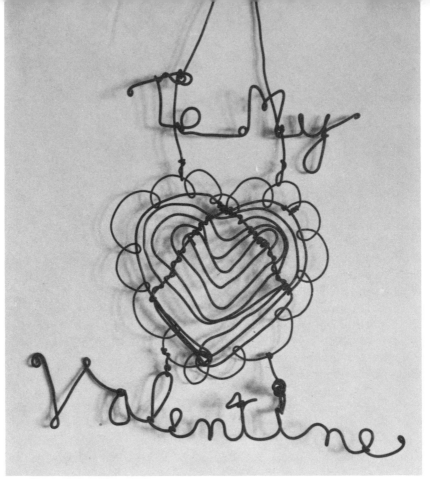

'I think best in wire'
Sandy's Valentine for his mother, 1925

Sandy had triumphantly returned to his basement workshop bearing armfuls of copper wire scraps. With them he made jewelry for my dolls, umbrella frames, a branding iron with our circle "C." The same little brother who used to reduce me to despair in those corner-lot baseball games when he swung "like a rusty gate," missing the ball completely and putting our side out! I wondered at the coordination that led to drawing a curve so perfectly with pen and ink, yet missed the curve of the ball so consistently.

And how many spirals he used! The dark rings around Curt Valentin's eyes were expressed by elliptical spirals in ink; Josephine Baker's belly and bosoms were spirals in wire. There were so many spiral pins, and a great many spirals, both tight and open, in the gouaches, rugs, and tapestries. In the wire sculptures, the sharp ends

wound into spirals, becoming water plants in the fishbowl he made Mother for Christmas, 1929, and the base of the flower Father had so admired. Another spiral he used to make a lock for the doors under the kitchen sink the night his daughter Mary's cat was caught preparing to feast on the remains of our dinner.

"Put him in the cellar, Mims," Louisa had suggested. In ten minutes, there he was again, jumping onto the table.

"Put him in the cellar," Sandy ordered, with emphasis.

"I did," protested Mary, opening the cellar door and pushing the cat down with irritation. Not more than four minutes later, "Look."

There was a little white paw reaching through the doors under the sink, pushing up the latch. As the doors opened and the cat emerged, Sandy picked him up by the scruff of the neck and took him to his studio, where he stayed for over half an hour. We were all wondering if he was murdering the cat in some elaborate and silent manner when he returned with a latch of heavy brass wire, of beautiful spiral design. The handle swung into place so that the doors under the sink could not easily be opened from behind.

The instructions he had sent me in 1958 on how to hammer wire were based on a spiral: "If you have a good *heavy* anvil it works much better. The edge of my anvil (for jewelry) is somewhat rounded from use and this works very well. Also there is a slight hum, and this is very useful." No wonder someone had suggested that he patent the form. How he had scoffed, "Patent a spiral! My God, it was and is used universally."

And yes, he had used it long, long ago. Some of the lockets and watches he made for my dolls in 1908 were spirals. And the little ring with spirals on each end that interlocked around the finger. By gum, I remember they were hammered on the cement sidewalk. That rascal had been making spirals for seventy years. No wonder they are so perfect!

A shriek came from around the corner. "Now what is that? What are those things?"

A murmured reply: "Doorstops."

"Well, I never and never saw doorstops like that! So you call that Art too?"

I looked at the nine-foot wire sculpture of *Romulus and Remus* with their wolf mother. The she-wolf's teats and the boys' genitals are indeed made of doorstops.

"It really is outrageous," I thought, in such a magnificent way! Sandy had exhibited this group and *Spring,* a seven-foot damsel made entirely of wire, holding one green flower, at the French Salon des Indépendants in 1929. A French paper carried a two-column article headed *"Au Fou! On remplace le crayon et la couleur par . . . du fil de fer."*

Could this joyous abundance, this irreverant creativity, have been foreseen? I saw a sturdy boy of three, delight shining from his large gray eyes, turn a little horse-drawn cart over and over in his chubby hands. "You always bring me something instringting," he says to Mother and Father. By the next day he had detached the horse from the cart, a feat Mother deplored until I, his advocate, pointed out that now the horse could carry a rider as well as pull the cart if only she would help by cutting a saddle for it. This she did, out of an old shoe top, while Sandy made a harness out of string with thin leather strips for the reins.

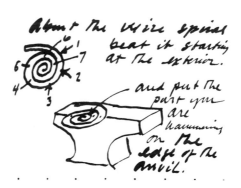

Only two-and-a-half-years-old when Sandy was born in the summer of 1898, I do not remember his birth as I was sent next door to the German couple who lived in the other side of the farmhouse my parents then rented in Lawnton, Pennsylvania. Years later I was told that tubs and kettles of hot water were ready when Dr. Stewart drove up in his gig, leaving horse and driver while he and the nurse he brought with him took over in the kitchen; that Father was called on to administer chloroform drop by drop onto a piece of gauze stretched over a strainer placed over Mother's nose; that Sandy weighed eleven pounds (I had weighed nine), in part a consequence of the prevailing

view that pregnant women should eat for two; and that the birth had been a difficult one, requiring the use of forceps.

Later I was allowed to hold Sandy in a warm towel while Mother got ready to nurse him, a proceeding of never-ending fascination. Had I really begun that way too?

Sandy grew to be a bonny baby; lusty, responsive, good-natured, and affectionate. When he was old enough to sit up, we were bathed together in a round tin tub that was filled by a pitcher as it sat on the kitchen floor. We were washed with an oval cake of resin-colored soap. Mother squeezed a big sponge over us to rinse the soap off, prompting shrieks and squeals of joy. Later on, there were peas to be shelled, the cradle to be rocked, and, failing all else, a large bunch of Concord grapes to be eaten, with instructions not to swallow a single seed.

Much as my parents loved the country and outdoor living, Father found commuting difficult during the snowy winters, so when in 1901 he was commissioned to model the *General William Joyce Sewell Memorial Cross,* he and Mother decided to move nearer his studio in Philadelphia. We moved first to a dreary little flat, permeated by the smell of Brussels sprouts cooking next door and overlooking a railroad yard. The tall windows were only partially covered by the grayed curtains. Mother put pots of geraniums along the sills in an effort to make the place more cheery. Sandy did not need cheering; he loved to watch the switch engine couple and uncouple cars and shunt them from track to track. We were both happily oblivious to the puffing, whistling, and banging that so distressed our parents. We spent many hours in Father's studio, posing for *Man Cub* and *The Mighty Giant,* while Mother read to us.

Although she was essentially sound and strong, Mother's childbirth injuries contributed to the despair that overwhelmed her now and then, as did our living in crowded, unattractive quarters with little money and less security. She could never be sure where or when Father's next commission would come. Then too, she wanted to work. A talented portrait painter, she wanted to paint, but in these years could not manage to do so. All this made the inevitable bickering of her children, with whom she lived in very close quarters, the harder to bear. Although we were on the whole pacific children, easily amused, we sometimes sensed her desperate mood and vied for her attention, grabbing and shoving one another. On one such day she was reading

Sandy grew to be a bonny baby.
Nanette Calder with Sandy and Peggy. Lawnton, Pa. *Photo: Louise Wood*

Much as our parents loved the country.
Peggy and Sandy in 1901. *Photo: Louise Wood*

listlessly from *The Blue Fairy Book*. The disguised Prince was just
setting out to win the Princess when I gave Sandy a shove. He re-
taliated. Not even trying to reconcile us with her standard "Birdies in
the nest agree," Mother rose abruptly, put on her hat and cape and
left.

Aghast, Sandy and I rushed after her, catching up with her halfway
down the block, bawling and terror-stricken at the prospect of a
motherless world. We clung to her and promised to be good forever-
more. The episode seems to have made a deep impression on Sandy,
who described it in his *Autobiography*. I had forgotten it altogether
until I was reminded of it there.

Most of my parents' friends were penniless young artists like
themselves. Mother was the first of her Art School class to marry and
have children. So we posed not only for Mother and Father, but for
their friends as well, and thus learned early the lovely smell of linseed
oil and turpentine.

Sandy's outstanding features were his large, intelligent, beautiful
gray eyes and a Whistler lock—a streak of white hair over his left eye.
Although always friendly and cozy, he was a rather reserved and
thoughtful little boy, happy to be with others but also quite content to
go off by himself for hours and "make things." His pockets were
always filled with odds and ends: bits of string, unusual and interesting
pieces of wood, glass, or stones. He would display his treasures at
mealtime: "Look what I found."

Mother would often make a face, recalling the conglomeration
already stored among his belongings, while Father laughed, "Scav-
enger!"

We were both affectionate and responsive, but Sandy was also
exceedingly generous. Both of us were shy, hanging our heads when
attention turned our way. We usually stood just behind a parent as
though for protection, an attitude doubtless fortified by the prevalent
notion that "children should be seen and not heard." As he grew older,
Sandy mumbled. "E-N-U-N-C-I-A-T-E" Mother would urge, stiffening
her lips and speaking with unaccustomed crispness. Me she would
admonish, "Toes straight!" because my right foot turned out in an
unacceptable manner. Poor Mother! Her exhortations were in vain.
My foot still points out, and Sandy mumbled all his life, a trait oddly
at variance with his trenchant wit and with the universal eloquence
of his art.

Sandy was choosy about his food and, like Mother, would eat no meat. Father, also choosy, would eat nothing white. Only I was omnivorous. "Greedy gut," taunted Sandy, "Eat the whole world up."

Sandy was still eating no meat when we were invited to dine with Theodora Burt, one of Mother's Paris art school friends who lived in a large house on Rittenhouse Square. Despite prior instruction in the manners appropriate to such a grand occasion, Sandy refused the baked chicken. There was a flurry of servants as Miss Burt asked if a boiled egg would be acceptable.

"Yes," said Sandy.

"And how long should it be boiled?"

"Hard, with a little juice in the middle."

Miss Burt instructed the cook to boil it for five minutes.

As the payments for the *Sewell Memorial Cross* came through, we moved to larger quarters in a more appetizing neighborhood. Mother got out her paints and Sandy and I began posing in earnest.

During the hot, close summer when Miss Burt was off in Europe, she lent us the gardener's cottage on her farm. It was in the beautiful Pennsylvania countryside, with berry bushes growing along the roadside and fresh milk delivered to us each morning in a little tin bucket with a lid. In the meadow before the house two Jersey cows ambled or lay and chewed their cud. One had a nursing calf that we could touch through the fence. One day two men grabbed the calf, shoved it into a small cart, and drove off, with the calf bawling and the old cow lowing as she pursued them along the fence, her milk bag swinging from side to side. In consternation we rushed inside to Mother, who gently explained that henceforth the cow's milk would be used for humans, for cream, butter, and cheese, and that the calf probably would be sold. The next day, to our horrified amazement, the cow seemed to have forgotten her offspring. It was long after we returned to the city before Sandy began to drink milk again.

Despite such respites from city life, Father's hacking cough grew steadily worse, and during the summer of 1905 he was found to have tuberculosis. The doctor decreed that he be isolated from the rest of the family, and that he move to a more propitious climate until he had recovered.

As he and Mother sorrowfully packed for Arizona, Sandy and I cheerfully prepared to move in with Charles and "Aunt Nan" Shoemaker, kindly friends of my parents who had offered to care for us,

and their daughter Margaret, my namesake, two years younger than Sandy and nicknamed Maggie No. 2. We considered Maggie No. 2 a very privileged child, primarily because of her vast, munificently furnished playroom. There was a large rocking horse, covered with real hide, saddled and bridled, ready to gallop anywhere. There was an enormous doll's house, built by her father, who made furniture for it, using the fragrant cedar from cigar boxes (he used a little jig saw with an eggbeater-like handle, which Sandy would turn while Dr. Shoemaker guided the wood); a pastry shop; and dolls' buggies. We had brought our favorite toys, including a stable with milk wagon and horses, an ark with numerous small animals, and Sandy's beloved train, which he could for the first time leave out on the floor for a week at a stretch.

Among us we had several Noah's Arks, some larger and more elaborately stocked than others, and jointed wooden animals and clowns with slots in the hands or hooves, which could be made to bend and stand and to balance in various postures, even on their heads or hanging from a ladder. We built zoos and farms and forests for the animals, all of whom took frequent rides in Sandy's train. Pooling the lions, tigers, and elephants from the arks—size differences being disregarded by unspoken convention—with the jointed toys, Sandy made a modest circus. Milk wagons trimmed with ribbons became lion cages, the elephants sported cardboard howdahs, the clowns stood on their heads. Horses of all sizes, some of them deftly detached from vehicles, joined the troupe. For the spectators at Sandy's circus performances in the 20's and 30's, for the visitors to his homes and studios, for the viewers of the Tate, Guggenheim, and Whitney Retrospectives, Sandy re-created the amplitude, the boundless universe of playful creativity, that was ours in Maggie No. 2's magic playroom.

The Shoemakers' good-natured Irish maid, Carrie, loved to take us on excursions, particularly to the Fire Station, providing us each with a couple of carrots for the horses. We loved the feel of their silky noses, but snatched our fingers away quickly when the big yellow teeth crunched on the carrots. We gazed in wonder at the bulging muscles in the great chests. A favorite was Gray Boy, a gentle giant whose hooves, if dropped on a foot, would crush every bone in it. Sandy was particularly entranced with the way each horse's harness was held suspended by pulleys positioned over the animal so the harness could be lowered in a wink. During one of our visits, the

boom of the alarm bell filled the building and we watched from a safe corner as the locks on the horse stalls were tripped from afar. Each horse, tense with excitement, moved into position, the collars dropped from above around the great necks, and collars and belly bands were buckled as firemen appeared from everywhere, clapping on helmets and buckling on axes. In a minute they were careening down the street in a glorious din of galloping horses, clanging warnings as the red hook and ladder wobbled and lurched.

On dark, wintry afternoons, Sandy and I worked out a formula for drawing birds: one uninterrupted line flowed around the entire body, including in its journey the tail (a series of loops) and the wings (another series of loops). Only the eyes and feet had to be added.

As I looked at Sandy's *Sow* and *Lion* at the Whitney, I wondered if his technique for wire sculptures could have been founded on these childhood experiments. Our parents responded with such approval

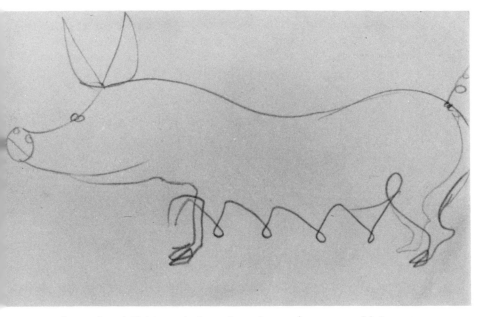

. . . I wondered if his technique for wire sculptures could have been founded on these childhood experiments. Sandy's sketch for his brass wire sow

when I enclosed some of our birds in my weekly letters to Arizona that we experimented endlessly with the formula. Beginning with ducks, we soon found that, with simple adjustments, turkeys, geese, chickens, and other birds could all be drawn the same way.

By the end of the winter, Father had gained thirty-five pounds and had ceased coughing. Dr. Harte said the family could be reunited, provided we all lived in Arizona. Hooray! Sandy and I would be making a four-day train trip—and also would be rejoining our parents. Mother arrived for us at the end of March, 1906. We suddenly realized how dear she was, though she looked oddly different: she, too, had gained many pounds. Then she heard Sandy cough. He had been sleeping in a room next to Carrie's, on the unheated third floor, for of course he could not share a room with us girls. He had had several bouts of croup, followed by a bronchial cough that off and on had plagued him all winter.

"Peggy Calder!" Mother exclaimed. "I expected you to take care of your little brother! I left him in your care!" Stung with shame and consternation, I hung my head.

Ever since, long, long after Sandy was more than able to care for himself (indeed the roles were reversed years ago), added to my love for my only brother has been the feeling of concern for, and involvement in, his happiness and well-being.

'I expected you to take care of your little brother!'
Sandy and Peggy in Philadelphia, 1905 *Photo: C. P. Shoemaker*

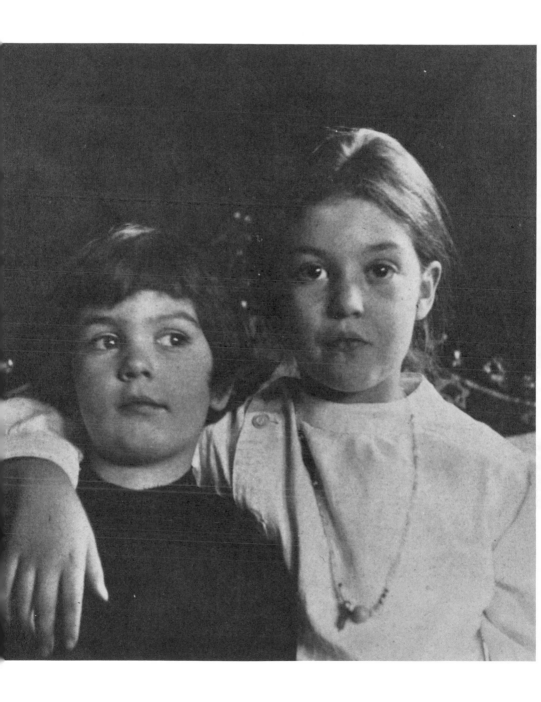

2

The trip across the continent by train required five days. Mother took advantage of a six-hour stopover in Chicago to take us to the Chicago Art Institute and what was for us much more exciting, the Natural History Museum. Then we hurried to find our compartment, Number 9, on the train that would take us to Tucson.

Mother showed us how to fold our coats so they fit in the green string hammocks provided for them, and how to stow our suitcases under the seats. Of course Sandy and I both coveted the privilege of sleeping first in the upper berth, from which one could peek out at the passengers, looking curiously foreshortened when seen from above, as they went up and down the aisle. We admired the ingenious way the porter made up the berths for sleeping, and enjoyed the feeling of privacy as we buttoned up the musty green curtains at bedtime. The lower berth had its advantages, too: we could look out the windows when the train stopped, see the conductor hidden by darkness above his legs, watch the brakeman check the axles and brakes, looking spooky in the glow from his lantern, and hear the clang, clang, clang of the bell at the crossing.

Sometimes all three of us sat on the back platform for hours, exclaiming over the marvels to be seen every mile or so. Avid readers of Ernest Thompson Seton's *Lives of the Hunted,* we watched eagerly for packs of wolves and hoped every herd of horses we passed would be led by a pacing mustang. We saw no wolf packs, but we did see herds of antelope, an occasional fox or coyote, and big jackrabbits bounding over bushes with their ears aloft—all in a landscape of never-ending expanse.

Our happy hours on the observation platform were interrupted by the gentleman in Lower 10, who thought it the ideal spot to pursue his friendship with a blonde from another car. Embarrassed by their spooning, Sandy and I left whenever they appeared. At noon the second day out, the porter asked if we had seen our neighbor. We remembered only seeing him in the observation car the evening before. The berth in Lower 10 was still made up for sleeping but no one answered the porter's rap. The mystery was resolved, for the adults at any rate, when the conductor came holding a telegram and told the porter to pack the man's clothes and bags and send them on to the station-master in Kansas City. The amorous traveler apparently hadn't known that cars for Kansas City were switched during the night while the main train continued on to Los Angeles. He had been shipped off to Kansas City clad only in his pajamas!

Disembarking in Tucson, we stayed there overnight, leaving the next morning by stagecoach and six for the ranch in Oracle where Father was convalescing. The three other passengers on the coach were also seeking clear lungs. Two were newlyweds, John and Dolly Way, dressed in what they took to be true western style, six-shooters and all. John startled everyone, even the horses, when he leapt to his feet yelling "Antelope!" and blazed away at a jackrabbit as it soared over the cactus. The other passenger, a long, skinny man named Paterson with a remarkably acrobatic Adam's apple, loved to pat little girls on the head, tweak their pigtails, and tell them to hurry and grow up so he could marry them. I took an immediate, intense dislike to him that lasted throughout our stay in Oracle. Whenever he appeared I ran indoors or slid behind Mother or Father and even then could not escape the inevitable, odious remark.

The trip to Oracle was only thirty-five miles but it took the better part of a day. It was a steady uphill pull over a dirt road from the valley floor to an elevation of four thousand feet. Father met the coach and helped us out with welcoming smiles and pats, but we were a bit shy of him. For one thing, he had grown a beard, which made him strange and different. For another, we had to restrain our natural demonstrativeness for fear of contagion; kissing Father was strictly forbidden, and though he did his best with pats and tweaks to express his happiness at seeing us, the impact of this prohibition—in force for several years—was lasting.

Oracle is situated on a plateau, with the Table Mountains miles

and miles away across a great stretch of prairie desert. The air is wondrously clean and clear (or at any rate it was in 1906). Although we had spent weekends at the seashore and lived briefly in the country, the distances of the Arizona plains and the breathtaking expanse of sky were a wholly new experience.

Mother sent for *The Friendly Stars* and exulted at the ease with which we found Ursa Major and Ursa Minor, Castor and Pollux, and Pegasus. The four of us sat together on the steps of our hot little cottage as the cool desert night took over, Sandy in Mother's lap, leaning contentedly against her shoulder. Following the book's instructions, we located Arcturus, and a lovely big planet we thought must be Mars.

"Doesn't it look red to you?" Mother asked. "To think they have been appearing in the same place since the world began and they will continue after we are dead and gone. They are so dependable: the sun to warm us, the moon to mystify us, the stars to guide us with their beauty and brilliance."

"Interesting to think there may be creatures, people, some kind of life on that planet," contributed Father.

"Do you think our earth looks like that to them?" asked Sandy sleepily.

As more and more stars came out and the vault overhead deepened from blue to blue-black, we fell silent, awed by a feeling of reverence for the vast unknown that on the plains is three-quarters of the landscape. Sixteen years later Sandy was to have an even more striking encounter with the solar system. On board a ship that lay idle off the coast of Guatemala, aligned due north and south, he saw the sun rising fiery red in the east, while the moon, pale and clear, was disappearing in the west. So profoundly did these experiences with our solar system touch Sandy's imagination that much of his work, early and late, relates to the solar system. And indeed Sandy himself has said, "When I have used spheres and discs, I have intended that they should represent something more—the earth is a sphere, but also has miles of gas about it, volcanoes upon it and the moon making circles around it. The sun is a sphere—but also is a source of intense heat—a ball or a disc is a rather dull object without this sense of something emanating from it."

Sandy's Retrospective at the Whitney could not have been more appropriately named: Calder's Universe.

Oracle was only a speck in the landscape; just a rambling ranch house with stables, servants' quarters, corrals, and a small primitive house (the one we stayed in) across the road. The Bar-N Ranch, owned by Mr. Neal, a Negro, and his wife (an ample Cherokee Indian), was basically a cattle-raising enterprise, with a few ambulatory consumptive patients being boarded as a sideline.

For fear of contagion we took many of our meals in the cottage rather than at the ranch. Most of the outside ranch work was done by two English brothers, Shad No. 1 and Shad No. 2.

The ranch cook, housemaid, and man-of-all work was called Smith. Smith didn't know how old he was—only that he had once been a slave. He dyed his snow-white hair brick red with some self-made brew and added very black eyebrows with charred wood. Not being too careful how he did it, he often got one eyebrow lower than the other or one going up while the other went down, giving a curious expression to his kindly, wrinkled face. He did the ranch washing, including ours, by scrubboard and hand; all four of us wore khaki shirts and pants to eliminate the need for ironing. Smith's hands were gnarled from work and age and bleached by the strong soap he made from tallow and other fats from the ranch kitchen. We often watched him stir in the lye and pour it into shallow pans to dry.

When Mother was preparing to fetch Sandy and me, she asked what she could bring him from the east. He answered, "Some plush." So she found him a luscious piece of pink velvet, from which he cut a cover for his piano and ruffles for everything else in his cabin, using his sewing machine, which together with his small piano he had bought from a mail-order house. Mother also brought him some sheet music, only to find that he couldn't read it, so she played and he then reproduced what he had heard. As we cuddled down in our beds we could often hear the thin tinkling of his piano and his quavering voice singing "Nobody knows de trubble I've seen" in the dark silence of the plains.

For two dollars, Father bought Sandy and me a burro named Jack-O, on which we took turns riding. Sandy had him in the morning for a week, I in the afternoon. The next week we switched. Mornings were much better; by afternoon Jack-O had tired of carrying his load hither and thither and became decidedly balky. Father also bought a very nice horse named Pico Blanco because of the white spot between his eyes. He was gentle and tolerant of his inexpert riders. From the

innumerable litters of puppies born on the ranch came Koh-I-Nor, our Black Diamond, a big black mongrel with a white spot on her chest. Lunch was often made merry by these pets, who would stand gazing through the window, hopefully awaiting a piece of cornbread. Sandy trained the always greedy Kohie to wait on his command before gobbling up a mite he put before her. He would sit on the floor, his legs in a V, with Kohie opposite, a morsel of food no bigger than two bits between them. She would wait, muscles tense, saliva dripping great streams, until he uttered the magic word. Whereupon the morsel disappeared with a slurp and a gulp. We became adept at braying like Jack-O despite Father's suggestions that this might be prophetic, and would engage in an exchange whenever we heard the burro in the distance. These were our first pets. None were ever loved more.

To add to the menagerie we caught horned toads, for which Sandy made carts of matchboxes with thread harnesses. We raced them, or endeavored to, trying to guide their erratic steps by dangling flies on a thread in the direction we wanted them to go.

The tarantula, however, with his hairy legs and threatening mein was menacing and ugly. I looked at Sandy's *Spider* and *Little Spider*

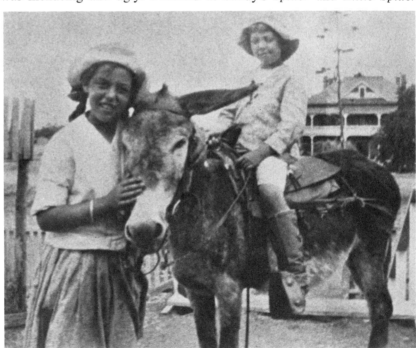

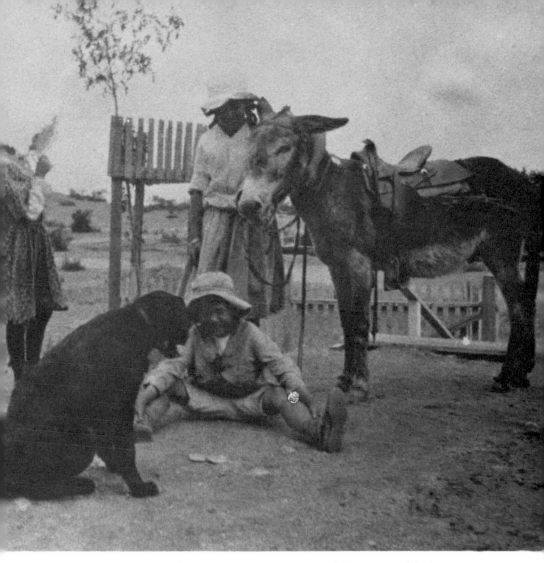

*Sandy taught Kohie to wait on his command before
gobbling up a mite he put before her.* Arizona

*Sandy had Jack-O in the morning for a week, I in the afternoon.
The next week we switched.*

at the Whitney. Airy and graceful. No tarantulas they! Sandy's mobiles are Daddy Longlegs. In Oracle, we found the scorpion to be a harmless enough little fellow if you followed the rules.

We were most respectful on meeting one of the old range bulls rumbling along the fenceless prairie. When the big roundup raised the dust for miles, we watched from behind the little fence around our house. But when the branding of the calves started we watched for hours from the top rail of the corral fence. The cowhands not only branded and ear-notched the calves, but castrated the males. This operation was utterly bewildering to Sandy and me. We asked Shad No. 1 what they were doing.

"Blimey, go ask yer Paw, and don't you kids fall off that fence. It ain't safe for kids inside this 'ere corral. One of them old cows might take it into 'er 'ead to get ornery. Better git on 'ome."

Later that day, Father asked Shad what they had been doing. "De-nuttin' 'em. Oi find it 'ard to explain to city kids." Father, too, found it hard. I, who had always wanted to be a boy, suddenly found males at a decided disadvantage.

For the first two months in Oracle we made feeble attempts to keep up with school work. We started a butterfly collection, sending to Philadelphia for W. J. Holland's massive tome as reference. We marveled at the way butterfly wings are made, with the tiny scales laid like shingles on the wing membrane; at how easily they can be rubbed off, yet with what beautiful order they are arranged. We wondered that each butterfly was so perfect in itself, and yet each species different; that each pattern was predetermined in such a tiny egg. We became adept at catching and mounting butterflies. Many lovely sulphur-yellow and little bright blue fellows found their way into padded boxes with glass windows. We painted the boxes appropriate colors or covered them with material that would show the inhabitants to best advantage.

The only other buildings nearer than Tucson were the post office–general store and another small dwelling occupied by a family named Krause. The Krause children, whose father was also ill, were our constant playmates. They had two family burros, one large enough to carry double. Together we explored neighboring ravines and played cowboy endlessly, throwing our home-made lariats around one another, around stumps, and now and then around a calf that had no protective mother standing by.

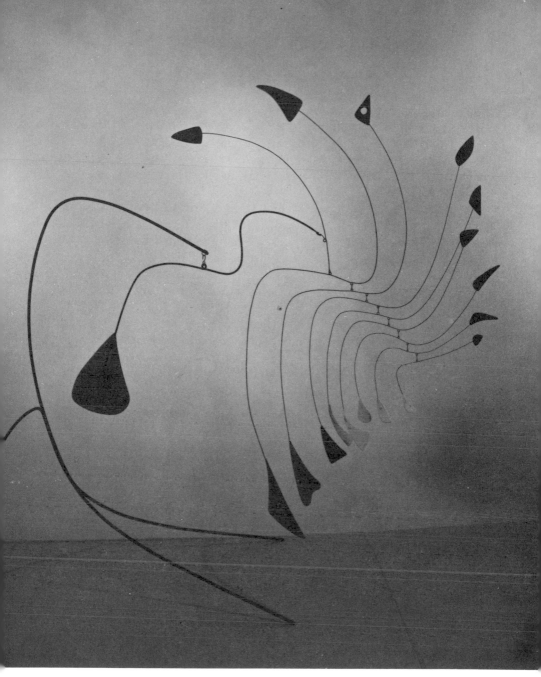

LITTLE SPIDER
Sandy's mobiles are Daddy Longlegs.

Photo: *Perls Galleries*

It was in the all-purpose store that Sandy and I indulged in our own version of a classic con game. We were both very aware of the packages of gum displayed in their original boxes on the counter. We each had picked up a pack at one time or another only to reluctantly put it down; five cents would have exhausted a whole week's allowance. "Look, Sandy, one of us can talk to Mrs. Neeley and the other just take a pack while she's busy at the other end of the store." The ease with which our trick succeeded unnerved us both. The gum lost all flavor. After we each had had a whole piece, we gave the rest to the Krauses. A few days later, we left five cents on the counter where it would easily be found, thus laying our guilt to rest.

On April 18, Mother came walking back from the store with a curious expression on her face. News had come over the only telephone in Oracle that San Francisco had been razed by an earthquake and was now on fire. We felt her horror, though we had only a vague notion of what an earthquake was. Mother also had an indefinable feeling that God was punishing the reputedly wicked city as a warning to the world. Father scorned such "superstitious rubbish." "Earthquakes," he said, "are attributable to stresses and strains in the earth's surface, and to the cruelty of Nature."

The brothers Shad organized a parade on Decoration Day. Everyone who was well enough took part. The Neals rode at the head of the procession in their buckboard. Father rode Pico Blanco and Mother an old buckskin mare whose skittishness was blamed on her having eaten the locoweed. I rode the ranch burro, larger and livelier than ours, and Sandy brought up the rear on Jack-O, on whom Father had attached some old cow-horns. A Scotsman named Fraser who claimed to be an expert horseman rode the ranch stallion. Whether it was the locoweed or the rhythm of nature, Mother's mare and Mr. Fraser's stallion were refractory. Finally, fearing someone would be hurt, Shad No. 2 roped the stallion. The mare, with Mother hanging on for dear life, bolted for the barn. Mother narrowly missed being either brained or rubbed off as they dashed through the barn door. After Shad No. 2 had finally caught and quieted the mare and helped her badly frightened rider dismount, concentrating intently on coiling his lariat he said, "Misus Calder, Oi takes me 'at off to you. You sure did stick on that crazy buckskin."

Another kind of excitement was caused by a tin lizzie, which came wheezing up the dirt road one afternoon. Its arrival was heralded

by Shad No. 2, who dashed up on horseback to announce breathlessly that an *automobile* had stopped at the post office! Everyone dropped what they were doing and rushed forth to greet the Ford when it arrived at the ranchhouse. The car's headlights were kerosene lamps, one of which had extra tires slung rakishly across and over it. Canvas water bags were draped over the front and rear; the back seat was piled with boxes of extra tubes and tire-mending equipment. To protect the occupants from the desert sun, an old carriage top had been fastened to the body. It looked top-heavy, as if any kind of breeze would blow it off. There was no windshield.

Sandy's cup was full when he was allowed to sit in the car while its owners took refreshments and questions in the ranchhouse. Perched in the front seat, he honked the rubber and brass horn with one hand and pretended to steer with the other. The entire ranch community stood in a respectful semi-circle when the driver emerged from the ranchhouse with a handcrank to start the automobile. Cranking it was quite an athletic performance; many strenuous whirls were required before the engine sputtered to life—at which point the driver prudently yanked his arm away and leapt aside.

Toward the end of the summer, bands of Apache Indians came riding their miserable, skinny horses to gather ripe acorns from the mesa oaks. Despite their belief that having their picture taken would jeopardize their passage to the next world, several were willing to take a chance on the future for four bits (50 cents) in the present. Besides taking photographs, Mother and Father bought two of the baskets used in collecting acorns. These carrying baskets hung between the shoulders in back, with their weight borne by a band across the forehead. One irate squaw felt she had been underpaid for her basket and went after Mother, who dodged behind the only tree while Father fished out another four bits.

Still convalescent, Father rested every afternoon, but had been given permission to begin sketching again. He sketched both sculptures he had been dreaming of, to be modeled later, and local scenes. In the second category were sketches of Sandy on Jack-O and of me in a Mexican hat. Mother sketched also, usually the plains with the Table Mountains in the far distance.

One day as we were playing with the Krause children, two girls aged nine and eleven appeared from nowhere. The children of an Indian woman and an Irish cowboy named Daly, they lived several

miles away and thought nothing of walking those miles to play with us. The girls, whose Indian names were Herakamani and Tasinke Wauble, had long black pigtails down their backs and wore ankle-length black dresses, black stockings, and shoes. They would appear Saturday mornings after finishing their numerous chores at home and stay with us all day. For weeks they never said a word. After refusing lunch many times, they finally succumbed to Mother's offer of a sandwich, which they ate as they sat outside on the steps, too shy to come in.

They brought a whole new aspect to our play. It was they who showed us how to make a slip-knot in true lariat style and then splice the ends so they would not ravel, who knew which acorns were sweet and edible, who showed how to find the entry of a trap-door spider, and who alerted us to the approach of an incensed mother cow when her calf, entangled in homemade ropes, bawled for help. In turn, they heard of big cities, of horse-drawn trolleys, fire departments, the wonders of riding on a train, the huge ships that crossed the Atlantic to far-away Europe, and the deliciousness of ice cream, which they found hard to imagine.

On the girls' last visit before we left Oracle, they brought us gifts, a ten-cent piece for each of us and a small, uncut garnet.

Rest and ten months in the clean mountain air had done their work. Father was cured. On Dr. Harte's advice, our parents decided to move to southern California, where the climate was said to be much like Arizona's, where cities were laid out pleasantly, where there were buildings and architects and, it was hoped, enough interest in art for Father to find work.

So we packed up our clothes, said goodbye to everyone in Oracle, tearfully took leave of our pets, and left, vowing to return and become cowboys.

The trip from Tucson to Los Angeles was not a happy one for Sandy and me. We mourned the loss of our beloved pets and felt certain that the only life worth living was herding cattle on the open plains. Sandy recovered his composure first, for he soon was absorbed in examining the train itself, the scenes from the window, and especially the ingenious lavatory appointments: faucets with clips instead of handles, and basins that folded against the wall, swishing out their contents onto the track below.

After a day in Los Angeles we went to live in a little rented house on Euclid Avenue in Pasadena. It had the conventional plot of crab-grass in front and behind it a largish garden dominated by a fruit-laden orange tree. Pasadena, like Oracle, held delights for eastern children and their parents. Geraniums like those Mother had carefully nurtured in pots in Philadelphia grew riotously in vacant lots. The fresh, clear air was laden at night with the fragrance of orange and lemon blossoms, night-blooming jasmine, and gardenias. The sky, china blue by day, was filled at night by the same friendly stars we had learned to recognize in Arizona. Rows of stately palm trees led up to the mountains or to avenues lined with magnolias. We loved the place immediately.

Our parents improvised most of the furnishings for the little house, buying only what was absolutely necessary. Orange boxes, painted,

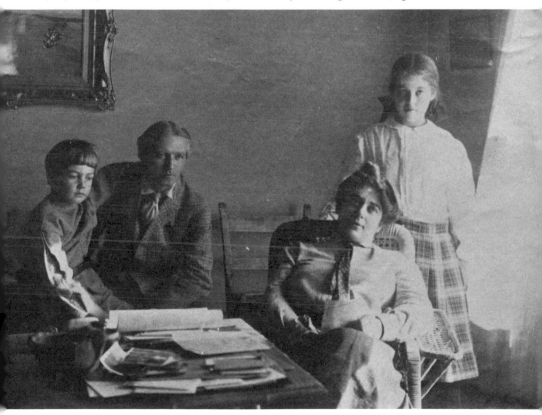

Our parents bought only what was necessary, improvising the rest.
Pasadena, 1906

Sandy's drawings made in Pasadena, age 8 *Photo: James Stipovich*

lined, and curtained, made bureaus. They discovered the little Mexican chairs with laced rawhide bottoms, at that time four bits each. A Japanese *kakemono* or two were hung on the walls. A previous tenant had painted Cupids intertwined with rose garlands around the edge of the dining room ceiling. The landlord indignantly rejected my parents' request to paint over them, so they drowned their distaste in jokes.

Sandy and I shared one of the two bedrooms. We reconstructed a ranch scene on the largest wall, making horses and cows of cardboard. These we painted like the old range cows, with an occasional Texas longhorn thrown in. They all showed brands and ear notches. We made corrals, water holes, and ranchhouses, and cut out a few saddles and bridles, detachable so they could be rotated among the horses. All these were attached to the wall with thumb tacks and moved about according to the dictates of our play. In those days it was I who insisted on mobility. Since the wall was stucco, we made quite a mess of it.

Mother bought an easel, which she kept in one corner of the living room. When she had a commission or just wanted to paint, she pulled it out, spread newspapers under and around it, and went to work. Sandy and I often augmented our five cents a week allowance by posing at twelve and one-half cents an hour.

A friend of Mother's sent Sandy a mechanical train with tracks. These he installed in the back garden, where they became a leading attraction for the neighborhood children. When he needed more tracks, he made wooden ones. One day he brought home a wooden packing box, which he sheepishly admitted having cadged from a neighbor. Sandy made it into a castle under the orange tree, surrounded by a moat, which later was traversed by a drawbridge with portcullis. Prince Gustav, transformed from a humble French gendarme by the addition of royal robes and a sheet-brass crown with sealing-wax jewels, was duly installed in the castle with Princess Thomasine. We all helped Sandy make the thrones and all the other paraphernalia of royalty, including standards for the royal flags.

That was the winter when flooding made it possible for Sandy to scavenge for pieces of discarded copper wire by following the repair men. By Christmas, I had saved enough money from my allowance and posing money to buy him a pair of pliers. This enabled him to work with more precision. Princess Thomasine was fitted out with watches, lockets made of copper-wire spirals or 22-gauge rifle shells,

combs of copper wire threaded with beads. From the wire scraps Sandy fashioned not only adornments for all our dolls, but buttons for Mother and a ring with spirals at each end of the wire, which were curled around one another once the ring size had been determined. He also made a branding iron of a single copper wire with the Circle C we had adopted as our own.

When it became too hot to be held barehanded we held it with the pliers. We used it on everything that would stand branding.

Sandy was given other tools and encouraged to use them in what became his basement workshop. For the Fourth of July we were each given a dollar to spend on fireworks. After mulling over the question for hours, we concluded that the small Lady Finger firecrackers from China, woven together by their fuses, gave us the most for our money. So we bought only a few bigger ones and concentrated on various ways to use the small ones. Sandy made a cannon of a .22-caliber rifle shell with wheels cut from a slab of lead especially designed for Lady Fingers.

Neighborhood talent collaborated on the *Backyard Newspaper,* reporting such events as "Terrible Wreck by the Cellar Steps." Copy was set on a diabolical typewriter that had the alphabet on a wheel with one small opening. To type a word, one had repeatedly to dial the hard metal wheel around so that the opening was over the right letter. This laborious procedure created blisters, so Sandy made leather finger-protectors for the typists.

Uncle Ron, one of Father's younger brothers, visited us our first summer in Pasadena and made Sandy a coaster from a board mounted on wheels, with a steering wheel linked to the front wheels by ropes. On this all the children in the neighborhood enjoyed fine rides down the gently sloping sidewalks of Euclid Avenue. Although Uncle Ron also gave each of us a pair of skates and me a bicycle, it was the building of the coaster that made him a legend—a summer Santa Claus.

One evening Father arrived home with a furry black bundle of mischief under his arm. He had bought the puppy from some Indian boys who were mistreating her. As she looked for all the world like a small black bear, we named her Ursa Minor and fondly declared her a black spitz because her tail curled over her rump. "That," said Sandy, "is so the fleas can loop the loop."

Cannon made of .22-caliber rifle shell for
Lady Finger firecrackers

A plow, made of lead, for our horses. Pasadena, 1906-07

The ride on the big red electric train to Father's studio took him past Oneonta Park. On investigation, he found not only a small zoo, but the winter quarters of a circus, with such events as ostrich racing scheduled now and then. A Sioux Indian group was also part of the circus. When on the road, they danced and whooped in full war regalia. Father made friends with them and prevailed on Najinyankte and Kill-an-Enemy to pose. Mother took her paints to the studio and painted them while they posed for Father. Conditioned as we had been to thinking of Indians as impassive and forbidding, we were surprised by their gentleness and by their keen sense of humor. This revelation, along with our friendship in Oracle with the Daly girls, made us ardent advocates of Native Americans.

On New Year's Day, 1908, our family and friends went to the Tournament of Roses, then just starting. The Lucky Baldwin Ranch float, which paraded through the streets prior to the Tournament itself, was drawn by six matched percherons. The float's centerpiece was a peacock constructed wholly of white flowers, with the tail made entirely of unbelievably fragrant lilies of the valley. Instead of the football game that is now the highlight of the afternoon, jousting, tent-pegging, and chariot races were held in Tournament Park, now the athletic field of the California Institute of Technology. The tent-pegging contestants rode full tilt at the tent post driven into the ground, trying to unseat the peg with one blow of the lance. Sandy thought this sport super, but the rest of us loved best the chariot races. In these there were several heats, so by the grande finale, excitement was running high. The horses raced like mad, cutting corners close while the chariots swung wide. A clowning element was introduced by races between burro-drawn chariots. When a horse gallops his tail streams out behind him, but burros tuck their tails between their legs and bound like jackrabbits. To make them go faster, the drivers banged pieces of tin against the chariots' sides to frighten them.

Next morning, the sounds of sawing and hammering from Sandy's basement workshop woke our parents at 6:30 a.m. Sandy was sawing out horse heads from an old wooden box and hammering them onto handles—Mother just managed to save the handle of her new broom. Meanwhile I unraveled rope for manes and tails and found leather for ears and bridles. We stopped when called to breakfast and the unwelcome diversion of school, but that afternoon drove pegs into the lawn and soon had an eager circle of children galloping across the

Mother took her paints to the studio and painted the Indians while they posed for Father. Photo: Colin McRae

crabgrass at our targets. The jousting was hardly under way when Sandy began to make a chariot of an old orange crate. Wheels appeared from everywhere—even purloined from the beloved coaster. The chariots were painted or decorated with crepe paper. The whole neighborhood joined in. There were at least two teams with three or four "horses" of the two-legged variety for the chariot races. Luckily, there were few automobiles to interfere with our mad races down Euclid Avenue and around the corner onto California Street.

After two years on Euclid, we moved to a colorful, vine-covered "barngalow" on Linda Vista Avenue. Here Sandy and I had separate bedrooms for the first time since our winter with the Shoemakers. Uncle Ron sent us each tennis racquets, and tennis and baseball replaced cattle ranching as our favorite pastimes. We also invented a game called Robber, which involved getting into the house by climbing through a window or picking a supposedly locked door. During one of these games, Sandy fell off a high box and bruised one cheek, which led father to dub him "Mouldy Pippin." Apparently the fall damaged a cheek muscle, for ever afterward he had a crooked smile that gathered up the right side of his face. This is the smile that Father captured a few years later in *Laughing Boy,* the bust of Sandy that greeted visitors to the Whitney.

That Christmas, 1908, Sandy had no gift for Mother. Nothing was said, but on Valentine's Day she came in to breakfast to find hanging on the back of her chair a large, heart-shaped bag, made of brown paper and sewed together with string. The outside was decorated with a suitable Valentine sentiment painted with red water color; inside were six five-cent handkerchiefs, for which Sandy had saved his entire allowance from Christmas to Valentine's Day.

Although the years in the west were happy ones for Sandy and me and restorative ones for Father, our parents were convinced that an American sculptor could not make a living far from the art centers of the country, New York and Philadelphia. Over the vociferous and tearful objections of their children, they decided to return east. Before leaving the west coast, they thought we should make a brief excursion to San Francisco, as we might never have such an opportunity again. At the last minute Father was unable to go, but waved the three of us off gaily on the overnight boat from San Pedro.

We found San Francisco still in ruins from the earthquake and fire. Piles of brick and rubble were heaped everywhere. Chimneys and

fireplaces gave silent testimony that these heaps had once been homes. Twisted pipes and bathtubs sat forlornly on top of broken beams.

Chinatown was an exotic experience, full of strange and often not altogether pleasant smells and of many enchanting sights. We were too impecunious to buy the many things we loved on sight, but found it a wonderful place to play "Remember"; the game was to see which of us could later recall the largest number of objects seen in a given store window. Sandy always came in first. For ten cents Mother bought me a little articulated fish made of gold-colored metal. Each of the parts, which fitted neatly into one another, was held in place by a wire. The fish turned and twisted in a sinuous manner which delighted me so that I put it on a black velvet ribbon and wore it around my neck except when playing baseball.

Sandy and I expected life in the east to be tame to the point of dreariness after our years in Arizona and California, and at first our worst fears were confirmed. The owner of the house our parents rented in Croton-on-Hudson would not let us keep Ursa, who had crossed the continent in the baggage car of our train. We had no one to play with. The summer heat and humidity seemed intolerable. It was, I assured my Pasadena friends in lengthy, impassioned letters, more than I could bear. What finally made the summer quasi-bearable were the pond in front of Father's studio, our bicycles, and Harvey Stevenson, our landlady's only child.

The fair-sized pond provided both summer and winter pleasures. In winter, it was fine for skating and snowball fights. In spring, summer, and fall we explored the water life in a blunt-nosed boat. We gathered frogs' eggs, keeping them in jars to watch them develop. Then Sandy fixed long handles to sieves so that larger polliwogs could be scooped up and kept until they grew legs and lost their tails. We caught and examined newts as well as many bullfrogs, but were foiled in our attempts to catch the little green *hyla pickeringi*, which made a stupendous noise until we were almost upon them. We learned to identify the dragon fly larva from the decorative yellow and green patterns on its torpedo-shaped body. We watched it shoot forward from its hiding place to grab its insect victim with its wicked front pincers. Later we would find the larva sitting on the stem that it had

climbed along in leaving the water. There it would sit until the skin split up its back and the dragon fly emerged to soar, lay eggs, and relaunch the life cycle.

It was Harvey Stevenson, home from boarding school, who saved the day that first summer in Croton. He was several years older than I, had a nice sense of humor, and played baseball and tennis well. The Stevenson house, a chateau-like mansion on the highest hill over-looking the Hudson River, was one of several enclosed by a handsome stone wall. Beyond the pond, in the open space between it and the apple orchard that crowned the brow of the hill, was a fine grass tennis court, which we were allowed on only to play with Harvey. He was a stickler for playing whatever was in season, so we played a lot of tennis as the summer progressed. Along the part of the stone wall that ran across our back garden, Sandy installed his train where it could remain set up without causing the complications it did indoors. He built wooden tracks with elevations, so that his train could gather enough momentum coasting downhill to make it up and over the next incline. He also built a station and a turntable for the train, and at night put candles in the station and train to lend them a touch of elegance.

In the fall I began commuting to a private school in Ossining, while Sandy went to the local elementary school in Croton, where despite his friendly good nature he made no friends, brought home no playmates; indeed, he had none. He did not complain—he just went into his workshop and made things. His bedroom became a maze of strings; they pulled up shades and lowered them, pulled the casement windows closed, turned the lights on and off. Mother had given him a mahogany highboy, painted blue, to store his treasures in: wire gathered from here and there, rocks, pieces of wood, tools. On Thurs-day, cleaning day, a stormy scene always followed Sandy's return from school—a crucial bit of string had been removed from his door-knob, or wire from the chair. Mother sympathized, but felt obliged to maintain a minimum of domestic order. Forty years later, as she stood in the doorway surveying the clutter and seeming confusion in Sandy's Roxbury studio, Mother clucked her tongue and murmured, "That Sandy! He's a terror."

At the Ossining school, I became friends with Eleanor and Mar-jorie Acker. Their uncle, Gifford Beal, was a painter, and they not only were prepared to tolerate "artists and other nuts," they even

revered them. Subsequently, both girls studied art. Marjorie became a painter who collaborated with her husband, Duncan Phillips, in creating the Phillips Gallery, considered the most prestigious small collection in the United States.

As this friendship blossomed in 1910, Sandy and I now and then spent the night in the Ackers' big house overlooking the Hudson. Eleanor and Marjorie were the eldest of six children, and dinners with them were much livelier than ours were at home. After dinner the Ackers usually had dancing in the living room to the strains of "The Blue Danube" on the player piano. Like Mother, we loved dancing and took to it easily. Only Father's Scotch Presbyterian distaste had kept Mother from having dances at home; even after she became a grandmother, she would sally forth alone on cold winter nights to join a group of folk dancers, leaving Father curled up at home with a book and a stogie. Now Sandy and I began pressing her to teach us more about dancing. To meet this emergency, Mother played the piano while Anna Tuceling, our lively maid, taught us to waltz round and round the dining table to "The Pink Lady," played in Beethoven cadences. Thus prepared, we began our teenage social life.

Social gatherings brought other teenagers to our home, and for the first time Sandy and I became aware of the general attitude toward nudity. We were surprised and embarrassed for reasons we could not understand by the sly looks and salacious remarks of two boys from Ossining. Mortified, I went weeping to Mother, who tried earnestly but unsuccessfully to explain why charcoal drawings of nudes by my parents' friends Robert Henri and Everett Shinn were ART and therefore acceptable for living room display, whereas photographs of undressed persons were not. Having been surrounded by paintings and statues of unclothed figures all our lives, Sandy and I had never given the matter much thought. Suddenly the attitudes of our new friends became all-important, and the next time they came, we took down the offending drawings and hid them behind the piano.

At Christmas, Sandy gave Mother and Father a little dog he had made of sheet brass. He cut the metal out flat like a pelt, then bent it so that the dog stood on four legs; the tail and ears were also bent into position. The *Old Bull* shown at the Whitney (the only token I noticed of our childhood pledge of lifelong fealty to the open range), and the birds made of tin cans, cut and folded as though they were paper,

*For Father's birthday, Sandy made him a little
game of wood and four-penny nails.* Photo: Antonio Violich

were made the same way. For Father's birthday in January, 1910, Sandy gave him a little game he had made out of wood. A small wooden rectangle was divided into six pens by fourpenny nails. A tiger, a lion, and three bears, all suitably painted, were fastened into slots so that they could be moved from pen to pen. The challenge was to clean the pens without having two animals in the same pen at once (thus avoiding bloodshed).

One day Sandy returned from school with a black eye. In response to my parents' anxious questions, he confessed to being bullied on the school playground by some village louts. That day, he had been backed against the school wall and punched. When the teachers confirmed his story of constant harassment but showed little inclination to do anything about it, Mother found him a boxing teacher, who gave Sandy lessons until we moved to Spuyten Duyvil and he and I commuted together to Yonkers High School.

By 1912, Father was making business trips into New York with increasing frequency. To make the commuting less onerous, we moved down to Spuyten Duyvil, a pretty little rural settlement on the bluff overlooking the convergence of the Hudson and Spuyten Duyvil rivers. We rented the two lower stories of a three-story house and were at last permitted to send for Ursa. Spuyten Duyvil had a pleasant inn,

to which Mother and Father moved a few years later, when Sandy and I had left home. And it was on the courts of the local club that my tennis, begun on dirt in Pasadena and continued on grass in Croton, took on stamina. Several older men invited me to play, and shortly before we moved away, my partner and I won the mixed doubles in the yearly tournament.

Although tennis was gaining popularity, baseball was still king. Children from all over town gathered in the empty lot opposite our house, making a diamond with gunny sacks for bases. There we played daily, choosing sides if there were enough players on hand, making do with One O'Cat if there weren't. Sundays were a terrible bore—there were never enough for a game until late afternoon—but on Saturdays we were always able to form teams early in the day. Sandy played second base for the Spuyten Duyvil Boy Scouts, while I played first. One of our teammates had a friendly aunt with a Hupmobile touring car and a Springer Spaniel who always sat beside her in the front seat. She wore her hair in braids coiled in loops over each ear. One day after she had as usual conveyed our team to a game and bought us all treats afterward, Sandy observed: "Aunt Mabel sure is nice, but don't she and Spot look like one another, with her hair and his ears!"

We found the work at Yonkers High stiff. We studied on the train to and from school and at home in the evenings—Mother insisted that we play outdoors between school and dinner. Our first experience of a big, urban, coeducational school, it proved almost too beguiling for me. I found it difficult to concentrate on the square of the hypotenuse while an engaging male beat out "He's a Devil in His Own Home Town" on the back of my seat. It was one of these youths, however, rather than the teacher, who gave me my first inkling that physics could make sense.

We left Yonkers High right after the June examinations, and it was only when we saw the yearbook months later that we learned there had been fraternities, sororities, clubs, and all sorts of other activities going on around us. By then we were back in California, this time in San Francisco, where even more pleasant adventures awaited us.

We boarded the train for the trip to San Francisco in high spirits. Sandy and I felt we were heading in the right direction this time, and my parents were excited by the work awaiting Father in San Francisco:

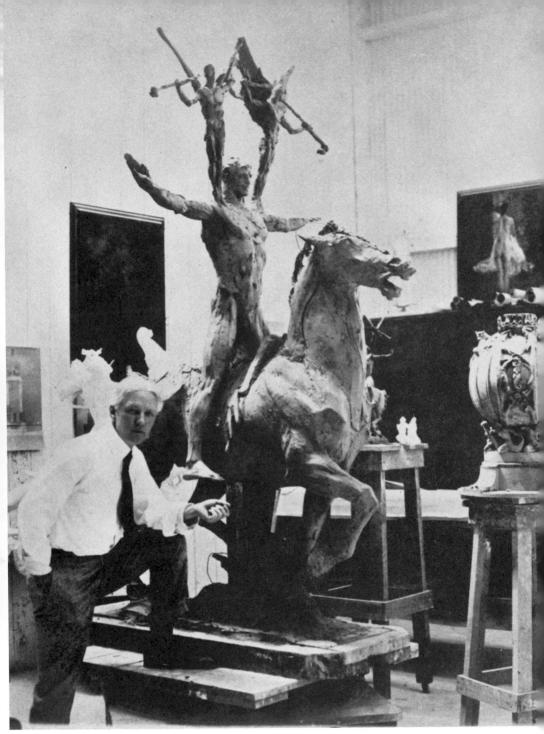

Alexander Stirling Calder in his studio at the Panama Pacific
International Exposition, working on THE FOUNTAIN OF ENERGY, 1915

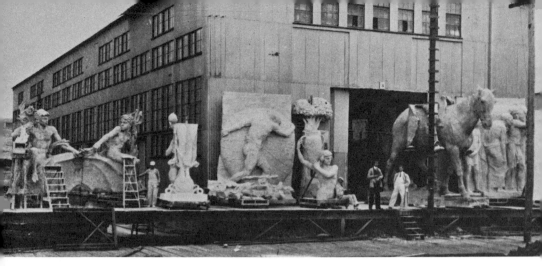

Shops for enlarging sculpture at Panama Pacific International
Exposition, located in old iron buildings

he had been appointed sculptor-in-chief of the Panama Pacific International Exposition, scheduled to open in San Francisco in the spring of 1915.

On arriving in San Francisco, we went directly to the house rented for us on Broderick Street, within walking distance of the Exposition's sculpture workshops. The shops had been set up in old iron buildings on the Fairgrounds, a block or so from San Francisco Bay. Here small statues that had been modeled by sculptors all over the United States were reproduced on the large scale required for use on the Exposition buildings. Sandy was fascinated by the enlarging process itself, for which a scissors-like instrument called a pointing machine was used. This consisted of two parallel needles, one longer than the other. The small sculpture and the framework for the large sculpture were placed on two turntables, which turned together through sprockets and a bicycle chain. The sculptor would put a cross on the small plaster figure and then a nail into the wood framework where the other needle touched. Thus the high and low spots would be represented by nail-heads on the enlarged structure. The gaps between nails were then filled in with plaster. This was treated to look like the beautiful pink porous travertine found in the Valley of the Tiber. Sandy, a constant visitor at the shops, continually urged me to join him. "The mechanics are great; you ought to come watch."

I went several times, but became fully engaged in college life at the University of California and in deciding how I wanted to support myself after graduation. Our love of the outdoors and games increased my sympathy for city children, whose plight had been made vivid by

the drawings and etchings of Father's friend John Sloan. After reading Jane Addams's *The Spirit of Youth and the City Streets,* I decided to major in social economics, then taught at the University by Jessica Peixotto, and become a social worker. Mother and Father liked the idea, and were pleased that I would not be professionally involved with Art, which they had found a hard, precarious life.

Sandy entered Lowell High School, San Francisco's high school for students of strong academic bent, where for the first time since we had left Pasadena, he was included in the friendly whirl of after-school activities. He went out for rugby and, though he did not make the team, enjoyed the practice in Golden Gate Park with his friends.

After six months on Broderick, the family moved to 1654 Taylor Street, the only house in a five-block area on Russian Hill that had survived the earthquake and fire, thanks to the eccentric patriotism of its occupant. Living there on April 18, 1906, was a Mr. E. A. Dakin, a Civil War veteran and flag collector. As he watched the flames licking up the blocks below him, he could think of nothing to do but to fill every available container—bathtubs, washtubs, pots, and pans—with water and run up his most cherished flag. In recognition of the inevitable, he dipped the flag three times—just in time to draw the attention of an infantry division arrived to help the stricken city. Such a house, the soldiers decided, was worth trying to save (it must be important; it might even be General Funston's), and, with Mr. Dakin's stored water, they wet the roof and shingles sufficiently for it to survive while every neighboring dwelling was blown up or burned.

The "flag house" overlooking San Francisco Bay from its hillside was roomy and pleasant. It had a player piano worked by foot pedals. Sandy and I made the walls shake as we boomed out our favorite roll, *The Hungarian Rhapsody,* and vied to see who could play faster. Sandy, then a thin teenager with the not-yet-jelled look so characteristic of the age, rode the cable car to school each day. He enjoyed the amusing assembly of this little car, which in those days pulled a trailer. He also enjoyed the garrulous friendliness of the conductor and the other passengers. He did well in his school work and my friends as well as his enjoyed his company. A sly tease, he was himself impervious to teasing. After the Fair opened, he was often the only male accompanying five or six of us freshman "dames" from Berkeley. He munched the scones dripping with butter and raspberry jam being featured at the well-attended Fisher Mills exhibit, and danced the

tango at the California building's *thés dansants,* taking turns with other swains who happened along in those pre-going-steady days. He also went with me to rugby and baseball games and track meets in Berkeley, or played tennis over the weekends.

I lived in a sorority house in Berkeley, coming home with my laundry on weekends. One day I had a surprise mid-week phone call from Father, urging me to come home earlier than usual that Saturday, so I could accompany the rest of the family to see *Disraeli,* a play of political intrigue during Queen Victoria's reign, starring George Arliss and Margaret Dale (a distant cousin of Mother's). As the wily Prime Minister sat at his desk, deep in thought, he inadvertently tapped three times with his pen. The door flew open and in popped Mrs. Travers, the beautiful Russian spy (Margaret Dale), exposed by this unexpected use of her signal by the wrong person.

We all were delighted by the play, and delighted, too, to be invited backstage after the performance, where we met George Arliss and located Margaret Dale by the star on her door.

Over her dressing table blazed a dazzling array of lights that remorselessly highlighted the most minuscule defect of costume or make-up. Sandy and I, reared in the belief that cosmetics were the preserve of the underworld, were astounded by the paints, pastes, pommades, false lashes, curls, and switches arrayed on the table beneath the lights. Accustomed to thinking of lipstick as something used only by harlots, we were startled by the number of lipsticks alone, some of which, we noticed, had been used to make red dots at the inner corners of Margaret's eyes and in her nostrils. Observing our fascination, she invited us to come before the next matinée and watch her get into the war paint with which she transformed herself into the exotic Mrs. Travers.

The football season at the University opened with a bang. The game played was rugby, recently instituted on the west coast after several deaths caused by the roughness of the American game. We had never seen a game of rugby, so it was with great anticipation that Sandy joined me in the University rooting section one Saturday afternoon. Cal was playing the All Blacks from New Zealand, a team composed of older men, each weighing more than 200 pounds, who disdained all training rules and smoked big, black cigars and swilled beer even between halves. Sandy and I found the game bewildering with its odd-looking scrum and exciting forward rushes.

As the game progressed it soon became obvious that Cal's valiant amateurs were outclassed. At one point in the game, the ball went sailing downfield into the arms of a Cal man who signaled for a fair catch. The New Zealand forward, racing after the ball with every intention of commiting murder, had to swerve at the last second because of the fair-catch signal. It was a tense moment as he stood glowering over the youthful Cal player with impotent rage. The Cal man reached up and tickled him under the chin. The tension dissipated in the ensuing roar of laughter and applause.

"Who's that guy, do you know?" asked Sandy.

"Yeah," I yelled over the cheers, "name's Kenneth Hayes. I met him at a dance several weeks ago. He's fun!"

"I'll bet he is!" Sandy was cheering with the rest.

And so Kenneth Hayes entered our lives. A sophomore who thoroughly enjoyed college life and a born athlete, Ken had spent the previous summer in Hawaii playing second base with the California baseball team. In Berkeley he lived with his mother, who was very active in the women's suffrage movement, and with his sister Jean, who resembled him so closely the two might have been twins. Together the three had toured the countryside with a group espousing votes for women, with Kenneth and Jean performing a song-and-dance routine between speeches.

His mother would begin, "Fellow citizens, and I can call you 'fellow citizens' because I come from the State of Washington, where women have the right to vote."

After leading the applause that followed her speech, Ken and Jean would step forward and, as they danced, sing the following verses alternately:

> Reuben, Reuben, I've been thinking
> What a fine world this would be
> If they'd give the vote to women
> All along the western sea.
>
> Rachel, Rachel, you surprise me
> There is one thing, don't forget
> What I want's a perfect lady—
> Not a headstrong Suffragette.

Reuben, Reuben, you are right, dear
Woman's proper place is home
From the cook stove and the washtub
She should never wish to roam.

Rachel, Rachel, you've convinced me
And I'll take you for my mate.
Woman's proper sphere is home, dear
But the Home's our Whole Great State.

I too, believed that women should be allowed to vote, to hold property, and to have all the rights enjoyed by male citizens. As time passed, I became an ardent follower of my "mother-in-law-elect." (How pleased she would have been when a grand-daughter-in-law was elected the first woman Mayor of San Jose, a northern California city of 560,000 inhabitants.)

The Exposition opened officially on February 20, 1915, when President Wilson pressed a button in Washington which turned on the water in the many fountains. After that, Sandy and I spent as many weekend hours there as studies and college affairs permitted. We even conquered our aversion to Art Exhibitions sufficiently to romp through the galleries of the Palace of Fine Arts. There, a notable collection of paintings was housed indoors, while most of the sculpture stood outside under colonnades or in niches backed by shrubs, trees, and flowers. Sometimes we went with a group of friends, sometimes it was just the two of us. We found and sampled all the free foods, collected free gifts and samples, such as little pickle pins given out by Heinz.

We watched wheat paste emerge through sieve-like strainers in long streamers, which were then cut off into little bales, baked, and labeled Shredded Wheat. We spent long hours waiting for our first coast-to-coast telephone call to be put through, and danced joyously everywhere free music and floor space permitted. In the amusement area, called The Zone, Alexander the Mind Reader dazzled us all by saying aloud things we thought were secrets. At rugby matches we yelled lustily for the University of California heroes, and were especially proud when Kenneth was chosen to play on the All American team.

The horse races took on added interest when we found the Dan Patch stables. Here we fell in love with Electric Patch, son of Dan Patch, modeled by Father in Pasadena four years before. A young, shiny black stallion, Electric Patch looked beautiful streaking down the track, his forelock blowing back from his forehead to reveal his

*The Panama Pacific International Exposition opened on February
20, 1915.* Left: Sandy before THE FOUNTAIN OF ENERGY. Above: looking
through the western arch at the Nations of the East.

only white spot. At first he paced evenly and fast, but to our dismay as we watched from the stands, broke and disqualified himself. It was then we realized the full import of Thompson Seton's story "The Pacing Mustang." Poor Electric Patch had to learn to pace, he was not born to it. He would have to become more experienced before he could take the competition.

We were there when John Philip Sousa introduced his "Stars and Stripes Forever" and when Mary Garden sang "I Love You, California" for the first time. We joined in a resounding, "Yes!" when Ted Lewis, hat in hand, came to the front of the stage and asked, "Is everybody happy?" We watched Beachey's stunt-flying exhibitions in that new-fangled device, the airplane, but happily were not present when he fell to his death.

Early in March, Sandy and I each received a formal, engraved invitation from the National Exposition Commission, requesting the pleasure of our company at a reception and dance in the California building. We felt we had arrived in high society, and were elated to learn that we could go and bring a guest. "But you must remember, we are all honored guests," admonished Mother. "None of those outlandish dances you do, the Bunny Hug and the Fox Trot." Ken drove me, Mother, and Father, as well as Sandy and his date, over to the Exposition in his car. We girls were all decked out with long white kid gloves and silk stockings with cotton tops and cotton toes.

Ordinarily, to go to the Exposition from Berkeley, one boarded a streetcar on College Avenue and transferred to a big electric car at Alcatraz and Adeline, which connected with a special ferry at the Key Route Mole. The trip cost ten cents. Returning to Berkeley, sprinting to catch the last ferry, which left the Fair at midnight, we often found ourselves surrounded by other sprinting students, equally sore of foot, out of breath, and filled with happiness. We sat in the stern as the ferry pulled out, listening to the mellow tones of the carillon in the Exposition's Tower of Jewels and watching the lights go out at the Fair. Singing was spontaneous. One moonlight night, Elizabeth Witter, a handsome, big girl with luxuriant sunkist hair and a lovely contralto voice, started "Sumer is Icumen In," the song she had sung in the Parthenia, the Women's Spring Festival. As we all joined in and the lights went out, the water seemed black and mysterious. Stars appeared overhead as the ferry churned along, carrying us back to reality.

After Father's work for the Exposition was completed he and

Mother moved to Berkeley to be nearer his next commission, sculpture for the seven arches of the new Oakland Auditorium. The Walter Blisses invited Sandy to stay with them until he finished at Lowell High. I finished out my sophomore year at Cal living at the sorority, although my parents were living in a flower-bedecked garden house just around the corner and within half a block of Kenneth's house on Bancroft Way. They could hear his Packard hum as he dropped into second gear to enter his driveway.

With the end of the school year in June, Sandy and I returned to the family circle. Louie Li, Mother's man-of-all-work, was engrossed by "Mrs. Pet's" romance; his head turned very nearly backward as he walked past the living room when Ken and I were there. On Sundays, when Louie returned to his family in San Francisco, Mother would go into the kitchen and mutter ominously as she dug out dirty corners.

Sandy and Kenneth spent many happy hours in the men's Strawberry Canyon pool that summer. Sandy became a proficient swimmer and diver under the tutelage of the Cal lifeguard, an old Norwegian. We three played lots of tennis, and I found to my chagrin that playing on the Women's Varsity did not guarantee that I could beat Ken, for whom tennis was a secondary sport. One day after the three of us had played tennis, we returned home to put on records and dance. Sandy and I fell into a fierce argument. Sandy gave me a push, and I bumped my head against the doorjamb, whereupon Ken sailed into Sandy. This was too much for me and I lit into my would-be defender. An aggrieved Kenneth was trying to figure out what he'd done wrong when Louie Li rushed in with a broom to rescue whoever needed rescuing. He looked so funny that the three of us collapsed in laughter and went off to a movie together.

With the completion of Father's work in Oakland, my parents planned to return east. Despite my tearful pleas and my "revelation" that Kenneth and I were engaged, Mother insisted that I return to New York with the family and complete my college work at Barnard.

Before heading east, we all had one last fling—a trip to Glenbrook, Nevada, on Lake Tahoe, as guests of the Walter Blisses. Kenneth's mother, sister, and sister's fiancé, Frank Partridge, were already there. We Calders climbed into Kenneth's family Packard and ran her onto the Delta Queen for the overnight trip up the Sacramento River. We dined on board and cavorted without restraint to the tunes of a Dixieland Jazz band. Even Father joined in the fun but soon left the dancing

to Sandy and Mother, Kenneth and me. As we four had the floor to ourselves, we danced with abandon. The rage then was the Kitchen Sink: four or five stiff-legged waltz whirls counter-clockwise, followed by a quick bend and dip in the other direction, a vigorous routine which Mother claimed hurt her back.

In 1915 the trip from Sacramento to Lake Tahoe took ten to twelve hours, a long, hot drive. The main hazards then were not today's notorious traffic jams, but the all-too-frequent tire punctures. The car was loaded with a dozen spare tubes as well as extra tires, patching material, and tire-changing tools. With each puncture, Ken would get out, crawl under the car (long-handled jacks were unknown), and jack the car up under the axle until it cleared the road. The tires had an inside iron band, against which the rim lugs had to be screwed to hold the tire in place. The tire and tube had to be separated, and the tube tested—usually by judiciously directed spit—after a bit of hand pumping had located the puncture. Once the hole was patched, the tube and tire had to be reassembled with the tube partially inflated in order to make sure that it was not pinched anywhere and also that the tube stem was in the proper position. If all was well, the tire and tube were then remounted on the rim and pumped by hand to the desired pressure. Sandy proved so skillful at these laborious maneuvers that Ken gladly relinquished the whole sequence to him. Wrestling together with the clincher tires, they became fast friends.

Mother suffered in the open car from the glare of the sun and heat of the valley, so Sandy made her a visor of cardboard, like those he later made for himself, and fashioned an icepack with ice bought along the way. These made her much more comfortable. Everyone was getting tired as we boiled up Slippery Ford Grade, and we were overjoyed to hear Kenneth yell "Thar she blows" as we rounded the summit. He pointed to the tip of Lake Tahoe shimmering in the afternoon sun. "Only about twenty miles more and all down grade. See that Rock over there? Well, Glenbrook's just beyond." It looked longer than twenty miles, but the scenery was gorgeous and we were on the home stretch. Not long afterward, "that Rock" loomed immediately before us. "What do we do now?" asked Father. "God," he shuddered as the car ran along a tiny wooden shelf overhanging the lake. "What will you do if you meet someone?"

"Back up," said Kenneth blithely. We all began breathing again as the car hit the dirt road.

The water of Lake Tahoe at Glenbrook is very clear, very blue, and very cold, so only the younger members of our party went swimming. We usually went off the pier, about twelve feet above the water. My future brother-in-law, captain of the California swimming team, executed a graceful swan dive. Sandy performed a reasonable imitation. Recklessly I followed, with such a resounding result that at first it seemed I would not swim again for days, especially because one could return to the pier only by climbing a wobbly rope ladder. So Sandy built a stationary ladder on the piling to spare my bruised ribs.

We had a fine family frolic together; even the elders joined us at tennis, causing much mirth as Mother, her skirts fluttering, popped the ball high into the air while Father stood off and whammed it into the nearby meadow as though it were a baseball.

But the blow fell. We left California in a shower of flowers and tears in August, 1915. We found New York grim that winter, even though we lived across from the Barnard playing field, which seemed, from the front windows, like a park.

Since Sandy had finished high school, the question arose what he should do next. Thoroughly enamored of college, I would hear of nothing but that he should go to college, too; but where? and to study what? Before we left California, Sandy had discussed the matter with a more purposeful high school friend, who declared that *he* was going to be an engineer. To Sandy this sounded appealing, so Father made some inquiries about engineering schools and obtained the name of the Stevens Institute of Technology in Hoboken, New Jersey, from one of the Fair engineers. Sandy applied and was accepted. Mother and he visited the campus as soon as possible and arranged that he would live there during the week. He was soon totally caught up in college life and studies.

Kenneth visited us for a month over Christmas vacation. He and I went to every show in town, with Sandy accompanying us whenever he could. He was with us at the Hippodrome for a show in which elephants slid into a pool on a revolving stage as the backdrop was transformed into a wall of simulated rose vines, with faces peering out from each rose center and singing, "So we'll climb up the ladder of roses and soon reach the Garden of Love."

After a spring of fervent letter writing, during which I wrote a thesis for Barnard on "Marriage and Divorce Laws in the State of

Kenneth visited for a month

over Christmas vacation. Photos: Sandy Calder

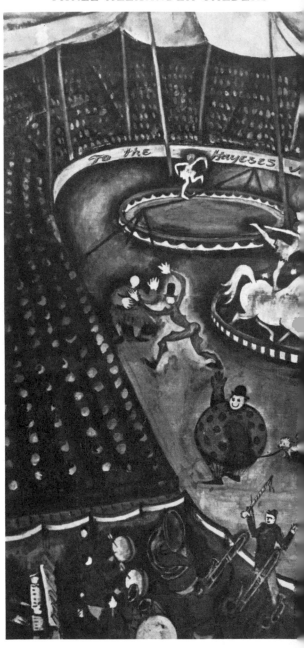

Ten years later, June 27, 1926, Sandy sent a 69" x 83" oil painting
of a Circus, inscribed to the Hayeses. Photo: Peter Carter

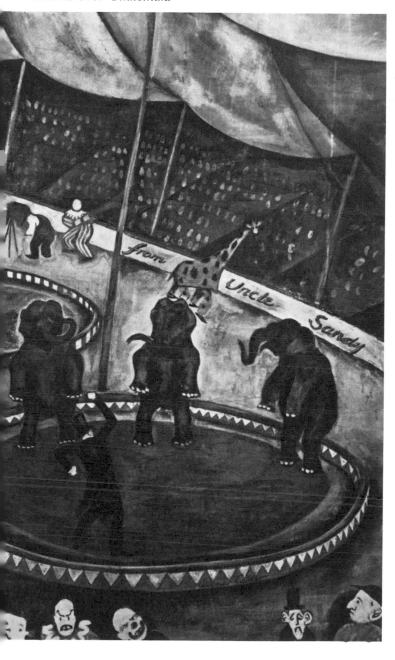

New York," Kenneth returned in June, this time bent on marriage. He and I felt sure our families would not think well of the idea, so we put off breaking the news until he was there. Sure enough, Mother reminded me of my promise to finish college; I would do so, I said, but at the University of California. Ken's family thought we were both too young; I should finish college and Kenneth work a while. We replied to these objections by pointing out that as I was to spend the summer visiting in Aberdeen, Washington, we would be traveling west together in one train compartment. All opposition crumbled at this scandalous threat.

So were were married on the 27th of June by the Justice of the Peace in New York City Hall. Father, who had been contributing to the general mood of joking and merriment, suddenly felt we should be more decorous. He had just succeeded in quieting us when hilarity broke out again as Kenneth, all joy and excitement, asked for a marriage license. Without a flicker of his eyelid or a glance in our direction, the clerk answered in a dour voice, "Two dollars, please."

Sandy, who was finishing his sophomore year and busy completing an assigned survey of the Stevens campus, elected to skip the ceremony, claiming "You'll be the same at dinner time."

Subsequently, his failure to attend our Big Event was the source of much teasing by Kenneth and me. Ten years later, just before he left for Europe, Sandy sent us a 69″ x 83″ oil painting, *Circus,* inscribed *To the Hayeses June 27, 1926 from Uncle Sandy.* Thus he attoned for his seeming indifference. (This painting, too fragile to have been sent to the Whitney Retrospective, is reproduced on page 113 of *Calder's Universe.*) His survey completed, Sandy arrived later in time to shower and dress for the wedding dinner. California friends then in New York—Dorothy Reiber, Donald Carlisle, Dawson Howell—completed the party. There were glasses of wine for the toasts. Father was his wittiest. Sandy outdid himself. Our friends were light-hearted and joyous. After dinner, each performed some unique athletic stunt.

The following day, Mother, Father, Sandy, Ken, and I left for a week at the hotel in which Margaret Dale was living in Atlantic City. What a joyous week we had! Then Ken and I boarded the Overland for the trip west. Mother stood beside the train, waving bravely through the tears streaming down her face; Father stood behind, looking not too happy, while Sandy ran alongside the train, opposite our window, as long as the platform allowed. So anguished was I at leaving them

. . . before which the players ran a couple of quarter-mile laps. Sandy in LaCrosse suit

all that I turned and thumped a dismayed Kenneth on the chest.

For the next few years, Mother became the main conduit for our news of Sandy, who was studying hard and playing LaCrosse, a vigorous game said to have originated with Indian girls, before which the players ran a couple of quarter-mile laps each day. His best subjects, she reported, were mechanical drawing and descriptive geometry.

3

Ken and I spent the summer of 1916 in Aberdeen, a coastal town on Grays Harbor. We stayed in the luxurious home of Ken's mother and step-father, W. J. Patterson. "W. J." was cashier-manager of Hayes and Hayes Bank, founded by Ken's father and Uncle Tom. Ken's mother was president. Banks were still independent in 1916; the town banker was a mogul in his community and "W. J." was a powerful figure not only in local financial circles, but throughout the northwest. In September, I returned to Berkeley to complete my senior year as I had promised my parents, while Ken stayed in Aberdeen to work.

"Now forget all that college stuff, kid," W. J. advised, putting his arm affectionately about Ken's shoulders, "and learn how business is really run."

Sandy returned to Stevens for his junior year, and in one of his infrequent letters told us he had joined Delta Tau Delta. "Several of my best friends are Delts; Billy Drew and Bob Trube."

As so often with college friendships, these were not only enjoyed at the time but brought other members of each family into a widening circle of friendship and affection. Bob Trube met Sandy when he went to Europe, and it was at the Drew farm in upper New York state that Sandy spent the summer of 1928 carving some of his most wonderful wood objects: *Uncomfortable Face, Flat Ladies, Bending Dangerously, Rampant Vitae.* Sandy's college years were full in other ways as well. The same talent for projecting shapes into space in his mind that helped him in descriptive geometry was central to his later ability to project forms in his imagination before realizing them in tangible objects.

This power took a particularly delightful form in 1968, when *Work in Progress,* a ballet consisting almost entirely of mobiles, was performed at the Rome Opera. Sandy said he had conceived of this ballet in 1932. It had no dancers, only mobiles and abstract shapes. Indeed the only humans appearing on stage came on undisguised technical missions.

"We saw only the dress rehearsal," Sandy wrote me on April 4, 1968, but "Carandente wrote that on the real première, there were curtain calls, and the technicians in *mechanics,* and in *music* took a bow, and that the following night there were 4 curtain calls, and nobody was there but the mobiles (2 of them had a dwarf inside, turning a crank)."

Andrew Imbrie, the Berkeley composer, and his wife, Barbara, did see the première of the ballet and were very enthusiastic:

> At first there was a multitude of mobiles high above the stage. Then against a white background a blue line moved, giving the feeling of waves. Across it black creatures and a giant starfish swam. The shapes were very simple, like a child's cut-outs. The remarkable thing was it gave the feeling that the mobiles were actually participating in a play. They took on personalities and character.
> After the moving blue, there was land or something that did not move with birds of every color and size which did move.
> This was followed by a flock of men on bicycles in gay colored tunics. . . .
> The audience loved the swoop of the bicycles, but I loved the fishy creatures.
> At the end there was a volcano-like shape, with a man who waved a red flag and a great jolly yellow sun. Then the whole stage was full of dancing mobiles. All sorts of significance can be read into the sequence, but the immediate effect was of a gay and light interlude of clean spring-like joyous movement.
> The music sustained the mood without interfering with one's visual absorption.
> It suggested all sorts of things that were not in the least specific, and went so rapidly one had only time to enjoy the visual experience.
> It took only nineteen minutes.

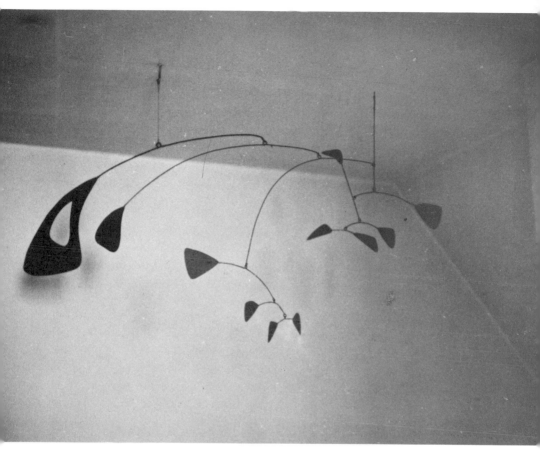

Mobile by Sandy *Photo: Nanette Sexton*

When he went to assemble the ballet, Sandy took his pliers and put much of it together on the spot. "Maybe I should have called it 'My Life in Nineteen Minutes,'" he said, grinning.

But fifty years before this performance, Sandy was studying engineering and no one, including Sandy, had thoughts of any other career for him. In fact, however, he drew on disciplines mastered at Stevens for almost all his work. Who but an engineer would have called one of his first shows (in 1931) "Volumes—Vecteurs—Densités —Dessins—Portraits"?

Sandy had finished his third year at Stevens in the summer of 1917 when he and Father joined us for a stay of several months in Aberdeen, Mother having come earlier to attend my Berkeley graduation exercises.

The Patterson house occupied a whole block and boasted a tennis court and extensive gardens—well watered by coastal Washington's nine-month rainy season and curried by a full-time gardener. Mother reveled in the gorgeous flowers and asked Father to bring her paints.

On arrival, Father was taken on a tour that included a sawmill, with its logging pond, screeching saws, and burner glowing red all day and night, and to lunch at the Elks Club, where one of the habitués, an ex-saloon-keeper, told him among other surprising things that the winter before had been so severe that his wife slipped on their steps and fell down prostitute. Father liked W. J., a warm-hearted Scotch-Canadian of quick decisions who agreed with his ardent Anglophile feelings about the war in Europe. He also enjoyed W. J.'s frontier stories, and after talking it over with Mother, decided to put their savings in Hayes and Hayes for safe-keeping.

We all enjoyed the beauty and luxury of the Patterson home, picnics on the clean white sand of the nearby beaches, and sharing the tidepools with scuttling little crabs and fishes. The Northern lights allowed us to play tennis far into the night.

The enterprising manager of the damp and shabby Grand Theatre brought *The Emperor Jones,* with Paul Robeson, for a one-night performance in Aberdeen while we were all there. The stage curtain had been painted with a scene depicting a Nubian slave fanning a lady who was stretched out on a chaise lounge, with a leopard at her feet. Labeled "The Feast of Flora," the scene had been punched full of holes by stagehands curious about the audience.

Mother reveled in the gorgeous flowers and asked Father to bring her paints. Photo: Nanette Sexton

"Folk Art?" I suggested to Father, who grinned back, "It's so awful, it's funny."

All shortcomings were forgotten as the beating drums and Robeson's superb baritone sent out their message of terror and defeat. There was a moment's silence as the curtain fell, and when it rose again for the actors' curtain call, out of pure enthusiasm Father leapt to his feet shouting, "Bravo! Bravo! Bravo!" Our whole row of family did likewise, while the rest of the audience hesitantly followed suit, evidently deciding that this must be the thing to do since the Pattersons' guests were from New York.

One day, as we were sitting on the warm sand with our backs to a huge log that once had been a giant of the forest but now, tossed up on the beach from a broken raft, lay bleaching in the sun, Father asked me if I was happy and how I liked living in Aberdeen, a "man's town." I confessed that I really wanted to live in California. He commiserated. He and Mother had discouraged Sandy and me from pursuing art as a profession, he said, because they had found it such a hard row to hoe. But it was not thinkable for someone brought up as I had been to live in the total absence of art and feeling for it. "The problem is Ken's family's business, of course. Money can be a tyrant too. Don't let it get you down," he finished.

There were other tensions in the air that summer. The United States had entered World War I. The Calders returned to New York, with Sandy adding student training in the Naval Reserve to his curriculum at Stevens. Kenneth enlisted in the Officers Training Corps and was sent to the Presidio of San Francisco. It was in San Francisco that our first son, Calder, was born on June 27, 1918, a fine second anniversary present for his parents.

That summer, armed with a degree from Stevens and a mustache that he hoped would give him a look of maturity, Sandy went about looking for jobs vaguely related to engineering. A firm of efficiency engineers sent him to Abraham and Strauss in Brooklyn to analyze the store's operations. The store was on several floors; when a purchase was made, the article was sent in a wire basket along a cable to the central office for wrapping. Payment was effected by putting money in a cylinder that was sent through a tube to the cashier's office, with any change being returned the same way. So that the clerks would work as usual without suspecting that their actions were being timed, Sandy wore a derby, mingled with the customers, and cast only an

occasional stealthy glance at his stop watch. He could not altogether avoid loitering, however, which led salesgirls to suspect he was trying to pick them up. They responded coyly, or indignantly sent for the store dick. On one such occasion the department head, not knowing Sandy was legitimately employed, set a store detective on his trail. Realizing that he was being followed, Sandy decided to have some fun: he hid behind tables piled high with bolts of cloth, darted into elevators, and fled down a fire escape. The upshot of his study was almost equally absurd. When the manager received his recommendations for improving the store's efficiency, he told Sandy he knew that they would help but that it was too much trouble to change.

After this, he worked as a salesman for International Harvester. His days as a tractor salesman ended abruptly when he inadvertently plowed up a farmer's cucumber bed with the machine he was demonstrating. "Young feller," fumed the enraged farmer, "next time you go monkeyin' around, learn to know a cucumber vine when you see it."

Sandy's next job was on the *Lumberman's Journal* in St. Louis, where he became seriously ill. Mother, with whom I corresponded almost daily, wrote me that the St. Louis doctor had diagnosed "stoppages." Frantic on hearing what sounded like dire warnings, she insisted Sandy return to New York, where Father's physician dismissed the previous diagnosis and straightened him out in short order on a diet of orange juice and little else.

One evening in the winter of 1921-22, Sandy was idly playing with the cat, Soufflé, for whom he had made a lion's head of a brown paper bag. "Get a book and improve your mind," Father growled, and later suggested that Sandy attend an evening drawing class conducted by an English friend, Clinton Balmer. Sandy went, found he enjoyed it, and continued going. His Valentines that year were made from a piece of lined tablet paper, on one side of which he drew a more or less insulting picture, with the other side bearing the stamp and address. Ken and I, knowing that his attempts to find congenial employment in the east had come to naught, replied with an invitation to come try his luck in the northwest. In June, 1922, with the help of W. J., he secured a job as fireman on the passenger ship *H. F. Alexander,* which would be traveling from New York to San Francisco via the Panama Canal, then on to Hawaii and return.

The *H. F. Alexander* was quite a large ship, carrying 700 passengers, elegantly housed. Sandy became disgusted because the crew,

Uncle and nephews built a harbor . . . Sketch by Sandy *Photo: Nanette Sexton*

numbering 1,000, on whose performance the whole ship depended, were bedded down in hammocks in airless, cramped quarters up front. He solved the problem for himself by sleeping on the great coils of howser fore and aft on deck. There he not only got the fresh air he coveted, but became acquainted again with the sky and stars. There too he had the experience that influenced him all his life: seeing a fiery red sun rising on one side of the horizon while a pale moon edged off the other. The beauty and drama of this experience affected him

so deeply that the universe or its parts appear repeatedly in his works, from his first mobiles of 1932 to the elaborate giant in the Sears Building tower, made in 1976, as well as in his gouaches.

He became impatient with the inefficiency that forced him to get a knife from the galley when he needed a screwdriver to tighten some plate or screw, so he devised some tools as well as short-cuts as he went about his chores. This experience too, with makeshift tools, seems to have had a lasting effect, for he later contended that fine tools contribute to fine work and invested in the best, buying Bernard pliers by the box and inventing other special devices to help in his work.

By the time the *H. F. Alexander* arrived in San Francisco, he had had enough of the fireman's job and so left the ship. In San Francisco, he visited with his hosts of 1915, the Walter Blisses. While there he made a slug catcher for "Uncle Walter," an avid gardener. Like many other California gardeners, Uncle Walter spent hours chasing after slugs, those slimy creatures who always seem to prey on one's most prized plants. Sandy took an old broom handle, attached a large nail at the end with which to impale the slugs, and added a pail of salt to drop them in.

Lumber schooners brought their cargo into San Francisco and returned empty to the northwest, so Sandy arranged to finish his trip to Washington on an empty lumber schooner. Even his recent sea-going experience did not condition him for the ordeal of sailing through the Golden Gate on a small, unloaded vessel.

He joined Ken and me and our two boys (Kenneth II, called Bunny, was born in Berkeley on August 3, 1920) at American Lake, one of several small lakes on the prairie near Tacoma. At the side of the lake, uncle and nephews built a harbor. Sandy made a drawbridge that operated with wooden handles and levers to admit the toy boats, barges, and rafts of logs they made from twigs. He also took the boys for water rides on his shoulders, swimming underwater so that his small passenger seemed to be gliding over the water by himself, sitting and clucking "giddyap" to his dolphin.

In August we all returned to Aberdeen, where Mother joined us in time to celebrate the birthday she shared with Bunny. The Patterson-Hayes tribe always made a great to-do of birthdays. Sandy entered into the fun, making placecards for everyone. These consisted of free-hand caricatures in India ink and watercolor, accompanied by a jingle that poked gentle fun at each one's most vulnerable spot. For "Nana

Frank," Ken's mother, that early and ardent feminist who later became the Women's Golf Champion of the northwest, he wrote:

> This is the Frank Baker Patterson Nana
> She hitta da ball whenever she canna,
> But if she can't she's a slave to her wrath
> Take my advice and keep out of her path.

And about himself:

> This is our silly simpering Sandy
> Likes music, girls and candy
> He's a foolish, fickle funny old slob
> Can't make up his mind what he wants for a job.

Sandy's next temporary solution to the job problem was to join a logging camp owned by Hayes and Hayes in the forest about fifty miles from Aberdeen. The loggers lived in shacks built on flatcars so they could be moved easily from a logged-off site to a fresh one. Sandy roomed with a hard-shelled old camp boss named Cranky Jack Moore, who believed that night air carried various maladies and maledictions. Convinced that fresh air was essential to health, Sandy rigged up a device that enabled him to pull open the window as soon as the rhythmic snores from the next bed proved his irascible roommate to be asleep. The alarm clock, which would alert him to close the window before Cranky Joe woke up, bothered Sandy with its loud ticking, so he put it outside the window, attaching it to his toe by a string.

Sandy was supposed to work as Cranky Jack's timekeeper, sort the mail, and sell snuff, newspapers, and sundries to the men. Naturally, he devised various distribution systems, operated from a distance by wires and strings, that left him free for more interesting pursuits. He took to drawing the cookhouse flunkies and loggers at a dollar a head. Sometimes his drawings were outrageous caricatures, but they were never malicious and the likenesses were amusingly gratifying; one after another, they asked Sandy to "do" them.

He also undertook to introduce reading for pleasure into camp, taking with him Jack London stories, *Bob, Son of Battle,* and Kipling's *The Naulahka.* Cranky Jack was scornful, claiming all books were lies, that only the Bible and the newspaper could be trusted. When Sandy left the logging camp in the spring of 1923, Cranky Jack growled to the man who would shortly set sculpture in motion: "Gubbuy, kid. You're a card. Just two speeds. Damn slow and dead stop."

Cranky Jack Moore believed all books are lies; only the newspaper and Bible can be trusted. Photo: James Stipovich

Sandy took to drawing the cookhouse flunkies at $1.00 a head.
Photo: James Stipovich

Sandy's nephews did not share Cranky Jack's assessment. From the camp he had sent them drawings of engines pulling loads of logs through the woods and of knights in armor, for the boys were then in the King Arthur phase. On his frequent weekend visits to Aberdeen, he always brought new toys of his own devising. There were Williamette yarders, gondolas, and a loading deck to lift little logs onto the gondolas. There were Packard trucks, drawbridges, rails and switches for small boys' trains. One toy that my sons remember with particular glee was a ferry boat that went the length of the bathtub on a wound-up rubber band. When it bumped against the side, it made the return trip on another rubber band, released by the impact. These toys were made of snuff boxtops, bits of wood, wire, tin cans, rubber bands, string, and old toys. Sandy brought them with him when he came out of the woods, which he did every two or three weeks and for special occasions. One such occasion was the Annual Dance at the Grays Harbor Country Club. He arrived too late to have his hair, of a length that would have been acceptable in the 1970's but was way out of line in 1920, cut professionally. So we set to work at home. Our inept barbering left great hunks of black curly hair on the floor and reduced us all to helpless laughter, which was still the mood when we

CALDER'S DOG, BINKIE

. . sent drawings to his nephews. KNIGHTS IN ARMOR *Photo: James Stipovich*

arrived at the club in time to hear the local politico, who had horned in with his campaign speech, promise that if elected he would do his duty in the Governor's chair!

Then, recalling our joys with the coaster Uncle Ron had made in Pasadena, Sandy made one for his nephews large enough to hold five or six delighted children.

Sandy was still not satisfied that he had found his life's work in the summer of 1923, when Mother came to Aberdeen for another visit, bringing paints for Sandy as he had requested. One day when they were sketching together, he blurted out, "The truth is, Mother, I want to paint."

Poor Mother. She had wanted less precarious livelihoods for her children and was content to have one married to a banker and the

other become an engineer. But she recognized the power and originality of Sandy's drawing, was impressed by his ability to express character and form with a few simple lines. She would not oppose him if that was what he wanted, so they agreed that he would return to New York and live with her and Father while he studied at the Art Students League.

Before leaving Aberdeen, Sandy helped me start a school. The local public schools were geared to the children of first-generation immigrants from Finland and Sweden who heard no English at home. There was no kindergarten. At six, a child entered first grade and was shut up for six hours, with an hour off for lunch. Ken and I wanted something better for our children, so I wrote to a friend who had just started an experimental school in Berkeley. I read the forty-five books on education that she recommended and that Nana Frank gave me at Christmas, signed up enough children to meet expenses, and wrote to Patty Hill, head of the prestigious Department of Teacher Training at Teachers' College, New York, for a teacher.

The Patterson garage, garden, and tennis court became the Tidelands School. Sandy undertook to install blackboards and put up swings and slides, but before turning to such mundane projects he made some toys he had thought of while playing with my boys and their friends. The toys were mostly of the runabout variety: a kangaroo that leapt when pushed at the end of a handle, a rabbit that hopped, a duck that bobbed its head. So began the line of toys that he perfected in Paris. Some he would sell to a toy manufacturer in Oshkosh. Others were the forerunners of figures in his marionette Circus. Nana Frank was censorious about his playing with toys instead of working on the school as he was being paid to do. Yet fifty-three years later, busloads of school children were being ferried to the Whitney Museum and solemnly urged by their teachers to appreciate the still-enchanting products of Sandy's self-indulgent toy-making.

It was also from Aberdeen that Sandy sent the Kellogg Company a suggestion for improving the packaging of their cornflakes. It would be more effective, he wrote, if they put the wax paper wrapping inside the box instead of outside, as they were doing. The company adopted his suggestion and has been following it ever since. To show their appreciation, they sent him a carton of twenty-four boxes of cornflakes and a pleasant note of thanks.

Peggy and Sandy in Aberdeen, 1923. *Photo: F. B. Patterson*

Once in New York, Sandy embarked on his new career with concentration and vigor. At the Art Students League he studied with John Sloan, George Luks, Guy Pène du Bois, Thomas Hart Benton, Kenneth Hayes Miller, and Boardman Robinson. He took the whole of New York for his subject. He sketched other subway passengers on bits of wrapping paper folded to fit into his pocket. He painted ships coaling in the harbor, ships crossing to the Palisades, steers in the stockyards, the Democratic Convention that nominated John W. Davis on the 103rd ballot, and of course, the circus. When more congenial subjects were lacking, he painted himself. One self-portrait is painted in such a realistic style that the eyes follow one around with uncharacteristic belligerence. On another occasion the remains of a dinner party became what he described as a "very purple" still life.

Not only did he paint diverse subjects, he experimented with different techniques. In the self-portrait just mentioned, the paint is put on very thin and the drawing is exact and detailed. For the ships in lower New York harbor, he used a more impressionistic technique—thick paint, brush strokes showing.

He tried etching, using Mother and Father as models, lithography with liquid tusche, and rigged up a little device that held bottles of India ink in a row. With this hung around his neck, he spent days at the zoo, capturing in a flowing line the languid cats, the bustling bantams, the grimacing baboons. He seemed to have an instinctive grasp of anatomy, expressing solid form, action, and character with a simple sweep of the brush.

Sandy lived with Mother and Father on East 10th Street, but did not regard this arrangement as a license for freeloading. He explored

He expresses so much with so little.

'When models fail, I paint myself.' SANDY, 1924. Oil on canvas
Photo: Colin McRae

Circus painting, 1924. Oil on canvas *Photo: Nanette Sexton*

He painted ships in the harbor.

every opportunity that presented itself to earn money, answering innumerable advertisements. He made picture frames, for instance, and electric light fixtures. Most of his earnings went for art supplies.

Grandfather died in June, 1923, leaving $50,000 to be divided equally among his five sons. Mother and Father decided to use their share for a trip they had long dreamed of taking—to Greece, where they could see on its own home ground the sculpture they so admired. In Aberdeen, Ken and I decided that the occasion of their departure in the spring of 1924 warranted a grand gesture—telephoning our Bon Voyage wishes long distance. It took more than five hours to put the call through, and when the connection was finally made, even Ken and I were asleep. The tears in Mother's voice started me crying too, and I could barely answer Father when he vigorously demanded to know whether I could hear him distinctly, a seemingly pointless question, although as Sandy later wrote, "the voice is the main idea" on such an occasion. The call ended with Sandy and Ken having a good laugh over those sentimental Calders.

Sandy moved into Father's studio at 11 East 14th Street and added writing to our parents and forwarding their letters to me to his other pursuits. On May 17, 1924, he wrote to report that they were due to arrive in Genoa the next day: "Aint that grand! It's more fun to wander about and see things than stay in one place and be dependent on things that come to one." He was greatly enjoying having the studio all to himself:

> Don't make the bed, seldom eat (I weigh 160, stripped) have two easels, three stands, two tables and the floor, just littered with junk—and Mother gave me all her paint, 'tho I'm still using my own.
>
> Margaret Dale posed for me the other day. I did some 30″ x 30″ canvases up in Bryant Park (behind the Lib. 42nd St.) just before and after the family sailed, and Mrs. Sterner said she'd accept one if I mailed it to her for her show of American Paintings in Paris. I took it off and stretched and rolled it up. They won't insure anything going into France and as I put on a value of $100 I suppose I'll get stuck 25 to 40% duty. But what the hell! If one doesn't show things one doesn't "arrive" and one must arrive!
>
> There is a show in Newport—entry blanks to which were sent to Father. Think I'll use them.

Apparently a bit lonesome despite his busy days, Sandy wrote frequently to ask for news and family photos from Aberdeen and responded enthusiastically to examples of his nephews' drawings. He wrote Calder, enclosing a postcard of a portcullis:

> Here is a picture of a real, live portcullis. In the days when we lived in Pasadena this card would have been treasured by me. A real live portcullis is wonderful! I used to make toy ones—and am quite sure we had one at the gate to the moated castle which we built in the back yard at Euclid Avenue. Ask your ma, she knows!
>
> I am going down to paint at the polo games at Westbury, L.I. this afternoon. It's very fine to watch, as the horses just go like the dickens.

He wrote of his astonishment at finding a 20-year-old boy who had worked at the League all winter and had been to the movies twice, but never to the legitimate theater. So he went with him to see *Fata Morgana,* a somewhat off-color, and in Sandy's view "damn poor" comedy with Emily Stevens. He also saw a well-done version of *Saint Joan,* Lenore Ulric in *Kiki* ("very clever and amusing"), and

> last night Bertha Kalish in the "Kreutzer Sonata" an awful old melodramatic Jewish affair, revived from 10 years ago. The cast was 98% Jewish and the audience 101%. I was in the front row of the 2nd balcony and you ought to have heard the din between halves.
>
> Tonight is the last night of the spring semester, and they are having a dinner for the Sloans at an east Indian restaurant on Forty-Fourth Street. . . .
>
> I am living on oranges and apples, and have had three or two and a roll so far today. (It's now 8 p.m.) so I'll look like a real Indian when I get there. The fruit diet seems to agree with me very well—and it eliminates cooking here, which is very convenient to have eliminated. I get up and put a sweater over my pajamas and paint.

Ken's mother passed through New York that spring on her way to meet our parents in Europe. From shipboard she wrote me describing her visit with Sandy:

> You would be amazed at the volume of work he is turning out, dozens of big canvases stand piled about your father's fine big

studio, street scenes, fighting bouts, some faces and figures, lots and lots of sketches, clever caricatures—constant experimenting that shows his love of the thing he has found. He did . . . the Democratic Convention—a very difficult thing to attack as you can imagine with all those moving masses and brilliantly lighted colors.

Sandy very kindly asked me down for supper to meet Miss Gould and three attractive Norwegians and a Russian. Mr. Gabrielson and the unpronounceable Russian were at the League with Sandy, I think. . . . His supper was very jolly. He used the model stand for his table and had one of your mother's handsome big platters for big pink slices of roast beef with whole bunches of radishes for decorations—that was the center. His salads, rolls, cheddar cheese were arranged on the outside. He had tea in tiny Chinese cups. Then he and the Russian took me up on a bus and walked over to the door with me.

In later years Sandy read little, but in those days he read a good deal, particularly books about art. He wrote and asked that I send from Aberdeen "a little book by Abendschein called Secrets of the Old Masters or something similar," and suggested that he send me John Russell's *In Dark Places,* which he had just finished. In June he was finding Faure's *History of Art* "very good reading," and, knowing of my interest in the education of young children, cited a passage (excerpted from James Sully's *Studies of Childhood*) that he thought would be of interest to me:

the child adheres to an almost exclusively symbolic representation of nature, to a stammering series of ideographic signs which he changes at each new attempt; he has no care either for the relationships of the forms or for their proportions or for the character of the object which he represents crudely, without studying it, without even casting a glance at it if it is within range of his eye. It is probable that he draws only from a spirit of imitation, because he has seen people draw or because he has seen pictures and knows that the thing is possible. If he were not deformed by the abuse of conventional language which takes place around him, he would model—and later do reliefs, etchings, etc. and then drawing.

We debated the passage by mail. I agreed that if he is given mud or clay, a child's first step is to model or manipulate it in some way,

delighting in the feel of the material in his fingers, but it was not true in my experience that he then progressed to reliefs and etching before coloring and painting. I also agreed heartily that "children become deformed by the abuse of conventional language" around and to them. Often the views of adults confuse a child's efforts and drown his pleasure in doing before he has a chance to develop strength and belief in himself.

Sandy, fortunately, never lost that confidence, that originality and wholeness which Erik Erikson, in his book *Toys and Reasons,* has recently reminded us is commonly found in the young child, lost in the process of growing up, and recovered only in creative moments in adult life. Sandy remained interested in the object for its form and was not troubled by any impropriety, caring just that the shapes complement one another and make the picture more interesting. For instance, in a gouache with shapes from the cosmos, he might include a starfish or any organic form that suited his mood. Can the result properly be called childlike? Yes, if by childlike one means to convey spontaneity, wholeness, cosmic gaiety. Why did Sandy never lose what Freud and Erikson call "the radiant intelligence of the child"? Because of our parents' encouragement and approval of his earliest efforts to make things, as well as their own absorption in art? The strength of his inner talent and drive? The good fortune of growing up in a simpler time, when a child's experience of the world came primarily first-hand, rather than through television? I can only raise these questions; I cannot answer them.

With Mother and Father due to return in the fall, Sandy set about finding new living quarters for them and for himself. He also wrote about the sad dashing of Uncle Ron's one hope of marriage. Of all Father's brothers, Ron was the one Sandy and I loved best. In his youth he had a terrific physique and Father modeled several statues of him. After experimenting with theosophy and other unconventional religions, Ron became an ardent Christian Scientist. Then one evening while trying to replace a light bulb during a neighborhood basketball game he was supervising, he fell from a very high ladder and broke his kneecap in seven places. Convinced that the power of prayer would mend his knee, he refused medical attention. When that didn't work and he had to undergo surgery, he went to pieces: his faith had failed him.

Ron followed Father to San Francisco in 1913 to work for him on

the Exposition, then moved to the Oregon cherry country. When he received his share of Grandfather's estate, Ron returned east, hoping to persuade his childhood sweetheart to return with him to Oregon. Sandy laconically reported the end of the affair: "Uncle Ron arrived in Philly about Friday. He wired Alice Smith to meet him at [uncle] Charles. So she went over. She really is awfully nice. She finally decided she didn't want to marry him after all, but they parted perfectly amicably, tho sorrowfully." After all thought of marriage had been abandoned, Ron himself later returned to Philadelphia, dying there in February, 1966, having lived a most uneventful life. No hits, no runs, no errors.

After our parents returned to New York, Sandy lived at times with them, at times in various rented rooms. For a while he shared a room at 7 Bleecker Street with Charles Howard, a young painter from Berkeley whose father, John Galen Howard, was architect-in-chief at the University. According to Mother, Sandy was then paying court to a tall, handsome girl. Her father, a hard-boiled, self-made business-man, took a dim view of his suit. The penury and insecurity of most artists' lives were not what he wanted for his daughter. "Show me your first one thousand dollars, young man," he was quoted as saying, "and I'll think about your attentions to my girl."

If Sandy had yet to make his first thousand dollars, it was not for lack of trying. He worked at several jobs. He decorated the Spalding sporting goods shop on Fifth Avenue with drawings of such well-known athletes as Helen Wills in action. As a freelancer, he made many drawings for the *National Police Gazette;* he covered boxing matches, ball games, bicycle races, prize fights, horse shows, and the Ringling Brothers, Barnum and Bailey Circus. One of his jobs left even Sandy confessing to fatigue:

> Last week [he wrote in November, 1924], I worked every night down at the Provincetown Playhouse shifting scenery. It was rather fun. It is a very tiny theatre, a converted barn, and there is no room above, behind nor much to the sides of the stage, so that everything must be hauled up and down and through a slot in the floor. They are the people who produced "Emperor Jones," which proved so good in Aberdeen. Throckmorton said they might stage it again and I have made some sketches for it, tho I don't hope for much in the immediate future.

*Wood bought
at Monteath's*
Photo: Nanette Sexton

I have been trying pretty hard and consistently to sell some drawings. It has been pretty tight so far, but things ought to loosen up any day—but they just don't. It's rather exasperating at times, but it's quite an intense game—and when it's your own stuff you want to unload, it beats any other kind of selling in existence.

Everytime I smell linseed oil I want to go back to painting, but I think that if I stick to this for a while, I ought really to get adjusted so that the selling will be more or less automatic, instead of comprising most of the job. Then I will paint.

Jane Davenport was a student of Father's at the Art Students League who came to know Mother and Sandy well, too. Forty years later she wrote me her reminiscences of the three of them. She had a studio not far from Mother and Father's apartment. "I was doing wood carving then and it was at that time that Sandy and I went to Monteath's and bought interesting tropical wood and he started carving. He made some wonderful things. Some were shown at the Guggenheim Show in 1964. He said I started him carving."

Jane invited Father and Sandy to Cold Spring Harbor, and Sandy subsequently went out there quite often. She recalled the time Father said, "Come along, Jane, and I'll buy you a suit. Sandy and Nanette are coming." So Jane went with the three Calders to Wanamaker's, which was featuring a sale of English tweeds. "Sandy fell in love with a mustard-orange mixture. That suit became famous on two continents,

He gave me THE LADY AND THE LIFEGUARD. *Photo: Colin McRae*

but your Dad never forgave me for encouraging Sandy by liking it too."

Sandy wore the suit made from the tweed bought that day, or at least its coat, until it would no longer hold together even with the leather patches he sewed over the elbows. He was still wearing it in 1930, when he went to install a show at Harvard. Pliers bulged from each mustard pocket and a coil of wire was slung around his shoulders as he was met by his astonished hosts.

Several years later Jane and her husband, Reggie Harris, were in Paris when Sandy arrived. "I had flu," wrote Jane. "Sandy and Reggie had always wanted to see what a Fancy House in Paris was like. They had heard stories of demonstrations. I told them to go along together and have a look and be sure to be good boys. There were two girls who demonstrated the thirty positions of love. When the demonstrations were over, Sandy said, 'but that was only twenty-five!' "

I visited New York in the fall of 1925 and found Sandy sharing the untidy studio on Bleecker Street with Charlie Howard. He was sketching game cocks, birds of paradise, chickens in India ink, but also carving the wood bought at Monteath's and picked up elsewhere. Pieces of wood were stacked or piled in corners. Each by its form, texture, size, or color suggested an object. How unusual these were can be judged by their titles after they were carved: *The Flattest Cat, Giraffe Cameloparbitis, Black Elephant, Brown Elephant, Large Elephant, Three Men High.* He carved a cow from one piece of wood, using a limb with an erstwhile branch so cleverly that she looks backward with a soulful expression. Even discoloration in the wood served to give her markings. His *Shark and Whale* is made from two pieces of wood, almost in the state he found them, a crescent shape balanced on a pointed-nose-shaped block. For Sandy had the imagination to see the resemblance to some animal—human, wild, or domesticated, often fantastic and usually humorous—in the most commonplace objects; corks, stones, or a branch. With slight manipulations, he transformed them so all can see what he has seen.

Charlie and Sandy each produced a little book. Sandy's *Animal Sketching* came out the next year. Ken and I found our copy delightful, as did Father and Mother. Charlie's *Design* came out later, but he did not send his family a copy or even tell them about it. They felt hurt when they finally learned of its existence, and my sympathy with their feelings caused one of the rare tiffs between Sandy and me.

. . . sketching creatures at the Zoo

Although he expressed impatience with ritual family pieties, Sandy himself was deeply loyal to family and friends. He found time to write a long and cheery letter, sprinkled with color drawings, to Ken's mother, then recovering from major surgery:

249 W. 14
N.Y.C.

Dear Nana Frank,

I am certainly very sorry to hear of your state of ill health, and realize that it must be doubly hard on you who are usually so active. I hope you are well on the way to recovery at the present setting.

As you no doubt have heard I moved out of the parental garage last December, and went to live with Alexander Brook (a painter) & his family on West 10th St., not far from where Bess & Vette held forth some years ago. They have 2 youngsters—so you may well guess that I had a swell time—especially as these kids are a fine pair.

After a couple of months tho Peggy (Brook) decided that she would like to have the room back to work in. I picked me a room on West Fourteenth St. among the Spanish. The room was painted with robins egg blue & crimson paint, & tobacco juice. So I whitewashed it, & managed to compare favorably with a recently decorated chicken coop, tho I *did* glue down the dirt.

After that the place looked so bare and cell like that I took my tempera and decorated one side with stuff in a jungular vein.

Now it is quite habitable. Its so small that its easy to straighten up and therefore I dont feel overwhelmed by the job, and have the pluck to keep it in shape (according to *my* standards). One wall has been left white and with the good-sized south window I find it quite good to paint in. And I do so a good deal.

I've been out to a few dances lately and had a pretty good time. The people seem to object to my paucity of costume & abundance of jumps & leaps. However, I can charleston with any of them—so thats an offset.

The Whitney Studio Club had an annual exhibition at the Anderson Galls. (39 & Pk. Av.) and I had a canvas in that which was favorably commented on, but *not* bought.

And I also had one at the Independents, at the Waldorf, showing medical students cutting up a stiff. It was amusing how it startled people & the cub reporters on some of the papers.

0249 W. 14
nyc

Dear Nana Frank,

I am certainly very sorry to hear of your state of ill health, and realize that it must be doubly hard on you who are usually so active. I hope you are well on the way to recovery at the present setting.

As you no doubt have heard I moved out of the parental garage last December, and

went to live with Alexander Brook (a painter) & his family on west 10th St, not far from where Bessie Vette held forth some years ago. They have 2 youngsters — so you

may well guess that I had a swell time —— especially as these kids are a fine pair.

After a couple of months Theo Peggy (Brook) decided that she would like to have the room back to work

in. So I picked me a room on west fourteenth St. among the Spanish.

The room was painted with robins egg blue & crimson paint, & tobacco juice. So I

¾ whitewashed it, & managed to compare favorably with a recently decorated chicken coop, tho I *did* glue down the dirt.

After that the place looked so bare + cell like that I took my tempera + decorated one side with stuff in a jungular vein.

Now it is quite habitable. It's so small that it's easy to straighten up

— and therefore I don't feel overwhelmed by the job, and have the pluck to keep it in shape. (according to my standards). One wall has been left white and with the good-sized south window I find it quite good to paint in. And I do so a good deal.

I've been out to a few dances lately and had a pretty good time. The people seem to object to my paucity of costume + abundance

of jumps & leaps. However, I can Pcharleston with any of them — so that's an offset.

The Whitney Studio Club had an annual exhibition at the Anderson Gallery (39 + PR4) and I had a canvas in that which was favorably commented on, but not boin at WONDERFUL

And I also had one at The Independents, at the Waldorf, showing medical students cutting up a stiff. It was amusing how it startled prof & the cub reporters on some of the papers —

Hope you will be fit soon again and get back to Aberdeen feeling better than ever.
Love to you + all
from Sandy

Hope you will be fit soon again and get back to Aberdeen feeling better than ever.

Love to you and all
from Sandy

During my New York visit in 1925, Sandy gave us several merry evenings as he "did" each member of the family in customary postures or occupations with India ink. He also made several objects by winding a wire design around a small rock or piece of wood. Despite my entreaties, Sandy refused to take out his whole Circus, stored in a couple of banged-up suitcases under Mother's piano—a refusal she endorsed, since it would have made a mess of her smallish apartment. He did open one case, and we had a fine time playing with its contents. Two items he gave me for his nephews: a blue velvet cow with a soulful expression who turned her head when her red velvet udders were pulled, and a daring-young-man-on-the-flying-trapeze which was not up to the demands of Sandy's full-dress performances but was very amusing to small boys.

Our friend of Ossining days, Marjorie Acker, by then Mrs. Duncan Phillips, invited us to lunch. Mother, Sandy, and I went, Sandy with his portfolio under his arm. After lunch, Marjorie bought several of his India ink sketches of birds and animals for her small son. How embarrassed I was at such crass commercialism! Perhaps I did not fully grasp the transition then under way between the open-handed younger brother who gave things away as spontaneously as he made them to the ambitious young man striving for a professional identity. Of course the later Sandy never completely displaced the earlier one. Years later, Mother told me there was not a friend or neighbor in Roxbury who did not have one or more of Sandy's objects that was not interesting, beautiful, amusing, or, in many cases, all three.

Before I left New York, he gave me *The Lady and the Lifeguard,* a sculpture carved of lignum vitae, a wood as hard as stone, showing

Photo: Colin McRae

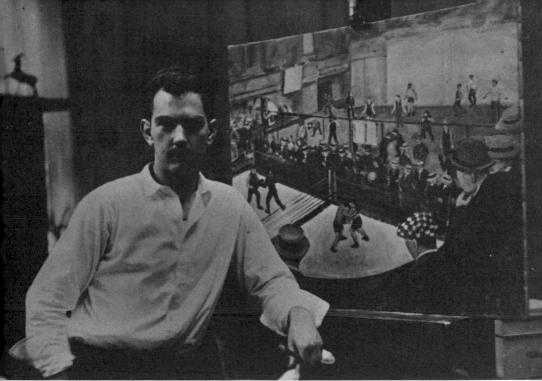

Young artist before his easel

two reclining figures with an umbrella behind. To carve it, he had to grind down his chisels continuously to prevent breaking, but as the marks on the wood show plainly, he used a rasp as well. He wrapped the carving carefully in stout paper and tied it with rope, then made a special wire handle so that I could carry it onto the train more easily.

"My God, lady, what you got there? A ton of bricks?" exclaimed the porter on the Overland as he pushed the package far back next to the steam pipes so he wouldn't have to move it when making up the bed. Next day, as I sat watching the landscape race by, I recalled our first exciting trip to the far west and how Sandy had loved it all, even the smell of those green curtains. Then I could see the distance he had gone. As I looked at the handle he had made for my heavy package and thought of its contents, it came over me: He's not "me little bruddah Sandy" any more. From now on I'm going to say a bit smugly, "Yes, I'm Sandy Calder's sister." Mother's voice and big brown eyes came vividly to mind as she reproached me for not taking care of my little brother in 1906. Any such obligations had long since been laid to rest. Yet that lop-sided grin of understanding would always touch something deep within, an echo of shared experiences and responsibilities.

In the spring of 1926, Sandy had his first show, an exhibition of oil paintings at the Artists' Gallery in New York. A press release shows him standing, brush in hand, before his large canvas of *The Democratic Convention:* "Alexander Calder, formerly mechanical engi-

neer and now one of the most promising of the young artists. . . .
Despite his change to art, he does not forget his profession, as at dif-
ferent times he makes new devices to facilitate the mechanics of art."

Nonetheless, he was growing restive in New York; he felt he
needed the stimulus of a change in scene and in professional associa-
tions. Like his father and grandfather before him, he naturally thought
of Paris. To my parents it seemed a reasonable move and they agreed
to help support him in a modest way. He would work his way across
on the cargo ship *Galileo,* painting its rusty hull. Before sailing, he
sent off the large canvas, *Circus,* which he had painted and dedicated
to the Hayeses. It arrived in time for our tenth anniversary, carefully
wrapped around a wooden pole. We tacked it up and our sons and
their cousin quickly identified with the three clowns down front; I was
the damsel doing the Charleston on the tight rope, and Kenneth the
clown about to whack another on his rear.

Sandy had to report early the day his ship sailed. Father and
Mother hurried down to watch the cast-off and start in the charge of
a harbor tug. Then Mother grabbed a taxi and headed for Landsend.
There she sat on a rock, tears streaming down as she watched the tiny
vessel head out to sea:

> It looked like an eggshell bobbing in the water [she wrote me],
> the salt tears ran down my cheeks as I watched it.
>
> I was reminded of the day you in your gray suit got into the
> train with Kenneth. I felt so badly that your father took me to
> Lake Champlain. But the weather was hot and humid, the hotel
> horrid and the food inedible. But there was a waitress, a raw Irish
> girl of great beauty. Like a goddess. She lifted my spirits just to
> watch her move about the dining room.

That lop-sided grin of understanding.
SELF-DRAWING, Christmas, 1928(?)
Photo: Colin McRae

Things Beautiful, Things Rare . . .

PART II

*Alexander Milne Calder was born on Huntly Street,
Aberdeen, Scotland, in 1846.*

4

Grandfather, Alexander Milne Calder, was born on Huntly Street, Aberdeen, Scotland, on August 23, 1846, to Alexander Calder and Margaret Milne. According to several published accounts he was apprenticed in his early teens to a stone-cutter. He himself summarized his career in an autobiographical sketch now in the files of the Registrar, Pennsylvania Academy of the Fine Arts, Philadelphia:

My first work was among plants and flowers, and, seeing a portrait modeled by Brodie, a Scottish sculptor, I went to work in stone, and, in 1864, removed to Edinburgh, to be under the late John Rhind, R.S.A., and became a pupil at the Academy's Schools. After three years I went to London and Paris and, returning to the former city, was engaged on the Albert Memorial, Hyde Park, for a year. In 1868 I came to Philadelphia and became a pupil at the Pennsylvania Academy of the Fine Arts. While modeling for a number of the leading architects of Philadelphia and New York during the next three years, I became a citizen, and, with the exception of a season in New York, have resided in Philadelphia ever since. In 1872 [I] was engaged by the late John McArthur, architect, to design and model groups for the new City Hall. At the Centennial Exhibition, in 1876, I was represented by several figures and a carved panel in stone—birds attacked by a snake—now in the Drexel Institute. In that year, also, the new schools of the Pennsylvania Academy of the Fine Arts were opened and I became a regular student, devoting all my spare time there for the following seven years. In 1877 I removed to a studio in the City Hall, making many designs, historical, allegorical and emblematic, including

statues, reliefs, etc., for it, and in 1881 entered into competition for the equestrian statue of General George Gordon Meade, gaining the prize in competition with seventeen other sketches.

Since 1887 my work has mainly been colossal, including the statue of William Penn and groups for the City Hall tower, but I have occasionally made and exhibited several portrait busts and figures, including those of Samuel C. Perkins, General George Gordon Meade and Dr. H. Earnest Goodman for The Union League and the portrait memorials, also in bronze, of the Hon. George Sharswood, the late Chief Justice of Pennsylvania, and of the late John McArthur, architect, and, while occupied with the largest piece, also had the smallest of my work in hand, the Ferdinand D. Hayden Memorial Geological Fund Medal, for the Academy of Natural Sciences.

Grandfather landed in New York when he arrived in the United States in 1868. When visiting in Philadelphia, he met a family of young women, daughters of John Stirling, newly come from Glasgow. After a brief courtship, he married Margaret, on November 26, 1869. Shortly afterward Grandfather found he would be one of two sculptors in Philadelphia, so the couple decided to settle there. He went to evening classes at the Pennsylvania Academy of the Fine Arts, where he became a student and friend of Thomas Eakins, continuing there even after he was chosen by John McArthur, the architect for the projected new City Hall, to design and model decorative groups for the entire massive structure, inside and out.

Grandmother was a dour, austere woman for whom the term up-tight should have been invented. She maintained that each of her six sons was the result of rape. Despite such inauspicious beginnings, she was deeply, indeed excessively attached to her sons, only two of whom ever married. Father and Mother were married before the marble mantel in my grandparents' parlor, and Sandy and I, her namesake, were her only grandchildren. Yet she was stern and undemonstrative with us, and between her and Mother the traditional tensions prevailed. Mother, who felt keenly the loss of her own mother when she was eight, said she would gladly have been a loving daughter-in-law had she been given the chance. Probably Grandmother Calder could not easily admit another female to the household of men she was used to running without challenge. Besides sitting at her Busy-Body, a series of mirrors attached to the second-floor window so that one could watch the un-

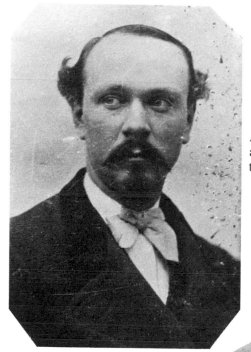

Alexander Milne Calder
at 22, when he came
to Philadelphia

Grandfather married
Margaret Stirling
November 26, 1869.

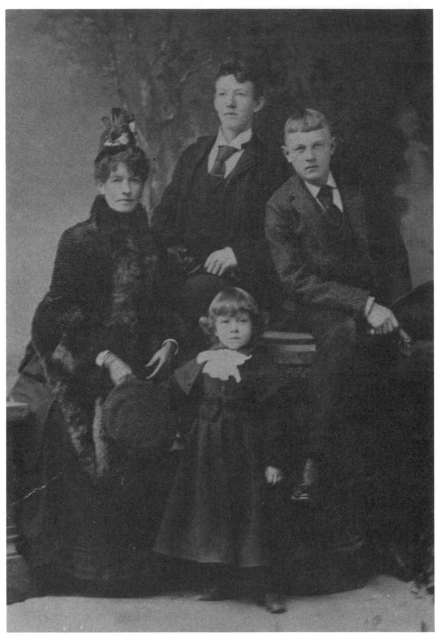

Margaret Stirling Calder with sons Alexander, Charles and
Ralph, about 1887.

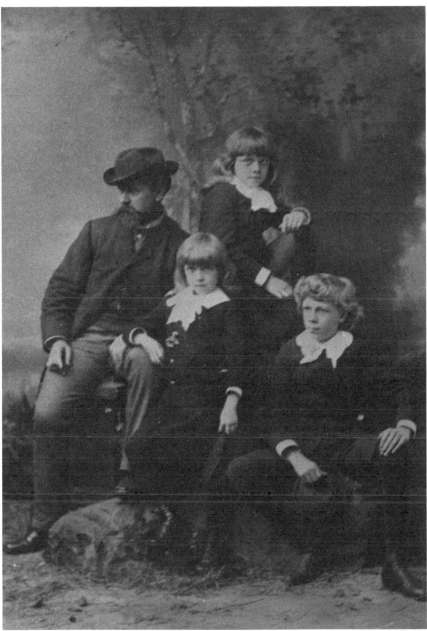

Alexander Milne Calder with sons Ronald, Walter and Norman, about 1887.

suspecting neighbors come and go, the greatest frivolity she permitted herself was the mournful singing of "The Bonnie Earl O'Morey Come Soundin' Through the Toon."

Grandfather was good-humored and debonair. He wore his hat at a jaunty angle and well-cut suits made of Scottish tweed. In his *Autobiography,* Sandy misidentified him as an unprepossessing little man in shirtsleeves in a group photo taken before one of Grandfather's bronze eagles, a mistake unfortunately perpetuated in other books and articles since. Uncle Ron was indignant: "Daddy," he wrote (all Alexander Milne's grown sons called him Daddy) "was a dandy. He would never have allowed a photo to be taken in suspenders . . . and he never had a paunch." (The man Sandy mistook for Grandfather was, according to Uncle Ron, his assistant, James G. C. Hamilton, and Grandfather is not in the photo at all.) Grandfather was very Scotch in measuring life, but kindly with a pleasant personality.

He returned to his birthplace each summer. On one of these trips he met Harry Lauder, the Scotch singer then making a great hit in Europe and the United States. Father took Sandy and me with him to meet the ship when he returned. As we waited for his luggage, he was full of fun, singing "My Scotch Bluebell" and executing a few steps of the Highland Fling. Later, describing Grandfather's high spirits to Mother, Father added, "Poor devil, he'll get over that once he gets into the gloomy atmosphere at home."

However gloomy the atmosphere at 1903 North Park Avenue, it was the one unchanging family residence that Sandy and I knew as children, and we found ways to amuse ourselves when we repaired there for the usual feast days despite Grandmother's dour outlook and rigorous housekeeping routines. Like other conscientious housewives of her day, she locked away the silver and other valuables each night with keys that hung at her belt.

The house, a large one on four floors, stood in a phalanx of identical brick houses with marble steps that were scrubbed daily by a wretched-looking servant. An unhealthy-looking poplar tree, dripping with caterpillars and surrounded by a fence with spikes pointing outward, stood in front. There was a vestibule, where one shook off the snow or rain in bad weather. Inside a long dark hall, lit by a gasjet and covered wall to wall, a red carpet led past the closed doors of the parlor, which we were forbidden to enter without an adult. Its "Empire" furniture, upholstered in red velour, was usually under protective linen covers. It was perhaps his memory of this uninviting setting that led

to Sandy's lifelong distaste for things that cannot be used and enjoyed for what they unadornedly are. On the parlor's marble mantelpiece, in glass domes, were deployed the stuffed earthly remains of once beloved pet canaries. Between the windows was a four-foot statue modeled by Grandfather of Alexander Wilson, the dialect poet, ornithologist, and bird-painter, who fled Scotland after lampooning the mill owners in a bitter labor dispute. Wilson arrived in America with nothing but a gun and the clothes he was wearing. After trying his hand at various jobs, including teaching, he found a backer for the first volume of his *American Birds,* published in 1808; he published six more volumes by the spring of 1813. Grandfather depicted his compatriot with a dead bird in his hand and a gun by his side, with the same exactness and attention to detail that Wilson had shown in his drawings of birds.

Grandfather's live birds were kept in the sitting room at the back of the second floor, one of the few rooms in the house where Sandy and I could wander without restraint. There at least three canaries always held forth, trilling defiance of one another from different corners of the room. Usually we could get them to respond to our whistling. Those which especially endeared themselves in life found their way to the parlor mantel after death.

Father's youngest brother, our Uncle Ralph, teased us over Grandfather's protests until we joined him in daredevil flights down the long polished bannis er from the second floor to the first. And we had other evidence that our uncles were not the models of restrained deportment Grandmother represented them to be: on the ledges and crossbars of the elaborately carved dining room table, our exploring fingers found shriveled bananas, hardened crusts of bread, once even a dish of ancient rice pudding.

When the doors to the upstairs sitting room were closed, shutting out the canaries' voices, the silence was broken only by the loud tick-tock of Grandfather's collection of grandfather clocks. Somehow they never all struck at exactly the same moment, so there was a tuneful succession of bings and bongs every quarter hour. Grandfather carried the keys to the clock cabinets on a massive watch fob, and Sandy and I would follow him around to watch him wind the clocks by pulling down the short chain to its full length. Sandy once found a cabinet unlocked ard hid in it. I thought this a wonderful jape; Grandfather did not.

Nonetheless, he was not afraid to show his affection toward "Allie's" children. When Sandy was five Grandfather, who called him Laddie, brought him a kilt of the Calder tartan, complete with a sporran (purse),

made of white horsehair with a little black switch in the middle and a jaunty Glengarry bonnet with a crest, a thistle pin with a topaz setting, and two little black ribbons trailing down behind. Sandy looked very fetching in this costume, and was wearing the bonnet when Mother painted the portrait of him that now hangs in the living room of Sandy and Louisa's Roxbury home. For me Grandfather brought pins of Celtic design set with Cairngorm, native stones of Scotland colored dark red, brown, and gray. He loved painting watercolor scenes of the Scottish countryside, and lovingly described for me and Sandy the little stone houses and fields of heather in the beautiful Auld Countree. In later years he let us know how pleased he was with both of us for being college graduates, and sent us each ten dollars in honor of the occasion. "Tis grand that noo oor laddie an' oor lassie baeth hae diplomas frae universities."

Whenever we were living in the east, Grandfather often came to our house to play with Sandy and me and to discuss art in general and sculpture in particular with Father. Because the two men had very different attitudes toward their work, the discussions often became quite heated. I can still hear Grandfather saying skeptically, "Ah hae me doots."

Grandfather's impetus toward art had come from viewing a portrait bust. His launch into a new world took courage and imagination, but also demanded accuracy. His work was solid, factual, allowing for little fantasy and only occasional touches of humor—a cat chasing a mouse in and out of the City Hall frieze, urchins playing marbles, a distinctively mischievous-looking bison's head. Much of the abundant wildlife in his work—the great bronze eagles over each of the four entrances to City Hall, owls, a beehive, elephant, bison, and lion heads; squirrels, foxes, herons, songbirds, an otter with his fish—he called allegorical and symbolic.

My father grew up amidst his father's work, but he was influenced by the more released philosophy of the *fin-de-siècle*. He thought an artist should interpret character rather than produce a likeness: "The realm of the ideal must always be the most attractive to the artist. Without it there would soon cease to be any sculpture. The restless desire to embody our thoughts exists as a kind of superior instinct for visual beauty." (All quotations from Father's speeches or writings are from the collection *Thoughts of A. Stirling Calder*). "Art," Father held, "is the means to create not only expression of what we believe and cherish, but just as much a means for the creation of images of what

Much of the abundant wildlife in his work . . . Photo: City of Philadelphia Records Dept.
AN OTTER WITH HIS FISH, by Alexander Milne Calder

we hope and desire." He felt most of the sculpture being doing in the United States was "meticulous and unimaginative," slavishly imitative of the admittedly beautiful works of antiquity. Sculpture should not be involved with the ephemeral details of everyday life ("The greatest art is that which creates a world of its own, removed from all the hurly-burly"), yet sculptors could not pretend the twentieth century was the fourth century B.C. In his book, *Thoughts of A. Stirling Calder* (New York, 1947), he wrote,

> Sculpture reflects in choice of subject and treatment the spirit of our time. It is ugly because our age is ugly—the gasoline age of noise and stink. We cannot go back to the golden age that produced the Venus of Cyrene, but we must and will go forward to find a new way of life when the emphasis is put on the things that really matter. The world is groping for it, and perhaps sculpture can help by creating gracious images of truth, beauty, with all the hate, greed, and envy left out.

And in a way that Grandfather and Father helped make possible but could not have anticipated, Sandy did just that—using materials appropriate to an age of noise and stink, he created joyous images of beauty with all the hate, greed, and envy left out.

Grandfather felt he had expressed emotion and ideals in his work. In Philadelphia's City Hall, the hapless felons passing through the arch leading into the Sheriff's office, for instance, might look up at the figures of Justice and Mercy overhead and repent. The eagles over the entrances, each with a fifteen-foot wing spread, convey through their threatening mien and gesture the power of a nation just emerged from the crisis of the Civil War. Every feather is indicated. The birds' wings are spread as though for immediate take-off, their beaks are hooked and sharp, their talons menacing. Their repetition gives equal importance to the building's four entrances. The posture is conventional, the style consistent with the prevailing taste for realism.

But when Father modeled *Son of the Eagle,* he used the bird's strength and nobility to symbolize the character he felt inherent in the Indian. The bird is realistic in form, but his wings and posture are adapted to a composition that sacrifices exact representation in order to enhance the overall romantic quality. The whole is carefully composed, with the bird clinging tenuously to the man's head and shoulder to indicate the relation Father saw between the two as well as to create a dynamic outline. Father's deliberate omission of superfluous detail is a prophetic foreshadowing of the abstract style his son would adopt.

The discussions between Father and Grandfather usually ended with shared laughter and an affectionate clap on the back.

In all, Grandfather completed more than two hundred and fifty reliefs, statues, and groups of decorative sculpture for the City Hall. At the same time he continued to study at the Pennsylvania Academy, and won out over seventeen other sculptors in the competition for the equestrian statue of George Gordon Meade. General Meade had ensured the safety of Philadelphia and earned the enduring affection of its citizens by his conduct of the decisive battle at Gettysburg. Congress had voted to donate twenty 12-pounder condemned bronze cannon for the necessary bronze. The final choice was enlivened by the demand of the Women's Auxiliary of the Fairmount Park Art Association that it be allowed a say in the choice of sculptor as well as a fund-raising role. The bronze horse and rider, which stands on a base of Pennsylvania granite in Fairmount Park, was unveiled with enormous pomp on October 18, 1887. The ceremonies included performances of both Army and Navy bands, a very long Invocation and Prayer, three speeches and an Oration—followed by a reception.

GENERAL GEORGE MEADE in Fairmount Park, Philadelphia
Photo: City of Philadelphia Records Dept.

Beaks hooked and sharp, talons menacing, posture conventional
One of four eagles over the entrances to Philadelphia's City Hall—
the work of Alexander Milne Calder
Photo: City of Philadelphia Records Dept.

SON OF THE EAGLE. Alexander Stirling Calder, sculptor
Photo: Walter Russell

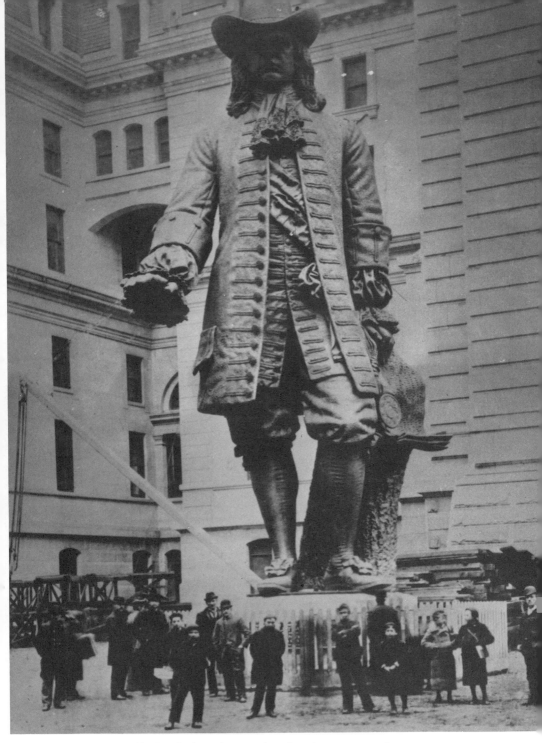

Grandfather is best known for the giant statue of
William Penn atop City Hall in Philadelphia.
Photo: City of Philadelphia Records Dept.

As he watched helplessly from the ground, his statue of
Penn was mounted facing the wrong way.
Photo: City of Philadelphia Records Dept.

Grandfather is best known for the giant statue of William Penn
atop City Hall, still the highest point in Philadelphia. Working with his
usual meticulousness, he first made a three-foot clay sketch and then a
nine-foot clay model. This model was then enlarged by the pointing
system to its ultimate height of 37 feet; the nose alone is nearly thirteen
inches long. The 37-foot model was made in fourteen separate sections,
beginning with the legs. Because clay can freeze, dry out, or both, each
section was cast in plaster as soon as possible. When the last section,
the head, was to be lowered onto the rest, a hole had to be cut in the
ceiling of Grandfather's City Hall workroom. There the model languished
for a year and a half because there was no foundry in the United States
capable of casting in bronze a statue weighing some twenty-seven tons.

Finally the newly founded Tacony Iron and Metal Works in Philadelphia undertook the assignment, and Penn was carried in sections by four large horse-drawn trucks to be cast in bronze.

To Grandfather's everlasting disappointment, as he watched helplessly from the ground his statue of Penn, the crowning piece of more than twenty years' labor, was mounted on the dome of City Hall facing the wrong way. Instead of being lit by the sun all day as he had planned, it is illumined only at dawn, when virtually no one is there to appreciate the loving detail of face and costume. Grandfather would sigh disconsolately, shake his head sadly, and repeat the verses of his compatriot, Robert Burns:

> The best laid schemes o' mice an' men
> Gang aft a-gley.

Grandmother, who had a superstitious dread of doctors, died in 1905 without ever receiving the benefit of their attention, and was laid out in an open coffin all done up in the best "American Way of Death" style. Sandy, who was seven, was excused from the fifteen-mile trip to West Laurel Hill cemetery outside Philadelphia, but I rode in a black coach drawn by two black horses with my father and uncles Charlie and Ron to the family plot, where Grandfather had installed a Celtic cross bought on one of his trips to Scotland. Unfortunately it was very hot and I was so overcome that it was thought best to excuse me from the graveside services.

Grandfather died on June 14, 1923, and was interred alongside Grandmother in the plot guarded by his Celtic cross. The cross is crawling with serpents, a fact that Sandy always found very, very funny. His friend James Johnson Sweeney says the snakes suggest the cross is of Irish origin. I find that hard to believe of a Scotsman so dedicated to his native land that he teased his grand-daughter regularly for marrying a man who did not spell his name Hays as all rightly derived men would. It should be noted, though, that at the base of the cross the family name is spelled in its Gaelic version, CAWDOR.

5

Family legend has it that Father and Mother met over a cadaver. This may very well be true, as Father had been appointed Assistant in the advanced classes on artistic anatomy taught by Dr. W. W. Kean at the Pennsylvania Academy of the Fine Arts, where Mother was a "brilliant student of painting." He had been summoned to this position by a cable to Paris, where he was living with a fellow student, Charles Grafly, on the rue Campagne Première in Montparnasse, studying first at the Académie Julien and later at the Ecole des Beaux Arts. However they met, Alexander Stirling Calder and Nanette Lederer were married on February 22, 1895, after Father had won the competition to model a statue of Dr. Samuel D. Gross, the great surgeon whose clinic is depicted in a noted painting by Thomas Eakins. Mother was then twenty-eight, Father twenty-five.

Father had grown up with the smell of clay, for he and his brother Charlie were often called on to pose for their father and to assist him in other ways. He recalled with wry humor how pleased he had been to be put in charge of the horse used as a model for Grandfather's equestrian statue of General Meade. His pride in riding the horse to and from the livery stable and sitting astride him while they posed soon turned to dismay. First, it was impossible to get the horse to maintain the appropriate pose of a spirited charger. Instead, he drooped, with his head hanging down and his eyes half closed. Worse, Father discovered that his assignment included cleaning up the steaming piles of manure the horse left on the studio floor each day.

Father's real longing was toward the more romantic world of the stage. He saw Edwin Booth as Hamlet when he was six, and in his early

teens dreamed of becoming an actor. By then he was an inveterate theater- and opera-goer, seeing and hearing the foremost actors and singers of his day. He usually paid twenty-five cents to stand through an entire performance, and later spoke feelingly of the luxury afforded by an occasional empty seat. He had to feign surprise when Grandfather decided he was old enough to go to the theater, gave him twenty-five cents to see *The Taming of the Shrew,* and told him the whole story: he had seen it the year before.

Father continued to love the theater all his life, and communicated that love to Sandy and me. However, he was unable to overcome his native shyness sufficiently to become an actor himself, and at the age of sixteen enrolled at the Pennsylvania Academy. He was quickly advanced to the life class under Eakins, who was fired during Father's first year for indecorum and shocks to prudery.

Thomas Eakins, who had been Grandfather's good friend and teacher, innovated arrangements first to study and dissect a horse and then in January, 1881, for the first time to model a live horse in the classroom! But Father was indifferent to the Eakins controversy, for unlike many of the other students he had not yet fallen under Eakin's spell— "All my heroes were on the stage." Father did find it droll, however, that the female models were required to wear black masks while posing nude, so that "while exposing the body that was usually covered, they covered the face that was invariably exposed." Thomas Anshutz became his favorite instructor. Most of his close associates were young artists. Besides Grafly they included Robert Henri, John Sloan, William Glackens, Frank Whiteside, Charles Davis, Edward Redfield, Everett Shinn, Hugh Breckinridge, James Preston, Charles Harley, Curtis Williamson, Theodore Robinson, and of course, Nanette Lederer.

Mother's route to the Pennsylvania Academy was more tortuous. Born in Milwaukee, she was twelve years younger than the last of her four older brothers and inevitably the family pet. Her photographs show a cunning little girl with mischievous eyes and wavy black hair. But she was reticent about discussing any aspect of the world she abruptly lost at eight, when her mother died. Thinking a family of men could not make a suitable home for her only daughter, her mother requested on her deathbed that Mother be sent to Philadelphia, to be reared by an aunt. The years that followed were hateful for her, a Cinderella story with no fairy godmother. Although her aunt meant well, for Mother the sudden change from being the petted baby in her own family to being a tolerated

outsider in another's was hard to endure. She resented it when her cousins wore her mother's jewelry and lost or damaged it, and when her requests to take music and swimming lessons were turned down (learning to swim was unthinkable—it might "develop her muscles"). The daily walk to and from school was two miles each way. Her pleas to return to her father's home were finally acceded to when she was sixteen, but the return to Milwaukee brought defeats and disappointments, too. She found the housekeeper inefficient and dishonest, but made a dismal failure of trying to run the house herself. She was shocked to meet her brothers in the company of "scarlet women"; when she remonstrated with them, they laughed at her. She surprised her father playing the violin one afternoon when he was supposed to be working, and thus cornered, he agreed that she could take piano lessons—a concession that opened up a world of pleasure and solace she had recourse to all her life. Though never a perfectionist, she practiced regularly and seriously from time to time, and when Sandy and I were growing up often played for an hour or so after we were tucked in bed.

When her father died, Mother displeased her brothers by taking her inheritance and leaving to study art in France. She had always been praised for her "art work" and encouraged by her teachers to study more intensively. Her brothers considered painting a legitimate occupation for a cultivated young lady, but not something to be thought of seriously, certainly not as a profession. She should invest her money prudently and marry one of their circle.

However, she was in earnest, and proceeded first to the Pennsylvania Academy of the Fine Arts in Philadelphia and then to the Académie Julien in Paris. There she studied painting for four years, living with friends from Philadelphia: Theodora Burt, Charlotte Harding, Dickie Owens, and Mary Middleton. (Mary later married the sculptor Albert Laessle.) She and Father presumably overlapped at the Académie Julien, but they did not meet until both had returned to Philadelphia, when they saw each other daily, as Mother continued her studies and also found employment with an exclusive firm of dressmakers. Her job was to see that each garment leaving the shop was in elegant taste and had "some artistic touch."

Immediately after their wedding ceremony in February, 1895, my parents left for Paris, stopping first in Scotland to see Grandfather's brother, Jack. In Paris they rented a studio on the Left Bank, where they studied, worked, and shared experiences with other artists from Philadelphia, including John Lambert, a wealthy painter who greatly admired

the work of both. Lambert later introduced them to Mrs. Leverett Bradley, Charles and Adolphe Borie, and Wilson Eyre. It was Lambert who came to the family's rescue when Father was stricken with tuberculosis.

It was in their Paris studio that I was born on February 1, 1896, reputedly the first girl in nine generations of Calders. The doctor and nurse in attendance apparently did little either to ease the pain or to shorten the labor. Years later, Mother wrote me, "The French doctor took all the money we had. I still remember the darling baby that was washed and cleanly dressed in a little flannel dress and put in a berceau next to my bed, but O! What a night! It was agony for both your father and me, Peggy. I'm afraid we didn't love you during it. But what a blessed morning!" Sandy's birth in Lawnton, two and a half years later, was even more prolonged and difficult, and Father had to be pressed into service to administer chloroform drop-by-drop onto gauze over the nose of his pain-wracked wife—a harrowing experience for such a retiring, sensitive man. Sandy, he declared, would be their last child. Father's preoccupation with Cruel Nature, a theme for which he made many studies, was given great impetus by the ordeals of his childrens' births.

He took very little part in our care. We were fed early and put to bed or given something to keep us occupied. When we were older and came to the table, if he was tired or silent, we usually took the cue and followed suit, ceasing our chatter and efforts to chide him out of his glum mood. How different was the son who grew up at that table! When asked if he had ever been unhappy, Sandy answered, "I haven't got the time!" Once when I was thirteen or so, some impudence on my part made Father so angry that he struck me on the cheek. As I dared him with steely looks to repeat the blow, his anger faded and he turned away very fatigued. That and a paddling on the bottom administered by Mother with a soft bedroom slipper when I was four are the only times I remember being struck. Sandy, I believe, was never struck.

In more cheerful moods Father was witty, fun to talk to, and full of plays on words, or amusing quotes; for example, this one from a gravestone: "Solomon Pease who left only his pod, having shelled out his peas and gone to his God." Though never demonstrative, he would happily put an arm around one of us and read or tell us a story. After he had recovered from his illness and we were older, he found our observations amusing, especially Sandy's, and enjoyed probing our attitudes. I married a man of very different temperament—Kenneth was

Mother and Father rented a studio on the Left Bank, 1895.

full of gaiety, noisy, gregarious, light-hearted; and to my father and brother's amazement, he thought it great fun to pitch in and help, playing with his sons, hanging out the laundry. He even made up a song, "Diady! Oh Diady! Oh Diady! That is the Baby Rag," which his boyhood chum Sam Chamberlain put to music one hilarious summer day.

Yet I was very proud of my tall, handsome father, and his strain of romantic idealism struck a deeply responsive chord in me. Sometimes he expressed this in essays or speeches: "I see Art's function," he wrote, "as a constructive power, capable of changing life, of creating life as we would have it." And "Art is the eternal optimism of humanity expressing itself." In the 1940's he often repaired to his desk to write. He and Mother were so pleased with one of his poems that they had copies printed and enclosed it in Christmas letters and other correspondence:

> Things beautiful, things rare—
> Let's fill the old world with them,
> Nor think to overtop its holding.
> What's beautiful, what's rare
> Will never want for care—for loving.

Of course the fullest expression of Father's romanticism comes in his sculpture, some of which I find enormously moving to this day.

Mother, by contrast, was warm-hearted, buoyant, and full of the joy of life. Annoyed by arguments, which she called "wrangles," she would try to divert them: "Look at those lovely azaleas." Sentimental, she was moved easily to tears by the corniest situations, a trait that Sandy and I seem to have inherited, much to our embarrassment and Father's amusement: "Time to turn on the waterworks." Mother was very fond of children, particularly young ones, for whom her pocket always seemed to produce a gaily colored crocheted ball with a bell inside. She would come intrepidly to the defense of both her own and others' youngsters. She was naive to the point of ignorance about politics, and her impulsiveness often led to mistakes, which she cheerfully admitted: "Oh rats, what a fool I am." She was utterly open about bathroom matters, and I now realize unusually frank with me for her time about sex and other sensitive aspects of adult life. Her richness, warmth, and strength were vital to us all.

Yet at the same time she was a discerning and dispassionate critic of her husband's work. He valued her opinion highly, often inviting her to his studio to comment on a work in progress. This sometimes re-

Father valued Mother's criticisms, even when she said,
'I liked it better yesterday.'

sulted in a glum and introspective dinner, especially when she said, "I liked it better yesterday."

My parents were more interested in the creation of things than in the recording of them, but it appears that after they returned to Philadelphia in 1897, Father modeled twelve nine-foot statues of Presbyterian divines to decorate the Witherspoon Building. Made of cast stone and placed at the seventh-story level, they were later deemed potential hazards to passers-by; six were relocated at the Presbyterian Historical Society. He also modeled *The Scholar and the Football Player,* a fountain given to the University of Pennsylvania by the class of 1892. Sandy and I, taken to play on the University lawns, especially admired the attached bronze goblet, the goblet's handle being an athlete about to do a backflip. Father's statue of the French explorer Philippe François Renault won the silver medal at the Louisiana Purchase Exposition of 1904 in St. Louis. The following year his memorial cross for the family of General William Joyce Sewell was awarded the Walter Lippincott 100th Anniversary Prize after being exhibited at the Pennsylvania Academy of the Fine Arts. In the design of this Celtic cross there emerges his preoccupation with Cruel Nature; in the center, Adam and Eve are being tempted by the serpent. In the period just before he fell ill, Father modeled busts of Mrs. Leverett Bradley and of Helen Harte, the two-year-old daughter of his physician, Dr. Richard Harte; for Dr. Harte's parents, William and Mary Harte, another Celtic memorial cross; and numerous studies of Mother, Sandy, and me. *Man Cub,* for which Sandy posed at four, was used in a little book, *Growing Up,* to educate the innocent child about a young male's anatomy. Other members of the family also posed, notably our well-built Uncle Ron, who became *Young Hercules Dozing* and *The Miner.*

A sundial for the Sunken Gardens in Fairmount Park was copyrighted in 1906, while Father was convalescing in Arizona. It must have been modeled in 1904-05, with Father working on the carving personally, an undertaking that probably precipitated his collapse. Four seated damsels, representing the four seasons, serve as caryatids, who support a circle of marble embellished with the signs of the Zodiac. A garland of blossoms, branches, and fruit winds in and out under this circle, topped by a bronze sundial. Mother twisted a small branch with apples into my hair, and I posed briefly for Autumn. The work on which Father expended his health was subsequently marred by vandals, who painted black lacquer initials on the caryatids' chests and nipples. A nose was broken. To erase these disfigurements, the whole work was sand-

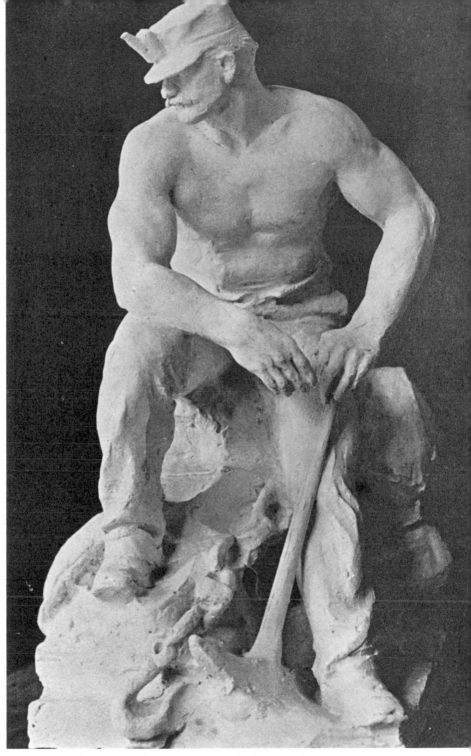

Uncle Ron had a terrific physique and Father modeled several statues of him. THE MINER

blasted, a procedure that also erased much of the modeling's original crispness. The base bears the carved admonition, "Watch therefore for ye know not what hour your hour doth come."

During these years when Sandy and I were small and money and living space were in short supply, Mother had little chance to paint. She did several small canvasses of a friend holding Sandy or me and of Father, but her major thrust had to be her husband and children.

When Father, who had had a hacking cough, began spitting blood, he went to Dr. Harte, who after extensive testing diagnosed consumption and summoned Mother to a consultation. Father must stop all work. To keep the rest of the family from contracting the disease, he had to be isolated, with his dishes and clothes kept separate and sterilized, the rags and paper cups he used for spitting burned. He must have no close contact with the rest of us. And, to ensure a complete recovery, it was highly desirable that he move to a much drier climate. Dr. Harte recommended Arizona.

This was a terrible blow. If Father could not work, they would have no money to live on, to say nothing of financing a move to Arizona. Furthermore, a family separation of some duration seemed inevitable. It was then that John Lambert came to the rescue with the extraordinarily generous gift of $10,000, and the Shoemakers offered to care for Sandy and me for as long as necessary. Mother, with her bitter memories of the loss of her childhood home, found the thought of parting from us nearly unbearable, but she was sturdy and courageous, and so steeled herself out of the fear that otherwise we, too, might become consumptive. She wept as she packed for Oracle, where Father was to sleep outdoors in the high, dry climate, eat quantities of fresh milk and eggs, and spend long hours resting in the sun. Just beginning to feel his powers and to achieve public recognition, Father would do no work for over a year.

Alexander Stirling Calder
THE GENERAL WILLIAM JOYCE SEWELL MEMORIAL CROSS

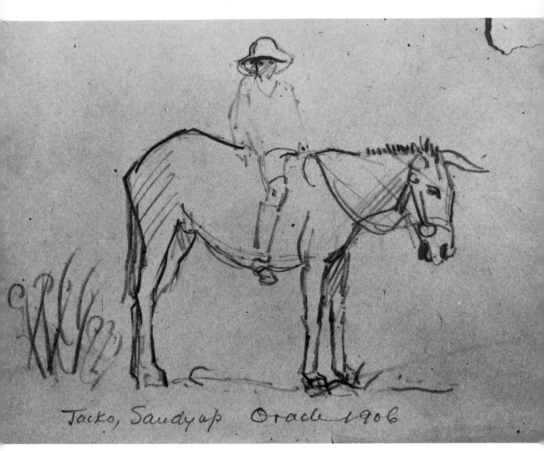

Father sketched Sandy on Jack-O. Oracle, Arizona

6

It was the fall of 1906 when Father was adjudged well enough to leave Arizona and move to the mild climate of Pasadena. There he was commissioned to model a relief of Cornelius Cole, one of California's first senators, so he rented a studio on Figueroa Street in Los Angeles, commuting there daily on the Pacific Electric Railroad. He got back into the swing of things gently, resting each afternoon on a cot in his studio. He soon found a model and began work on a group, *Cruel Nature*, as well as the Cole relief.

The daily ride took him past Oneonta Park, where signs all over the fence announced a zoo and winter quarters of a circus. Investigating, he found an encampment of Sioux Indians and prevailed on two to pose for him. Mother painted their portraits while Father modeled three statues of Najinyankte as well as several figures and a bust of Kill-an-Enemy. He and Mother were much amused when they asked Najinyankte which city the circus had played in did he like best, and he replied, "Paris. There the girls say 'que tu es si beau.'"

The family of Arthur Jerome Eddy, a corporation lawyer from Chicago, spent the winter in their Pasadena home on the opposite corner of California Street. Eddy, a patron of the arts, took an interest in our family and commissioned Mother to do a portrait of his son. A pleasure-loving youth, Arthur Jerome Jr. slapped his riding crop against his puttees and chatted amiably with "the Calder kids" as he posed in mother's living room studio. Mr. Eddy also sent Sandy and me to a gym, where Sandy took boxing lessons so he could fight better and I took fencing to make me "more graceful." Later, Eddy obtained a commission for Mother to paint two other Chicago boys wintering in Pasa-

dena. Their mother brought them to our house in an electric brougham and usually read to them while they posed. Like most mothers, she was very attached to her darlings' looks and constantly offered advice, which Mother found disconcerting.

"I finally told her today that maybe she wanted photographs and not portraits," Mother reported unhappily. "John has bands on his teeth and is a little snob, yet she wants me to portray him as an angel. She says I'm making him look like a mouth-breather. I told her I can only paint him the way I see him, and besides, Philip of Spain looks like a mouth-breather in Velásquez's portrait. Nonetheless, it is a great painting." "Stick to your guns," Father encouraged her. "These idiots who think everything has to be pretty to be Art!"

In Pasadena, Sandy and I began our first regularly sustained schooling, taking lunch and walking the ten blocks together. We found ourselves easily making friends; Arizona became more distant each day. One day as we were walking to school, we heard someone running after us, breathing heavily. It was a slightly older boy, a neighbor named Cam. Without a word he sailed into us. The ensuing free-for-all left Cam with a black eye and me with a bloody nose. We ran wailing home to Mother, who, after staunching the flow from my bloody nose and hearing our story, put on her hat and walked with us to school, where she went directly to the principal.

The man confessed to absolute impotence. Cam was the scourge of the school, the despair of teachers and staff. Perhaps Mother could speak to his parents. She agreed to do so, but as she turned to leave admonished him: "It is the law of the land that my children attend school. It is up to you to see that they are not molested as they obey the law."

Then she went to the boy's home, separated from ours by a geranium-filled vacant lot. This boy who had so abruptly shattered our confidence in our fellows was the third of a family of five children, the eldest being the only girl. Their mother, a southern lady whose health had been ruined by childbearing, spent her days rocking listlessly on the veranda. She revived only to attend church, driven by her husband in a gig drawn by their gaunt black horse. The father, left to his own devices, tried to control his sons by licking their legs with a horsewhip as they ran around the paddock, with squawking chickens running every which way. This usually happened after church on Sundays and was a spectacle that all four Calders watched with disbelief. For us, parental control was exercised through straightforward commands, restriction of activities and occasional confinement to our rooms. Cam's father's re-

course was to the rod, despite its obvious ineffectiveness. He readily admitted his own haplessness and gave Mother carte blanche to punish Cam as she saw fit.

She invited Cam to our house for a conference from which we were barred, and later reported her conversation with him:

"I tried to get him to say why he did it. He said he just felt like it, that the kids were new. I tried to tell him as gently as I could that he wouldn't get very far in life if he went around fighting just because he felt like it, and asked how he would like it if everyone acted that way; that we are here to help one another, to love one another, and he would not feel like fighting so often if he changed his attitude. We left it that we'd try to find something for him to take his feelings out on that wouldn't be hurt when he felt mean. Referring to his father, he said, 'I'd rather be liked than jawed at.' You know, Al, I think basically he's a very sweet kid."

Cam became our protector, riding us to school on his handlebars. Later, he joined in playing baseball and Run, Sheep, Run, but he was too sophisticated to take part in the floor games that now held sway in the back garden thanks to Pasadena's benign climate. He would swing in on his bike every few days to find out what we were up to now and ask shyly, "Am I being good, Mrs. Calder?"

Father, meanwhile, had been commissioned by Myron Hunt and Elmer Grey, architects, to model the spandrels for the main building of Throop Polytechnic, now the California Institute of Technology.

Mother, having completed all the portraits for which she had commissions as well as several small canvasses of Sandy and me, was overjoyed to receive an order to copy a portrait of General Pike for the monument atop Pike's Peak. With the owner of the only local art store that carried her favorite Winsor and Newton paints, a man named Vroman, she also organized the first Fine Arts Exhibition to be held in Los Angeles. The two tracked down and arranged to borrow a sizable number of paintings by well-known artists from private collections in Pasadena and Los Angeles, along with some small sculptures, mostly of animals, by such artists as A. L. Barye. She also arranged and coached an evening of tableaux vivants for an entertainment at the Valley Hunt Club in Pasadena, using well-known sculpture for the tableaux. This proved to be the big event of the social season.

The Ben Greet players, whom Father had taken us to see perform *As You Like It* at the University of Pennsylvania, now came to Los

Angeles. Our Shakespeare-loving Father took us not only to see a play, but also to go backstage to meet Charles Rann Kennedy and his wife, Edith Wynn Matthison, the company's leading actors. Later the Kennedys dined with us and I marveled out loud that we had ice cream, a luxury we did not often enjoy in 1908.

"Shh," Mother hushed me, "I want you and Sandy to remember meeting the Kennedys and Gwladys Wynn and Milton Sills, not what we ate."

Gwladys, Edith's niece, returned a year later in *The Third Floor Back,* along with Milton Sills, who was courting her. They joined us in picnics at Ocean Park and Santa Monica. At the Ocean Park plunge Mother invested ten dollars in six swimming lessons, three each for Sandy and me. We easily learned the basic strokes, which we then tried to teach her. We were stymied—she tried too hard. It wasn't until a small boy cruised up beside her as she struggled and said, "Say, lady, just dog-paddle like me," that Mother finally caught up with her child-hood longing.

Father and Mother had endless discussions about art and the relative importance of color and form which Sandy and I found deadly dull. Carried away by the beautiful flowers around her and the effect of sunlight streaming through their translucent leaves, Mother would lead with her chin: "Those flowers are so vibrant they make my heart sing. To me, their form is not as important as their color—"

"Now look here," Father would interject, "color of itself can be boring. It's the shape, amount, and relationship that make it a going affair. *You use* color to express form. And what of the lovely running line of forms into other forms—no color is necessary to make them speak to you. You often find pleasure in form alone."

"Oh, I know. You're right. I just mean if I had to choose *absolutely* between form and color, I'd choose color."

"But Net," Father would sound exasperated, "you spent years learning how to express form with color, and you do it superbly."

Years later, Mother was to be critical of the way Sandy and his friends used color in their painting. "I could teach him a thing or two about paint, but of course, he isn't interested. It's all very well to use clear color, but Ugh . . . the way it is put on! Like a Shell Oil station. That Léger! So brutal."

She was correct; Sandy wasn't interested. His whole approach was different. He used flat color. He was a child of his age just as Mother was of hers—an age when the world is violent, the lines are clean-cut,

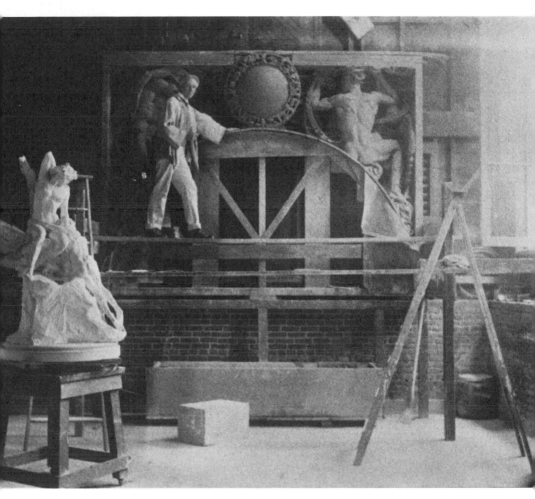

A. Stirling Calder at work on the Throop spandrels

Sandy used his color clear and flat, straight from the jar.

sharp, definite, hard. Mother's palette was that of the high-keyed French Impressionist school, whose revolutionary (and at the time widely ridiculed) approach to color dominated the sensibility of her generation. Like the Impressionists, Mother loved to paint sunlight glimmering through the trees, which often made the edges indistinct. As a rule, she used short, dauby brushstrokes to get the effect she wanted, mixing and modulating her paints from a carefully arranged palette to express her feelings and vision of her subjects. At intervals she would draw back and narrow her eyes, seeking to strain out the superfluous.

She saw color in everything about her, and while she did not of course think a work had to be pretty to be Art, she was addicted to beauty. "There is so much ugliness about us," she would shudder. "Why put it down to be an eternal reminder?" She was put off by the pipes, furnaces, and robots that Léger outlined in black. She herself used very little black straight from the tube, preferring to mix hers to get the richness she felt and wanted to communicate. One critic called her brushstrokes "absolutely delightful." Another exclaimed, "God! She's as good as the best of 'em."

Sandy, by contrast, used his color clear and flat, straight from the jar. No brushstrokes show at all. He painted from a row of jars of gouache, an opaque water paint, with each jar containing a separate color into which he dipped a separate brush. There was almost no mixing or modulation. He side-stepped the ugliness of the industrial age by using irrelevant shapes and gay colors. He often finished a gouache in one session, and sometimes even completed or nearly completed several in one morning. Only when he began painting some of his great stabiles black did he occasionally strike an ominous note.

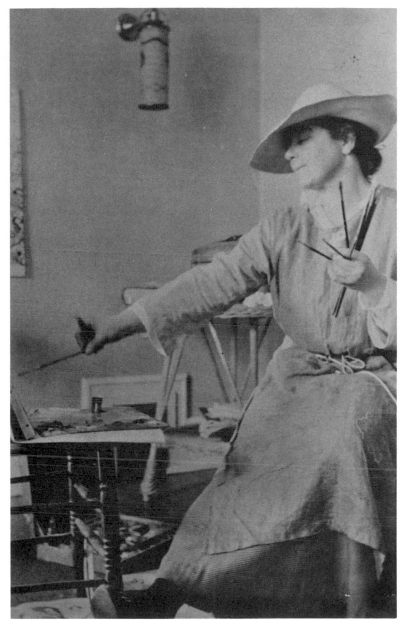

Mother mixing her paints from a carefully prepared palette
Photo: F. B. Patterson

In April, 1964, Sandy wrote my grand-daughter Nanette of his attitude:

> I think there is a great deal of crap written about what the artist thought when he did this or did that, I would like you to quote me. . . . My paintings, the more successful, have been mostly gouaches, which is a faster, easier medium—painting with oils requiring years of study of the technique of superimposing colors.
>
> My idea is to make a painting in which the gaiety of colors produces a real shock. The drawing (the form) is probably often secondary, although not always. And I often work in black alone.
>
> I often wish I had been a painter in 1906, working among the *"Fauves."* Everybody in Paris used lots of *red* in those days, and I belatedly, use lots of it now.
>
> Above all, I feel art should be happy and not lugubrious.

Although Father responded to gaiety of color and would have agreed heartily about the twaddle written of artists' motives, he was too respectful of art and too preoccupied with the cruelties of life to have made such a statement.

When Father was commissioned to model the sculptured arches of Throop Polytechnic's main building, Hunt and Grey, the architects, proposed that concrete be poured into the plaster models, the first time such a revolutionary technique had been used. The work itself was very handsome, dominated by the sun, symbolic of our bountiful planet; but there was much speculation about how pouring cement into molds would work. It worked so well that the arches survived an earthquake in 1971 that badly damaged the building itself. The building was replaced with a more earthquake-resistant structure. By popular demand, the arches were preserved and stored in the City Hall for future use.

At the unveiling and dedication on June 8, 1910, an enthusiastic crowd heard David Starr Jordan, the president of Stanford University, say: "Never has there been such a perfect combination of art and nature as in this work of art. . . . Future generations will be amazed to find such an achievement in this city on the outermost western coast, far removed from all art centers." Hector Alliot, a Los Angeles art critic, added, "It is wonderful, this thing we have in Pasadena. This is an epoch in art. This is the first monolithic portico ever attempted." Henry Van Dyke read poetry ("The flowery Southland fair, with sweet and crystal air") specially composed for the occasion.

My parents agreed with President Jordan that they were far re-moved from all art centers—too far. With Father being declared cured, they decided to return east. Before leaving he was amused and pleased when neighbors wintering in Pasadena, Earl and Pauline Savage, asked him to model a small statue of their champion pacer, Dan Patch.

Fearing that city life might bring a return of Father's malady, he and Mother found a suitable and attractive house in Croton-on-Hudson, within walking distance of the railroad into New York. The house and garage had been built by the owner on a handsome estate. Father converted the garage into a studio by installing a skylight and was soon at work on a Jack-and-the-Beanstalk mantel for Mrs. Harriman of New York City. Later he placed a small Celtic memorial cross in front of the studio, making it a very special place.

The house was divided into two wings, each with two bedrooms and a bath. Father and Sandy slept in one wing, Mother and I in the other. Although apparently cured of tuberculosis, Father continued to sleep outdoors or in a room stripped of everything but his bed with all the windows wide open. Mother, delighted to have enough space to paint, converted her bedroom into a studio. The ladies' wing was always redolent of turpentine, the bathroom basin full of paintbrushes. She was primarily interested in portraits, of people and of flowers. Landscapes and busy groups, such as "At the Soda Fountain," did not interest her.

Sandy and I became almost wealthy as we posed for twelve and one-half cents an hour, for Mother, lacking other nearby subjects, painted many portraits of each of us. One hot summer day she painted a homey scene in which I am darning the family socks, a weekly chore, while Harvey Stevenson, our landlady's son, reads aloud. The light shining through the trees on the central figure makes a lovely little painting.

The wife of the Stevensons' Italian gardener, clutching her baby tightly, was pressed into service when Father set to work on *Our Lady and the Holy Child*. She spoke no English, and was awestruck when her husband told her she was posing for the Madonna. I posed for the drapery at the customary rate. As I watched Father roll a piece of clay between his thumb and fingers, I noticed that he modeled the figure first, then added the drapery as if she were getting dressed!

"Is it hard to make cloth?" I asked.

"Not any harder than anything else. The big step is to make up your mind what you really want."

"Oh. Isn't it difficult to make the clay look like velvet, or chiffon?

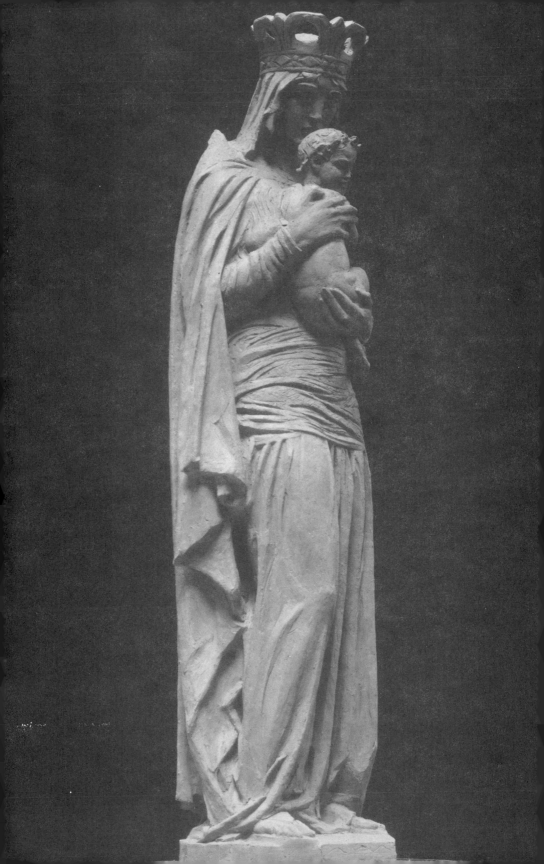

Father converted the garage into a studio
by installing a skylight.

Father modeled the figure first and then the drapery—like
getting dressed! OUR LADY AND THE HOLY CHILD
Photo: DeWitt Ward

Mother made her bedroom into a studio and soon Sandy

and I were posing. Sandy at 12 or 13 . . . Peggy at 14 or 15

You seem to do it differently now and then."

"Nope. Not especially difficult. Depends a bit on whether it is to be cut in stone or cast in bronze."

"I like the way the Nike of Samothrace's clothes cling to her. They're blowing back and seem wet, as if she's standing somewhere high, with the wind blowing."

"Oh, you do, do you. That's not a bad choice for a beginner. What else interests you?"

"Hair. The way different artists make different kinds of hair. That must be hard to do. I notice in the Greek and Roman busts, the hair is sometimes like rope, or a wig or cap. They don't look at all natural."

"Did you think they might have worn their hair that way? Actually, some of the old busts show signs of having been colored, also. They must have been pretty fierce. Time has improved them. Now be still for fifteen minutes. And straighten up, you're sagging. Fifteen minutes more and we will be finished."

When Mother later confided that Saint-Gaudens had called Father's modeling of drapery "superb," I felt virtuous and oddly elated.

Fifty years later, Sandy was to voice his dislike for the materials his grandfather and father used, which he disdainfully called *mud*. When he fabricated his structures he preferred metal so hard that it sometimes had to be cut with a blowtorch. He also refused to gussy up his work. After seeing Mother off on a trip he wrote, "Mother had a room to herself and it looked like a pleasant affair. . . . You could still see the rivets (which hold the boat together) which always appeals to me. The big boats always cover up their rivets and try to make you think you're staying at the Waldorf." So in his great stabiles of 1964-76, the rivets stand in rows like the spores on the underside of a fern, making patterns and giving texture. Asked why he did not cover them, he said curtly, "If you don't like 'em, don't look at 'em." Of course, the rivets help in reassembling the work, for the holes must coincide before the bolts can be inserted.

Sandy seems also not to have cared for the kind of intermediary process that Father and Grandfather employed. His experiments with *cire perdue* (the lost wax method of casting metal) in 1930 were short-lived, resulting in relatively few objects: a yawning cat, a lumpy cow with her head tilted to one side and a come-hither expression, a pugilist, some bulgy females and acrobats. Later, in 1944, he again experimented with this medium, making two-piece objects in which the lower half, often limbs, formed the base for the top, which was suspended

In his great stabiles of 1964-76, rivets stand in rows like the spores on the underside of a fern.

Photo: Donald Freeman

so that it could swing freely. Thus a long-legged female form consisting of feet, legs, and buttocks creates a solid base for the torso, which with long arms and small head balances and sways or spins. The work is thus a mobile, though not an entirely abstract form. The models for these figures he made of plaster, not *mud,* but even so he did not find the two-step process gratifying and soon returned to working directly with the end product. His smaller works and mobiles were all made entirely by his own hands.

But Father worked only in clay or plasticene, the work being then cast in bronze or reproduced in marble. His work, not being abstract, challenged him to represent flesh, hair, leather, scales, feathers, and fabric. When designing a Memorial for Charles Henry Lea, now in the Laurel Hill Cemetery outside Philadelphia, he modeled a bronze Muse of History seated on a marble bench. Above her head, across the upper part of the marble back, is a bronze festoon of laurel leaves. The figure, bigger than life, is seated tome in hand, contemplating the beauties of nature and the life of study and service of the man thus commemorated. This design was one of several Father executed in clay and submitted for a final choice. He thus was involved not only with robes, hair, leather, and leaves, but also with stone-cutters, bronze foundries, and Committees of Judges, who came at intervals while the work was in progress.

Sandy side-stepped all this. His work, being abstract, does not involve details. The challenges are self-imposed. For large commissioned pieces he himself made of sheet aluminum a small, or not so small, maquette of what he intended and submitted it for approval. Then, if it was to be very large and the steel several inches thick, he took it to a foundry, where he superintended and advised every step of the way. After the pieces were ready, they were assembled to see if all was as he wanted, then taken apart and packed. "Yep," he said in response to a question of mine, "I like that part of it too."

Every now and then, Father hired a model to come to Croton from New York for the day. It must have been a long day for the model and an expensive one for him. On such occasions, Sandy and I kept a respectful distance. We would not have dreamed of entering the studio without knocking, even if the door had not been closed. Father usually placed a screen just inside the door so that it did not open directly on the model. He himself was very modest about his person, as was Mother— their love for the body beautiful notwithstanding.

THE CHARLES HENRY LEA MEMORIAL—a bronze Muse of History
Photo: DeWitt Ward

Father created several small figures in Croton: *Susan Lennox, Little Sister of Melpomene, Scratching her Heel.* It was there that he modeled *Laughing Boy,* catching Sandy's crooked smile. He also taught at the Art Students League in New York, going in by train once a week. In the city he saw his friends John Sloan, Robert Henri, George Bellows, and Karl Bitter.

Sloan, often referred to as New York's Hogarth, had attended the Pennsylvania Academy of the Fine Arts when Father studied there. He was still teaching at the League when Sandy arrived in 1923. Sloan was one of "The Eight," a group that also included Arthur B. Davies, William Glackens, Ernest Lawson, George Luks, Robert Henri, Everett Shinn, and Maurice Prendergast. He was the chief instigator of the International Exhibition of Modern Art—better known as the Armory Show—of 1913, for artists whose work was barred from the established galleries. Later referred to as the "Ashcan Group," they painted life as they saw it around them: the city streets, squares, and parks; cafes and restaurants; the antics and actions of city dwellers. Ugly as well as beautiful. Their subjects were considered too sordid for exhibition by gallery owners who felt that Art should be beautiful, uplifting, lofty. With their entries consistently refused, The Eight arranged to exhibit on their own, an association that led to the formation of the Society of Independent Artists, which Father joined.

While we lived in Croton, two of our uncles moved to New York. Ralph, only thirteen years older than I, worked for the architectural firm Carrère and Hastings. A jaunty, debonair young man, he had developed a wonderfully accurate flute-like whistle, with which he performed such arias as the "Jewel Song" from *Faust.* Norman, several years older, dabbled with oil paints. They frequented the opera and symphony and loved to reproduce for us what they had heard or seen.

On Sundays they often brought their friends along to our house, who in turn brought large boxes of Huyler's chocolates. Mother and Anna Tuceling produced prodigious feasts. Mother became an artist with delicious desserts; her prize when "the boys" came was trifle rising from the platter like Fujiyama.

The fun began after dinner while we still sat around the table. Ralph would start by mimicking some big-bosomed prima donna he had just heard, then cats a-wooing in the streets of New York. He and Norman became famous for a cat-and-dog fight. Sandy brought out the equipment he had made after Father took us to see *Macbeth*—shields, helmets, gauntlets—and he and I put on a spirited "Lay on, Macduff."

Father created several small figures. LITTLE SISTER OF MELPOMENE
Photo: DeWitt Ward

I sang "Oh, You Beautiful Doll" in the manner of a popular cabaret singer. It was always with regret that we waved our guests good-bye as they dashed into Croton to catch the New York Central back to New York.

Father took us to the theater in New York whenever he could. We experienced the delicious anticipatory moment when the house lights go down, the footlights go up, and the chatter of the audience subsides as the curtain slowly rises. The first performance we saw in 1909 was Shaw's *Major Barbara.* Sometimes Father knew the actors and went backstage after the performance, or to a reception where they were being entertained. It was at The Lambs Club that Sandy and I were introduced to Forbes-Robertson, to George Arliss, to John Drew, uncle of the Profile, and saw again the Charles Rann Kennedys, whom we had entertained in Pasadena. It was the Kennedys' performance of *Macbeth* that inspired Sandy and me.

Occasionally, John and Dolly Sloan spent a Sunday. Dolly Sloan was cunning, quite small, with an attractive, round face. On one visit to Croton, she had a badly cut finger. John was most censorious. "Bungling. Sloppy. Inattentive worker!" He held up the bandaged finger, then kissed it when he saw the bewilderment on our faces. We thought him most unfair, and indignantly maintained that she should be permitted to cut her finger now and then without being scolded for it.

She and John were believers in what seems in retrospect to have been Fabian Socialism. He and Father would argue for hours, for Father was a philosophical anarchist, looking toward the day "when all men's good shall be each man's rule." Governments, he contended, inevitably become corrupt; the fewer laws and regulations, therefore, the better. For men to become decent and responsible, they had to become aware of their relations to other men. There were many topics of discussion: the age of Pericles, and whether it was better to be a slave in those days than a miner in nineteenth-century England or a child laboring in the spinning mills; whether the artist was freer in the days when he had a patron who commissioned objects or in the present, when he could make what he chose and starved while finding a buyer.

Father and his friends often exchanged works. Later he gave a small statue, *Little Dear with a Tiny Black Swan,* to Robert Henri, receiving in exchange a beautiful vibrant protrait of a Spanish child, Dolores. Unfortunately, Mother had to sell the portrait after Father died. But for many years, it had a place of prominence in our homes and gave great pleasure.

During the summer of 1910 or 1911, the Calder family joined the Sloans and the Everett Shinns for a week in the country. This proved a riotous occasion as Everett Shinn, besides being a painter, was a gifted actor, wondrous to behold in the process of evolving a play. That summer his ideas crystallized in two plays, "Hazel Weston, or More Sinned Against than Ususal" and "Lucy Moore, the Prune Hater's Daughter." He would leap from one spot to another, playing all the the roles, changing voices to suit the character, grabbing up anything handy for a prop in a frenzy of composition. His wife Flossie, Florence Covel Shinn, an artist in her own right, assisted and abetted him. She was less exuberant, but equally able and far more witty.

Petite, with an exquisite, cameo-like face, she became a different person before our eyes as she swept her hair back tight in a bun, pulled her hat well down over her eyes, folded her hands around a small book, drew herself up primly, and began, "Ladies of the Parlor of the Purple Petunia. . . ." Sandy and I, the only children present, sat around the edge of the fun. Now and then Sandy would go off and put together some prop, which invariably pleased the actors.

Dolly Sloan also entertained, with a witty monologue or a merry exchange with Flossie. The week reached its hilarious peak with the arrival of Wallace Irwin, a man with a large expanse of belly who wore a gray ribbed knee-length bathing suit with cap sleeves, from which emerged his large hairy arms, carrying a very small typewriter.

That winter Everett Shinn built a little theater behind his studio on Waverly Place. He designed and built the sets and organized the "Waverly Place Players," a troupe composed of himself and his friends, the Glackens, J. Preston, and Wilfred Buckland. Mrs. George Bellows was the orchestra, playing "Greensleeves" and "Hearts and Flowers" over and over all evening. The sets, costumes, and make-up of this group were very fine—were, in fact, works of art. Sandy and I never saw a complete performance, for all their shows took place at night and the return to Croton would have been too late. Our parents went and reported in detail. We did visit the Shinns in their home, however, and were fascinated by the many paintings that lined the walls, stairwell, bathrooms. Everett laughed, "Not too good an idea, I guess. Looks as though we never sold any!"

It was a great shock when he and Flossie were divorced. We children could not understand how either could function without the other or bear to leave the perpetual circus they created for themselves. Our parents, who sometimes seemed so lacking in glamour alongside

this lively couple, appeared in much better light after this sobering event.

Besides teaching in New York, Father developed prospects for other work that took him to the city with increasing frequency. The trip from Croton came to seem unduly long. When he rented a studio at 51 West 10th Street in 1912, the family moved to Spuyten Duyvil, a move that shortened his commute but also deprived Mother of the space and domestic help that had allowed her to paint.

Any regrets about the move were short-lived. Through the efforts of his friend and colleague Karl Bitter, who did not want to leave New York, Father had been appointed Sculpture-in-Chief of the International Exposition scheduled to open in San Francisco in 1915. Plans for the Exposition had been completed and a six-foot table model, which showed the courts, buildings, and sculpture, had been built in New York. This was reportedly the first time that architects, sculptors, and landscape architects had collaborated on such an undertaking. Certainly it would be the first time that full-grown magnolia, olive, and eucalyptus trees were moved into place—a feat promised by John McLaren, creator of San Francisco's Golden Gate Park. In 1913 it was time to begin the actual work on the spot in San Francisco. So we boarded the train for the west again, overjoyed to be returning to California and very pleased that this time we would be living in the Bay Area. We speculated on the reconstruction that must have taken place since our visit in 1909, and had great fun with the names of the architectural firms with whom Father was to collaborate—Bakewell and Brown, Bliss and Fairweather (and Faville).

7

Father's position as Chief of Sculpture for the San Francisco Exposition brought him considerable administrative responsibility for the first time in his career. In addition to modeling many figures and groups himself, he was responsible for the execution of the overall plans and the appointment of the sculptors working under him. Expositions are stepping-stones for young sculptors, so Father brought with him several of his pupils as well as mature artists. Thus Ralph Stackpole and Beniamino Bufano came to San Francisco to stay. Bufano, then a young student, made such constant demands for money that Father came to regret hiring him. All the sculptors worked feverishly under simultaneous pressures to produce works of beauty and grandeur, to keep costs low, and above all to have everything ready for opening day.

February 20, 1915, was an appropriately bonny day. Full advantage had been taken of the magnificent site on San Francisco Bay. Spacious and elegant courts and avenues created vistas in all directions. Every court had a fountain, sculpture, flowers galore, and full-grown trees. The waters of the Bay sparkled in response to the Tower of Jewels, a major point of interest. The entrance to the Tower was flanked on one side by an equestrian statue of Cortez and on the other by one of Pizarro, symbolizing the linking of East and West by the Panama Canal. From the central Court of the Universe, broad steps led down to the Bay. There, yachts and other small boats could dock, and visitors to the Fair could sit and munch a sandwich. Water was used lavishly in the numerous fountains as well as the lake in front of the Palace of Fine Arts. Commercial ventures were kept out of

sight; nothing crass was to mar the grandeur of the Exposition. It was a lovely pink city in a magnificent park.

Sculpture depicting the nations of the East crowned the buildings along the eastern side of the Court of the Universe, others representing the nations of the West the buildings on the opposite side. Among the nations of the East, a mighty elephant was the central figure. He bore a palanquin on his tapestry-covered back, and was accompanied by riders on camels and horses and by standard- and fruit-bearers—all in Oriental splendor. The central group among the nations of the West was a covered wagon drawn by oxen and accompanied by Indian scouts and guides. Astride the wagon's whiffletree was *The Mother of Tomorrow,* while *Enterprise* flanked by *Hopes of the Future* crowned the top.

On the plaza immediately inside the main entrance rose the *Fountain of Energy.* Although Father had helped design and had collaborated on many other statues and groups, and was solely responsible for some (e.g., *The Mother of Tomorrow, The Flower Girl, The Star Girl*), the *Fountain of Energy* was wholly his own creation, a tribute to the completion of the Panama Canal and the joy of achievement. A globe symbolizing the planet supported a horseman. The evolution of mankind from lower to higher forms of life was modeled on the base, which rested in the fountain bowl. Around it the great oceans were indicated by figures riding cavorting marine monsters, and the lesser waters by sea-sprites playing on dolphins, which, heads down, sprayed jets of water to meet those cascading from the center. Energy, triumphant with the completion of the canal, sat astride a stallion, whose arched neck and uplifted hoof contributed to the overall feeling of vitality and triumph. The whole was powerful, imaginative, beautiful. It also proved controversial, for the figures of Fame and Glory, which sprang from the rider's shoulders, were criticized by some as too unconventional.

By interesting coincidence, another fountain of energy established Sandy's reputation as an original and creative artist. It was in 1937 that José Sert invited him to design a fountain to display mercury from the Almadén mines for the Spanish Pavilion at the Paris Exposition. Instead of a conventional fountain, Sandy studied the material and exploited its character and beauty by using iron bowls painted black with pitch. The unique fluidity of mercury which collects in a mass and then breaks led him to use a series of these black basins on

Father's FOUNTAIN OF ENERGY *was wholly his own creation.*

different levels. As the metal fell from one level to another, its motion moved a small mobile which proclaimed *Almadén.*

Although Father like Sandy believed that artists should spend their time working, not talking about their work, unlike Sandy he could give quite a fine speech when the occasion required. During the inaugural festivities at the Exposition he said:

> Sculpture is not a light accomplishment for the idle hour. It is the expression of persistent individuality in form, and as such is fundamental, not ornamental. . . .
>
> No matter how great past achievements have been, they do not satisfy permanently, much less arrest or confine the living perception and restless ambition to see and build ideals for ourselves. It is the men to whom their art means this who continually force new points of view and preserve artistic freedom.
>
> Such an assemblage of embodiments in plastic form of the fruit of the teeming brains of our young Art Nation, called upon to express itself—clamoring, exuberant, reflective, brooding and joyous by turn—is possible only on an occasion like the present. The result will astonish all.

For Mother, too, these were artistically fruitful years. After an operation to repair childbearing injuries, she turned the housekeeping over to Louie Li, rented a studio, and set to work painting everyone who would pose, including Margaret Schevill and Kenneth's mother and sister. She also painted my portrait (with tennis racquet) as a birthday gift for Father; my contribution was to pose without pay.

With the opening of the Exposition, Father's work in San Francisco was finished. Commissioned by the city of Oakland for sculpture in the arches of the new Civic Auditorium, he moved with Mother to Berkeley. Sandy, then in the middle of his senior year at Lowell High, wanted to finish there. This was made possible by Walter and Edith Bliss, with whom my parents had become very friendly while living in San Francisco. Walter was a partner in the architectural firm of Bliss and Fairweather, whose name had caused us so much fun. The Blisses had a handsome house on Vallejo Street, next to the Presidio, from which one could look down on the Fair and across the Bay to Berkeley. They had no children, and when my parents left San Francisco, invited Sandy to stay with them.

In Berkeley, Father and Mother often had their lunch on a patio

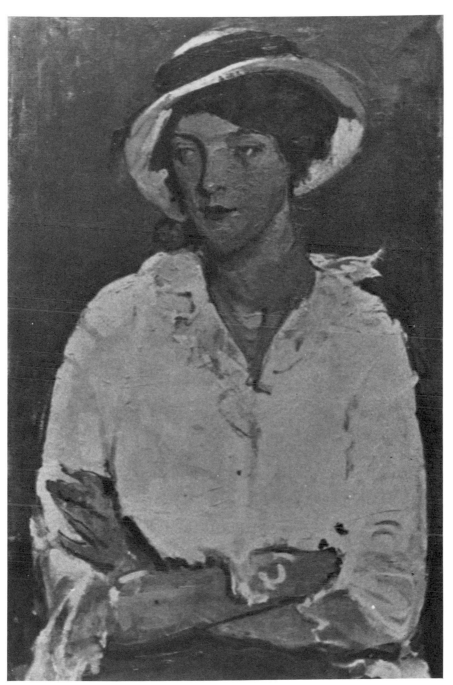

For Mother, too, these were artistically fruitful years. ELOISE

shaded by a large hawthorne tree, listening to Julie Culp singing "Chansons Indous." Half a block away, the Hayes victrola would be grinding out the latest ragtime hits, "When the Midnight Choo-Choo Leaves for Alabam" and "I'm Coming Back to California and You."

"Kenneth must be home," Mother would say. "I hear the hurdy-gurdy going." Al Jolson and his Honeymoon Express were performing at the old Curran Theatre in San Francisco. Father enjoyed Jolson's singing and also Kenneth's apt imitation of it.

When Father's work in Oakland was finished, my parents turned their faces eastward again. Desperate to remain in Berkeley, I announced—every other argument having failed—that Kenneth and I were engaged and wanted to be married that summer. I could then continue at the University of California. Mother's eyes filled with tears and her expression turned tragic: she and Father had expected to have me home for at least several more years. Less emotionally she pointed out that my education had not always been easy for my parents to pay for, but that they had wanted me to be as well prepared for life as they could manage. It would be unfair to them for me to marry and perhaps not finish college. Reluctantly, I promised to accompany them east and take my junior year at Barnard.

In New York we moved into an apartment on Claremont Avenue, near Barnard, and Father rented a studio on Fourteenth Street. He found it extremely trying to live in an apartment, separated from strangers by one thin wall. He still slept with all his bedroom windows open, and on Claremont Avenue, unfortunately, they opened onto a well with a phalanx of apartments opposite that fronted on Riverside Drive. Across the well there often echoed the din of raucous parties, including drunken obscenities, unartfully expressed. Often, too, the shades were left up, revealing behavior Father found appalling, particularly when he thought that Sandy or I might inadvertently witness the goings-on. One night, having endured all he could, he leaned out the window and bellowed, "Swine! SHUT UP!" Immediate silence followed, but the party was in full swing again when he called the police an hour later.

In the neighborhood drugstore one day, I met a former schoolmate from Ossining days. She was now married and living around the corner on Riverside Drive with her husband and baby daughter. Mother and I accepted her invitation to tea. On arriving, we found a sobbing little girl of eighteen months and a hard-eyed mother.

"Mercy me," Mother puckered up her mouth, "why all the tears?"

"She's got to learn." Gwen smacked the toddler's hands until her own were red. "She mustn't touch my things." Her defiant tone proclaimed, "She's my kid and I'll do what I like."

"But her hands! Not her hands! Here"—and Mother handed the child a gay crocheted yarn ball in which she had stuffed a tiny bell.

The baby stopped screaming but stood with her hands behind her back. "You may take it," her mother said regally.

Mother could hardly bear to stay for tea. She only did so for the pleasure of playing with the child, who was obviously delighted with the ball and with her. As tea was served on a low table, the youngster stood eyeing everything with round, scared eyes, her hands again behind her.

"You know," Mother began, clearing her throat, "the sense of touch is very important in your child's development. You are making her afraid of using her hands. I think it would be much better if you put your ashtrays up high where she can't reach them until she's old enough to understand."

We left as soon as possible. In the elevator, Mother sighed deeply and said, "I'm all jangled up inside. That beast of a woman! To think she was brought up gently and went to a good school. To be so savage with a defenseless youngster . . . her hands! You know, Peg, I've always had such pleasure watching you and Sandy use your hands. You are both deft, unhurried and deliberate, skillful. The way you used to put the butterflies in their boxes in Oracle and Croton, Sandy with his trains and making things. Even tying knots in string. That poor kid."

Our apartment became a meeting place for several graduate students from California who were attending Columbia. They were all very earnest about their part in a war-torn world, and spent hours discussing double standards of morality, the vote for women, minimum wage and child labor laws, and other pressing moral and economic issues of the day. When the great march down Fifth Avenue supporting Votes for Women was held in 1916, I strode along with the Barnard contingent in cap and gown. Sandy and his friends had threatened to throw firecrackers at us, but ended by cheering the marchers from the sidewalk.

Father was very upset in April, 1915, when his friend Karl Bitter was knocked down and killed by a run-away taxi as he stood in a

safety zone near the Opera House. Later, Father was asked to take over the creation of the *DePew Memorial Fountain* in Indianapolis, for which Bitter had been commissioned but had completed only the preliminary sketches. Father found he could not execute another artist's design, so he made a completely new one of his own. Oddly enough, this fountain, completed in early 1917 under the shadow of a friend's death, expresses youth and gaiety. Teen-aged children linked by garlands of seaweed dance around the basin of the fountain to the clapping of a cymbal held by a graceful damsel atop the central shaft. Luxuriant sprays of water gush from the mouths of frogs and fish, and cascade down from shells. The whole conveys a feeling of joy and happiness.

My parents stopped in Indianapolis to see the fountain on their return to New York from Aberdeen in the summer of 1917. In Washington, Father relaxed in the unaccustomed luxury of the Patterson home, happy to be sharing such pleasant surroundings with the rest of his family, and for the moment concerned only that the United States enter World War I in time to save England. He was pleased that Kenneth's step-father, W. J., agreed with him. It was because the two men got on so famously that Father and Mother then made the unfortunate decision to entrust their savings to Hayes and Hayes.

W. J. took us all to a logging camp. We rode through beautiful forests on a small logging train pulled by a rotary motor, our legs dangling over the sides. After lunching in the bunkhouse on the hearty fare required by the loggers, we went to the logging site itself. Not a tree was left standing on the hilly slopes. Trunks that had been tall, straight trees a few hours earlier were banged and shattered as they were hoisted over the high line; roots that a few days before had nourished a noble tree now groped skyward with spider-like fingers. No one seemed perturbed by the terrible waste. The operators were, in fact, jubilant: no one was threatening to strike, and the price of logs was high. Very quietly Father said, "This is unutterably sad. Man is the most ruthless and the most wasteful of Nature's creatures."

Shortly after my parents returned to the east, Mother, with whom I corresponded several times a week, wrote that the architect Paul Chalfin had invited Father to collaborate with him on the estate he was building on Viscaya Bay, Florida, for James Deering, the Harvester king. Father was particularly pleased to be brought in at the planning stage rather than asked to tack something decorative onto an already

Children dance around the basin to the clapping of a cymbal.
DEPEW MEMORIAL FOUNTAIN in Indianapolis

BROODING HEAD—never cast into lasting material

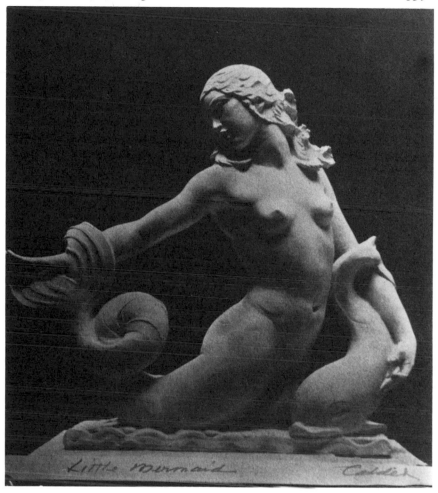

LITTLE MERMAID OF VISCAYA—the Deering Estate *Photo: DeWitt Ward*

CRUEL NATURE, a late work by Alexander Stirling Calder

Photo: DeWitt Ward

completed design. The following month Mother wrote from Florida:

> Mr. Chalfin and your father have decided on a teahouse made
> of limestone in the water with a walk leading to it that is made
> handsome by gaines along each side. Terraced steps lead down to
> the water. Your father is modeling a huge fish flanked by mermaids.
> The gaines, "Viscayads" they are calling them, are to be tropical
> people and there will be several smaller figures in the water and
> on the balustrades—a Sea-Mother and Little Mermaid. All pos-
> sible by millions made from farm machinery.

Some eight years later, the teahouse and water decor of this
sumptuous place were destroyed by a hurricane, but not before Father
had been criticized for the "indelicacy" of his full-breasted mermaids.
When she heard of the havoc, Mother rather reveled in the strength
of the elements which brushed aside man's puny efforts with such
ease. Father was chagrined but not surprised—Cruel Nature at work
again.

When World War I ended, a controversy arose over the form
suitable for a memorial honoring New York's dead. Father entered
the fracas. He wrote,

> The arch first offered meets the unanswerable criticism of being
> an obsolete imperial symbol of triumph in no way suited to express
> the bloody sacrifices of a free people in their combat against im-
> perialism. . . . Our aim should be to singly and solely create under
> a satisfying symbol a memorial that shall inspire Horror of War—
> the Joy of Courage—the Need for Law—The Pity of Humanity—
> The Obligation of Authority—The Patience of Effort—The Agony
> of Death and finally the Hope for the Unity of Nations through
> and by the Love of Mankind that must assure the future.

He submitted a sketch, but the Mayor's Committee rejected it in
favor of the "obsolete imperial symbol"—an arch to be placed at the
foot of Fifth Avenue, the entrance to Washington Square. The archi-
tects, McKim, Mead and White, commissioned Father to model George
Washington the Statesman for one side of the arch, and his friend
Hermon MacNeil to do George Washington the General for the other
side. As was his custom, Father set about studying the kind of man

GEORGE WASHINGTON THE STATESMAN, modeled for the right side of the Washington Arch by Alexander Stirling Calder, who stands at the foot of pillar.

George Washington had been. He recalled with wry amusement the saccharine perfections in his old history schoolbooks when he learned that the Father of Our Country had been a hard-drinking, hard-cussing slaveholder, reputed to have disapproved of slavery but not above becoming wealthy from it.

Then he set to work and was happy to find a model who suited perfectly. He liked this man, who one day while they were working suddenly collapsed. Father rushed to him and then to the phone for a doctor. When he returned, it was clear that the model was dead. Father was so unstrung by this experience that Mother had to summon a doctor to care for him.

During the winter of 1919-20, Father modeled a study he called *Brooding Head,* which although very beautiful was never cast in bronze. He also finished one version of *Cruel Nature,* but seems never to have realized a powerful group he called *Death and the Maiden.* That winter also, he and Mother were plagued by a series of bad colds. Friends were very free with recommendations. A typewritten page of instructions decorated all along the sides with sketches of the equipment he recommended was signed by Robert Henri. It was followed by a graphic drawing of the method he had found most helpful.

Disturbed over the debacle that followed "The War to End all War" (WWI) which nullified many of its declared objectives, Father wrote an open letter to President Harding.

President Harding:

Considering the list of offices composing the Cabinet, I am struck by the lack of balance in measures tending toward maintaining the peace of the world. There exists a Secretary of War and a Secretary of the Navy, both offices whose duty it is to be on the side of war-making. What is there to counter-balance these? Why no Secretary of Peace, to jealously guard against needless waste in hatred and war?

In 1920, Father was invited to submit designs for a *Swann Memorial Fountain,* planned as part of the Logan Square complex in Philadelphia. From those submitted, his *Fountain of the Rivers* was

FOUNTAIN OF THE RIVERS, Logan Square, Philadelphia.
Three figures recline back to back. *Photo: DeWitt Ward*

chosen. The three rivers running through Philadelphia—the Skuylkill, the Delaware, and the Wissahickon—are symbolized by three figures, two female and one male. As the figures recline, back to back, jets of water spray toward them from the mouths of frogs and fishes placed near the basin's rim. Other sprays arch over their heads. As a visual pun on the fountain's name, Father modeled swans behind the two female figures. A large fish supplies the spray from behind the male. In winter, these sprays of water freeze and coat the figures with a beautiful silver frost.

As he studied the swans, Father found them not only amusing but lovely, as they stretched their long necks for the crackers he fed them. Their postures suggested the small figure *Little Dear with a Tiny Black Swan,* which he created while modeling the fountain.

The models for the *Swann Memorial* were finished and at the foundry when he and Mother went to Europe in 1924, so Father did not see them in place until he returned. He was advised that the Fountain was stunning, and so eager was he to see it that he hot-footed it to Philadelphia even before he and Mother had found a place to live.

Even he acknowledged satisfaction with his handiwork. I was very thrilled when I saw the photographs, and wrote immediately to tell him so. He replied: "Your enthusiastic letter about my Fountain of the Rivers has given me much pleasure. I am glad it thrilled you for that is the quality Art must have to be Art. Did it thrill you because of itself or because I did it? Tell me that!"

On their trip to Greece in 1924, Father and Mother enjoyed the company of their friend Wilson Eyre, the Philadelphia architect with whom Father had worked on the Logan Square Fountain. "I enjoy and admire him," Father wrote, "witty, racy, and independent to a marked degree. He owes no man, is not a jobber in Art. Is refreshingly himself."

Mother's first letter, written aboard the *President Wilson* but mailed from Trieste, was forwarded to me along with some others by Sandy, who wrote across the top in India ink, "Aren't these fun?"

Dear Pegus and Sandy,
 . . . Three volcanoes in one day. Vesuvius-Stromboli and Etna. Vesuvius we saw until we were out of sight of Naples. Stromboli at daybreak with streaks of molten lava flowing red, red, red and a grand eruption. Just before it was light. Up at 7 to see our voyage

*As he studied the swans, Father found them not only
amusing, but lovely.*

through the strait of Messina . . . Messina to the right and Reggio to the left. . . .

Everyone admires your father. Even the men pay him compliments. . . . He is looking very well. All the crinkles gone, his face looks young and hair white. We are both browned by the sun. We came away without a watch, only the kitchen clock, which I bought and took with us when I took you two to Arizona. . . .

<div align="right">Mother</div>

On June 2 she wrote Sandy from Athens,

I have been feeling the desire to tell you to never let anyone persuade you to finish. This fine big Art here is in parts . . . but it seems as if the whole never got out of sight. It is all wonderfully beautiful, made so not only by man! . . .

Mr. Dinsmoor who teaches in the Architecture League at Columbia and is sent over here for research work is living at a country place near called Kephesia.

They asked us to dine on Saturday. Your father did not go. He was feeling so rotten so I was detailed to meet Mr. D. at the Acropolis. It was so very hot I had the whole place to myself. There is always a cool breeze on the hill from the Aegean Sea and I thoroughly enjoyed being cooled and looking at beauty.

Then Mr. D. came and we walked down, caught a bus. I only had tea with them and came back before dark. It was a treat to see the country and the Pentelicus Mt. from which they quarried the marble.

A few years later, it was clear that Sandy would need no urging to be selective in the content of his sculpture, to decide for himself when a work was finished. Indeed, it proved one of the particular marks of his genius to express so much with so little.

The spring of 1924 also saw Kenneth's mother sail off to Europe, stopping in New York en route. She had arranged to meet my parents in Paris. One of Father's favorite stories was of finding this stalwart Amazon standing irresolutely on the corner trying to get up enough courage to cross the street at a Paris *rond point*. Briskly he said, "Come along, Frank, or you'll be standing here till Doomsday," took her arm, and waving his cane imperiously, piloted her across without mishap. She, who called him the Earl of Fourteenth Street, claimed it was the cane that made the traffic part as the waves did for Moses.

My parents stopped in Algiers as they entered the Mediterranean. Mother was very upset over the recoaling of their ship by long lines of women who crawled up the gangplank with large baskets of coal on their backs: "like ants," she wrote, "too, too degrading." She was even more outraged when she saw children making Oriental rugs. "Pegus, little children of five or so, like our Bun, sitting before a frame tying knots when they should be out running around in the sunshine. Their eyes must be ruined by the time they are grown."

On the whole, however, despite such experiences, and despite Father's insistence on working during the three weeks they had in London (he bought plasticene and prevailed on her to pose), they had a beautiful, restful time. They stayed several weeks in each of the three countries that mainly interested them—Greece, England, and France—in addition to the two long, luxurious ocean voyages. In London, Mother visited the Tate Gallery, and wrote, "I wish you could see the water colors of Turner's, the Reynolds, as well as the other really good French things—Degas, Daumier, and all the rest—and Blake, Rossetti, and Burne-Jones, that I saw yesterday at the Tate." And *I* wish that *she* could have seen the Retrospective of her son's work that opened at the Tate just thirty-eight years later, in July, 1962, to the most laudatory reviews.

In 1924, however, Sandy was still getting critical reviews from his mother. On August 6 she replied from Paris to a letter in which he had enclosed some cards of his own design:

> Your letter last night sounded happy and gay and a bit wild. Especially the map of your phiz. I think the idea clever but not altogether well done—ear, neck, etc., should show nicer drawing but it is a *cute* idea.
>
> I'm, I was going to say *crazy* to see what you have been doing. Sounds breezy and a bit wooly (more slang). . . .
>
> I am enclosing a poster your father thought good. So it is, but not as up to date as many I see. They are not so attractive here as in Rome but they are very telling, which is a poster's first duty.
>
> There is such an old sewage smell about this place. I try to forget it but it gets into my nose. Sometimes I think Paris is one big pissoir. . . .
>
> Blessings, my boy. Are you not amused at my refraining from giving you advice?

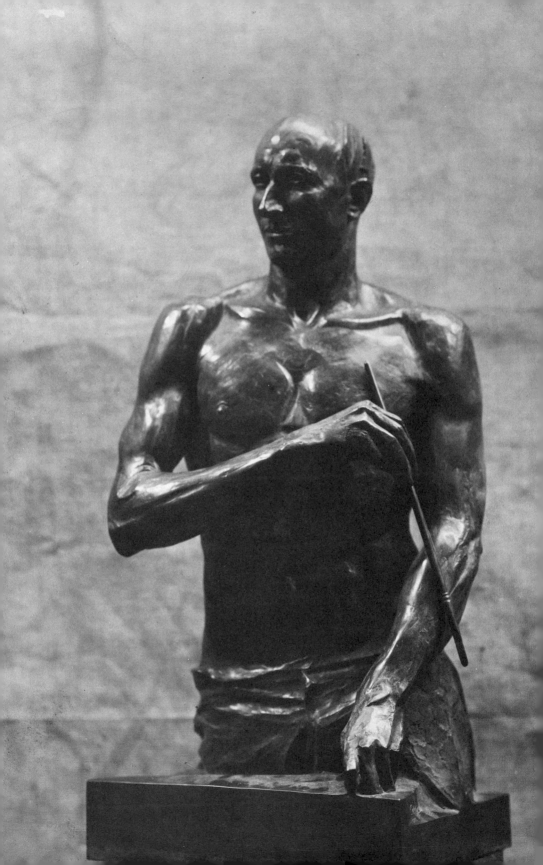

Although Father's athletic prowess was limited to wielding a cro-
quet mallet and floating on his back in a lake, he was very fond of
baseball and loved telling us of his friend George Bellows, a painter
who had once been a professional ballplayer. Bellows died just before
my parents set forth to Europe, so as soon as Father was settled in his
New York studio again, he modeled a three-quarters bust of Bellows
with brush in hand, a sculpture that expresses his feelings for his
friend's quality and character. It is now in the Arts Club, New York.

His first act on returning, however, was to dash to Philadelphia to
see his *Fountain of the Rivers* and to discuss with Wilson Eyre a
Shakespeare Memorial statue for Logan Square. As a Shakespeare
buff who memorized long passages from his favorite plays, Father was
very excited by this commission. He made several small models to
illustrate several different conceptions. One was a stage with a figure
in Elizabethan costume and the caption "All the World's a Stage."
Finally his design for *Hamlet and the Fool* was chosen by the Shake-
speare Memorial Committee. Father set to work happily. *Hamlet* was
his favorite drama.

Mother, restless and stimulated by what she had seen in Europe,
started attending a life drawing class. "We had a bully model today,"

*'I am trying to draw
with lines only, which
is difficult as I was
taught to paint—using
paint to model rather
than outline.'*
Photo: Nanette Sexton

*Father modeled a three-
quarters bust of George
Bellows . . . that
expresses his feelings
for his friend's
character.*
Photo: Chappel Studio

she wrote in the fall of 1924. "I am trying to draw with lines only, which is difficult, as I was taught to paint—using paint to model rather than outline." At the same time Sandy, searching for paying jobs, made some costume designs for his friend Martha Graham. Mother reported the outcome:

> Yes, that is Sandy's Martha Graham who is not going to use his designs. I suppose she could not get someone to pay, though she is applauded wonderfully by all. She stirs me though I cannot put into words exactly why. . . . She is anything but beautiful, and her costumes sometimes annoy me, but she gets a passion over to you. . . .
>
> I saw a bang-up Benares brass today in a shop on University. About 2½ ft in diameter on a little wooden table that had a leg to be mended. Those we have (animals, men, etc.,) are not Benares. $7.50. Your father tells me to look at it again before purchasing and he will give it to me for Xmas. . . .
>
> The *same old story*. We need coats and shoes but are intrigued by a brass table. Art is the finest element in life. It helps over the rough places. . . .
>
> This is a very critical time for Sandy, too. I wonder often what will happen. . . . His work is enthusiastic but it lacks so much knowledge that I did not get it the one look I had. And of course, I don't fall in readily with very modern ugliness. He understands. I have just come from the best in the world and it is difficult to admire. Your father said he saw some washes [watercolors] he thought were very good. S. takes a large canvas and brushes in but does not run it to the limit. We must be patient. He is in Robinson's class in the evening.

Mother and Father had long yearned for a house in the country. They knew it would be good for Father's health (he had been feeling poorly again) and for Mother's spirits. After returning from Europe they searched in earnest and found a house in Massachusetts between Pittsfield and Lenox which pleased them. It had been a farm built in 1824 and boasted apple orchards. Father built a fine, big studio on the brow of a hill facing toward the Berkshires, overlooking meadows of wild strawberries that fried in the sun, giving off a most delicious aroma. Mother planted a garden. Apart from furniture and personal belongings, this was the first property my parents had ever owned.

The idea was that they would live there permanently, going to

New York by train when occasion demanded. But stoking the furnace in the cellar and hauling wood for the fireplaces proved too arduous for a couple in their late fifties. Father also found it difficult to keep in touch with his various projects and commissions from the country. So for the next few years they spent the winter in New York, returning to the country in the spring. In the city Mother was inclined to read rather than to paint. "Your mother is becoming a bookworm," Father wrote me. "Ever-inquiring, she delves into all our old books— Epictetus, Old English drama, French verse, Marcus Aurelius. All is grist to the still-curious mind that draws practical conclusions quite her own."

"Your father," wrote Mother, "is not well. So he has been sent to a specialist . . . a very nice person. His hobby is urine."

Their rather tranquil existence was shattered in the fall of 1926, when the husband of a model irately claimed that his wife's face was recognizable in Father's nude statue *The Last Dryad;* he demanded recompense and threatened to sue. Father had entered the work, a poetic, life-sized figure, in an exhibition, but hastily withdrew it on the advice of his lawyer. He never again showed or enjoyed it. Eventually the case was settled out of court with no payment to anyone but the lawyer, who persuaded the blackmailing husband that Father was no rich playboy but a short-of-funds, hard-working artist. The man dropped his suit, but not before my parents had suffered deep distress of mind at the threatened besmirching of their name.

For the next twenty years, *The Last Dryad* rested in Father's studio, where it was admired by all who happened in. After Father's death in 1945, Mother and I gave the statue, impossible to set down in our steeply sloping Berkeley garden, to the University of California. After a two-year rest in the storehouse, it was placed in an inner courtyard of the Women's Gymnasium by a university committee that considered nudity unsuitable for a coeducational campus. When I asked about it twenty years later, however, a new university committee expressed surprise at their ignorance of the statue's existence. With Chancellor Bowker's enthusiastic consent, they had it moved to Faculty Glade, where it looks as a last dryad should, against a background of rhododendrons and trees.

At the time of the threatened lawsuit, Kenneth and I were inclined to treat the whole ruckus as a lark. Everyone in the family and many of Father's friends had posed for him repeatedly and considered it an

Alexander Stirling Calder in studio, LITTLE MERMAID OF VISCAYA behind him; LAST DRYAD with back to camera, LITTLE DEAR WITH TINY BLACK SWAN to right

An impromptu position taken by the model. STRETCHING GIRL.

Photo: DeWitt Ward

honor, and we knew that he never deigned to work for mere likeness except when commissioned to model a bust of a specific person. Furthermore, we thought it a great opportunity for some publicity, about which we considered him terribly backward. Work of far less importance, some by his pupils, seemed to make the headlines more often than his. New friends in Berkeley, even those engaged in art, knew nothing of his role in the San Francisco Exposition of 1915. No one appeared to know about the arches at the Oakland Auditorium. Getting commissions was a tense and agonizing performance for him, which grew no easier with the passage of time. "If only I could be his manager," moaned Kenneth. "It's ridiculous that he refuses to move onto the center of the stage." But refuse he did. When I wrote with plans to make his name more widely known, he turned them aside. "You are right about publicity," he wrote me, "but I do not think it means attracting work. I've been rather careless of my opportunities, but the fawning after public acclaim is disgusting." Sandy's more relaxed, straightforward attitude toward such matters certainly did his career no harm.

While the threatened lawsuit was still pending, Father was commissioned to model life-sized statues of several actresses for niches in the I. Miller building on Fifth Avenue. Included were Mary Pickford, Ethel Barrymore as Ophelia, Rosa Ponselle as Norma, and Marilyn Miller in her Yama costume. Although Father enjoyed his contacts with these stars, he was unhappy about the placement of the figures in niches around the cornice. Such treatment did not qualify for the purposeful integration of architecture and sculpture that he advocated. "Pediments, friezes, spandrels, medallions, niches—limit the sculptor to designs that will fill these spaces, and necessarily force a general resemblance in all such designs." Father responded more creatively to the interaction between an interesting model and an idea suggested by a book he was reading, or simply to some impromptu position taken by the model herself. It was such a spontaneous pose that had inspired the ill-fated *Last Dryad,* and also the smaller *Crouching Girl* and *Scratching Her Heel.* This last little bronze was bought by the Metropolitan Museum of Art.

Before finishing the I. Miller figures, Father entered the competition for a larger-than-life-size marble statue of *Our Lady and the Holy Child* for St. Mary's Church in Detroit. For his winning entry, he used the statue he had modeled more than a decade earlier in Croton for which the gardener's wife and her baby had posed.

The quest for commissions, the nervous waits in between, continued. "We have been living among frequent alarms of big jobs ahead," Father wrote me in January, 1927, "with no results so far but watchful waiting. Business is nervous and so am I, when I think of it, which always happens when I balance my accounts—*les mauvais quarts d'heures.*" Thirty years of such anxieties took their toll. When Mother wrote me complaining of Father's moodiness, I replied with sage advice to her and reproaches to Father. He answered, "It would be a lie to claim that we are happy, but it is only the lack of money that makes us so. When there is a rift in the gloom we bob up promptly. There is just a chance that I may connect with a commission. That will be a bracer." By the fall of 1929, he was feeling more cheerful. "My studio has now a pink interior," he wrote, "and I am pleased with it. When I have one of my waves of energy that makes life worthwhile, all seems possible." He had won the competition for the monumental statue of Leif Ericson that was to be a gift from the American people to the people of Iceland, commemorating the 1,000th anniversary of the Althing, the Icelandic Parliament.

Negotiations on the contract were disconcertingly slow and tedious, requiring Father to make several round trips to Washington in the winter of 1929-30. Between rounds of negotiation, he made small sketches and models of Leif, read up on Norse history, and of course fretted. "Your father . . . has a conference with an architect about the base of the Ericson," Mother wrote. "As yet, they have not sent him the contract, but he hopes to do the one-third or one-half model, so that next winter he can work on the full-sized, big one, here [in New York]. It would be calming to have the contract come." A few weeks later she wrote happily, "Our Gov't has finally sent the contract for the Leif Ericson. Now it is up to your Dad to sign and do. A job for the next two years. With all its work and worry. So here goes. He seems very happy about it and expresses more than usually."

Father had reason to be happy. His statue of the explorer, one of his major works, was to stand east of the Parliament Building in Reykjavik, enveloped in clouds and surrounded by green hills. On dramatic occasion, the clouds part enough to disclose his Ericson, bronze patined with gold and mounted on a pink granite shaft suggestive of a ship's prow. For a man who had loved drama all his life, the opportunity was incomparable.

Indeed, so absorbed was he in the project that he rued having to interrupt work on it to attend Sandy and Louisa's wedding in January,

1931. "I wish they would not make us go to Concord," Mother wrote me. "It is really hard on Father, though I am the only one he will tell it to. You see his work is in clay and if it freezes all his work and thousands of dollars will be lost. So he won't go with an easy mind and he says he has lost ten lbs. already." A few days later, on January 12, Father wrote, "I have to go to Concord for the wedding after all, or else explain once more and I detest explanations about 'me and my work.' . . . Perhaps it will do no harm to get away from the task for a day."

The clay did not freeze. Father continued to work on the model through the spring, then let it sit for a while to be sure all was as he wanted it to be. As often happens, great effort was followed by a letdown. Mother was called in to make suggestions. "Your Father says he is at the end of his tether. The Leif is really fine and I told him so. Of course, offering a few minor criticisms. He says that I think it fine because I reckon his effort, but that is not so. . . . He seems very spent." Finally, in the summer of 1931, the clay model went off to the Roman Bronze Works in Brooklyn for casting. A few weeks later he and Mother went to the Brattleboro, Vermont, marble works to inspect the base. Mother reported, "The base is gorgeous. I can still see your Father's start of pleasure and it brought tears to my eyes it was so grand. Nothing in any country I know like it but in Egypt and Greece. That is going some, I know. This great prow is pink granite. Simple lines and fine proportions. Your father designed it."

Father, recalling what had happened to Grandfather's statue of Penn, worried about the installation, and asked Sandy, then in Paris, if he and Louisa would be willing to go to Iceland that summer to supervise. Sandy expressed enthusiasm for the venture, but in the end a young sculptor from the Roman Bronze Works went instead. "The owners of the works were so proud of it they themselves invited people to see it," Mother reported. "About five hundred came the evening before it was taken down and prepared for boxing." In August the statue and its custodian went by ship first to Copenhagen, and from there via another ship to Iceland. The base and the figure were installed without mishap, just as Father had planned them. Father himself never saw Leif in place.

His statue of Ericson brought Father the Gold Medal of the Architectural League of New York in 1932. After the presentation of

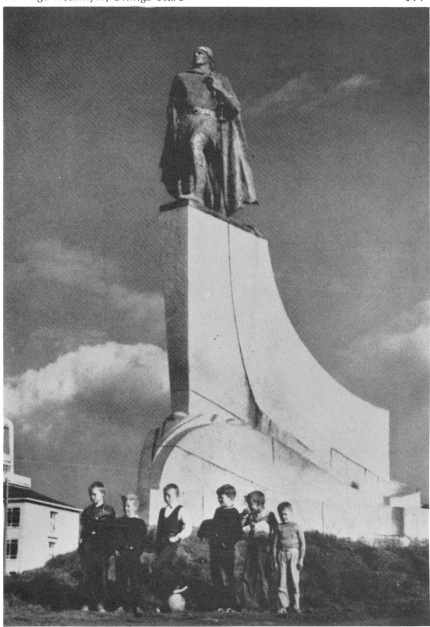

The Leif is really fine. The base is gorgeous. It brought tears to my eyes it was so grand . . . Prow is pink granite.

the medal at the gala dinner, Mother wrote, "Karl Bitter wanted to give your father this medal twenty years ago for his statue of *Our Lady*. Later your father resigned from the League, in disagreement with their policies. So the years rolled on. The Leif has made them wise that he can compose and has sentiment." Twenty-eight years later, in 1960, Sandy too was awarded the Architectural League's Gold Medal.

Father's medal was modeled by his friend Hermon MacNeil. He won another award the following year, from the National Arts Club. In accepting the Club's prize, Father said:

The receipt of a prize always raises a question that I have debated with myself for years. This is the question of whether or not it would be better to abolish prizes in exhibitions, and virtually adopt the Independents' attitude, with their slogan, No Jury–No Prizes. The giving of prizes does, in a way, raise invidious distinctions. It picks out a few at the expense of the many, and that has some aspects of injustice. But consider what happens at an Independent Exhibition. Although no prizes are awarded in the usual way, nevertheless a certain few works are chosen by the spokesmen of the exhibition, to remark, to extol, and to advertise, while the great numbers are overlooked; and this is virtually awarding choices. So long as some few are spoken of and the others ignored, that is making a choice. That is saying what the choosers prefer. This is finally precisely the same as awarding prizes, although no reward passes immediately. So I am reconciled to it as being essentially human and necessary in this very choosey world in which we live.

That beautiful saint and delightful artist, Robert Louis Stevenson, wrote a few words that mean much to me—and I think to you. He wrote: "To know what you prefer instead of humbly saying amen to what the world tells you you ought to prefer is to have kept your soul alive." Year after year through boom and depression, the National Arts Club steadily continues to preserve its soul by persistently proclaiming what it prefers.

Father was most indignant when a controversy arose over Frederick MacMonnies' group *Civic Virtue,* which drew a storm of criticism before being removed from Civic Center Park in New York in 1929. He wrote an open letter contending that the imagery MacMonnies had

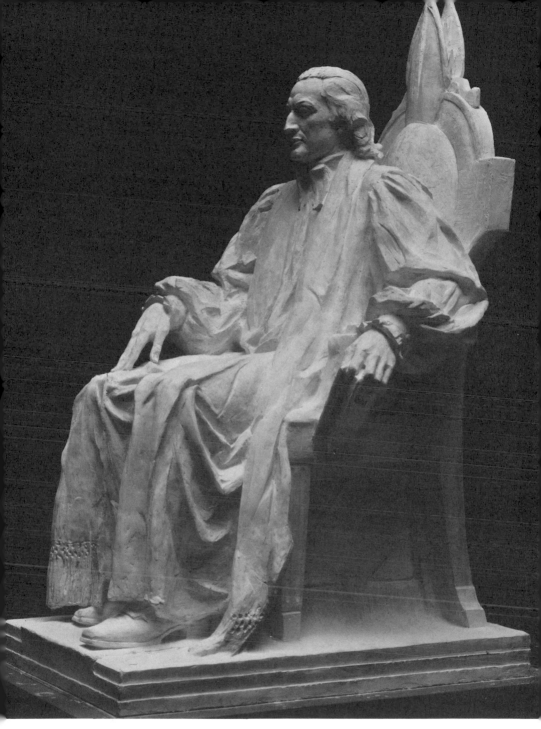

Alexander Stirling Calder's last large commission—a marble statue of Bishop William White who became the first Episcopal bishop of Pennsylvania in 1787

used in the group was more appropriate than "a realistic group of men in frock coats." And he blamed the city fathers' stupidity and ignorance of beauty for MacMonnies' early death.

During a visit to Pittsfield in the same year, I was lolling in a chaise longue reading *The Well of Loneliness,* a beautifully written story of a lesbian relationship. Father thought the pose suitable for a small tanagra, so he modeled as I read.

The suffering caused by public censure and ostracism made me indignant and I said so. Father put down his modeling tools and said, "It's all very well to be detached and rational about it, but one's emotional response sometimes is quite different." He continued, "Once I was accosted by a man on the Boulevard St.-Germain while on my way to meet your mother. I didn't hear what he said and so turned and inquired. He repeated his invitation and my instant reaction was to swing on him with my cane. Luckily he was quick and I didn't hit the poor fellow."

I insisted that so long as no one is harmed, such relations are no one else's business. "You may be right," conceded Father. "There's

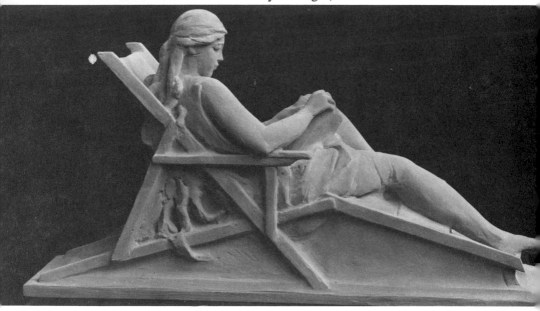

I was lolling in a chaise longue, reading THE WELL OF LONELINESS.
Father thought the pose suitable for a small tanagra.
Photo: *Walter Russell*

supposed to have been a lot of such goings-on in Greece and Rome. Didn't seem to hurt them."

"Miss Underhill never told us that!" And we both laughed at the mere thought of Miss Underhill, my teacher of ancient history and Latin in Ossining. One day I had told her that I rather liked Alcibiades. "Why, Margaret!" she exclaimed in horror, "That *rake!*"

In art, as opposed to life, Father was not troubled by sexual references, no matter how explicit. He admired Sandy's ribald illustrations of Aesop's Fables for their merriness as well as for the skill of their drawing. A few years after our *Well of Loneliness* discussion, in the early 1930's, the San Francisco Museum held an exhibit of works by members of the Abstraction-Création group, including several of Sandy's *cire-perdue* objects and paintings by his friend Miró. Some of Miró's shapes really bothered me; I was amazed at their resemblance to parts of the body not usually deployed so prominently. When I asked Father if he thought viewers were being laughed at, being made to look at parts of the body usually considered taboo, he replied, "Umm, maybe. But does it matter?"

Father was consistent in preferring Art to life. In January, 1928, he had written me, "One of my youthful favorites died yesterday. Thomas Hardy. How I used to live in his tales, more real and charming than reality, because they are Art . . . which is a memory of reality and more charming because time has cast a glamour over the defects of the moment."

Another family reunion was held in Pittsfield in the summer of 1933. Sandy and Louisa came after a brief visit to Concord, as Miss Bragg had invited Sandy to show his motor-driven mobiles at the Berkshire Museum. I watched with wonder as he and Louisa prepared for this first showing; polishing wires, adjusting motors, and tightening up strings that had become loosened during the voyage from France.

Sandy went to the museum ahead of the family and met us at the door with his broadest grin. The usually hushed museum was filled with strange buzzings and whirrings. The whole show seemed strange and somehow exciting. But was it sculpture, I wondered. Father tucked my arm under his as we left.

"Well, Pegsy, what say? Has Sandy got hold of something?"

"Oh! I don't know. It's all so different!" The mobiles were curiously evocative. One little one that went rig-a-jig-jig made me think of a

tugboat or a fussy little lady. Father liked a languid one, reminiscent of kelp undulating in the ocean current. He was bothered by the use of motors, which, he pointed out, were subject to breakdowns and would be difficult to arrange outdoors.

Dinner that evening was lively. Sandy expanded on his theories and hopes. Father, clearly interested, stated his doubts about durability. Mother concentrated on feeding us, casting glances at the wire flower and fish tank on the mantel, presents from Sandy. Both she and Father considered the flower "the essence of Art," as he put it, "without an unnecessary twist, perfectly organized and perfectly executed. Beautiful." The fish tank, a 1929 Christmas gift, was also made of brass wire, this time fashioned in the shape of a tank. It had two little segmented fish, which wiggled when a crank at the bottom of the tank was turned. There were waves indicated near the top, and water plants with spiral leaves in one corner. Mother loved it. Everyone hooted at me for wondering aloud whether these objects could legitimately be called sculpture, which I thought of as something made of bronze, marble, wood; something massive. "What an ignoramus out of the west!"

We all went to bed that night, our heads whirling with new ideas. Sandy seemed to be fulfilling Father's prophecy of 1915, when he declared at the opening of the Panama Pacific International Exposition that another young Art Nation was struggling to be born. Sandy himself soon tired of the motor-driven objects; their predictability and repetitiveness did not satisfy his vision of colored shapes floating in space. His fondness for the elements led him to think of how perfectly balanced objects moved in the air, and he was on his way. Later, in 1974, he returned to this discarded concept with his motorized mural for the lobby of the Sears Tower in Chicago, *Calder's Universe,* a smaller version of which provided the introduction and title for the Whitney Retrospective.

'The essence of Art. Without an unnecessary twist, perfectly organized and perfectly executed. Beautiful!'—Alexander Stirling Calder.
BRASS FLOWER
Photo: Colin McRae

Art Becomes Mobile

PART III

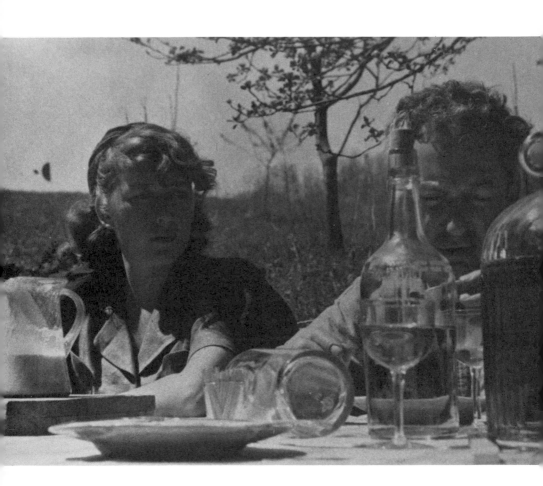

8

Sandy went to Paris by way of England. Passage on the freighter *Galileo* took seventeen days. Guessing correctly that his parents would be eager to know how he had weathered the voyage and what his first impressions of Europe were, he began on shipboard a long letter, which he finished on landing. He also wired ahead to Bob Trube, a friend from Stevens, then working in London.

Sunday, July 18, 1926 9:00 A.M.

Dear Mother and Father,

I am sorry my departure was so abrupt. I wish I had been more gracious in my farewell. But it was quite unexpected—leaving with three hours notice.

. . . There were eight sailors, six who take the wheel, and myself and a kid. The six have watches of four on and four off. At night the watch consists of two hours at the wheel, one lookout, one standby (below, but subject to call by a whistle). During the day, seven to five, when on watch, but not at the wheel, they work along with the kid and me, who are "daymon," i.e., we turn in at seven, work until eight and from nine until twelve and one until five with breakfast and "dinner" in between. At three, everybody gets tea. I have managed to survive though at times the food has not been so good. . . .

This isn't as good as the Alexander chiefly because there is no chance to swipe fruit, etc. The steward holds his job on the basis of his economy and this particular one has been thirty or forty years in the service, and can think of nothing more delightful than "bully beef" or "salt pork" and mashed or boiled potatoes three times a day, prunes

and rice twice a week and duff twice. Duff is a lump of soggy dough with currants. Comparatively pleasing, but apt to be disastrous as it is highly waterproof. Not as grand as it sounds.

There are some twelve or so in the blackgang. They live in the port side, and we in the starboard side of the foc'sle. The foc'sle is that part below deck right in the bow of the ship.

The berths are double deckers. I have the top. There are two vents for us as can be seen on deck, but no trace is felt of the fresh air that is supposed to enter thereby. So I at first fashioned a "windchute" from a tin can and slept comfortably the third and fourth nights, but the wind shifted and the chute would no longer operate and they insisted that all the ports be closed as we might ship sea. So I again suffocated. Next day, inspected the wheelhouse on the poop. And now I repair thither nightly with my mattress and blankets (all new) and sleep among the steering gear.

There seemed to be some possibility of my sliding into the steering chains if the ship should roll, so I tethered myself to the base of the extra steering wheel so that I couldn't slide all the way. I might have tried the deck but there was no shelter suitable, and we were apt to run into rain on short notice, altho we had very little, on the whole. . . .

The bo'son, an old fellow, has directed our work of painting ship—practically everything but the hull and masts. It, the work, was pretty good fun up in the air, scrubbing and painting. They put a heavy oil on the deck, which works in under the rust and scale and lessens it, so we didn't paint it.

No painting, etc., is done on Saturday afternoon or Sunday, so I have had those previous off and have waded through about thirty pages of Brieux [Eugène Brieux, French playwright]. Father and I read it last summer, so I have a faint idea what its about. I find the dictionary quite complete, only three or four words not being available so far.

One bright sunny morning in mid-ocean, somebody called down "porpoises" and I came up and enjoyed watching them play about the bow. They are tremendously swift and can distance any ship with ease. They seemed about seven or eight feet in length, torpedo shaped. And the tail seemed to do all the propelling, as the top fin projected out of the water, especially when they leaped. But I guess they used everything they had. They would overtake the ship and scrape their back against the prow. . . .

Practically the whole crew is Yorkshire (chiefly Hull) and each one in the foc'sle has a different twist to it, sometimes completely undecipherable to me. The sailors, and the firemen, too, have seemed to spend most of their time off in speculating and arguing as to whether we would reach "Hull in time for Sunday dinner."

We may get in about midnight tonight. But if we don't get there by one A.M. we will have to wait 'til high tide, (Monday noon) as the docks are artificial and closed in by locks which open only at high tide. . . .

It was rather spectacular sighting the Bishops. Just as one has become almost convinced that there isn't anymore land, in spite of all the geographies, we are told to look for the Bishops light at Landsend. We look and look and think we are being kidded and then think we are mistaken when we see a thin vertical white streak. (It was still twilight and the light was not yet on) at last the thing grows into an immense column.

We passed some two miles off, and the lighthouse looked about one hundred feet high, altho that may be a bit too much. I awoke at four this A.M. in time to see the famous white cliffs at Dover, of which you read to me at Linda Vista, when I had poison oak.

The sun was just coming up and at one level it made the palisades glisten. I don't wonder that the people on the continent tried so often to conquer the island. Dover and Epson looked quite interesting from the water. We have been out of sight of land for some time as we are making a bee line for Hull. . . .

The channel was dotted with lights and light ships, and the way is marked by them now, so it seems quite friendly now after having passed three or four days when we didn't see a ship.

I took the wheel several times, not to become proficient in steering, but to get an idea what it is like. Of course, I had a man by me to coach me. There seemed to be a sort of gambling interest in it, especially in a following sea, when it is difficult to hold the course, as the helmsman must always anticipate the fluctuations in the ship's direction. . . .

We didn't reach the 'umber (I have an idea there is an H) 'til two A.M., which was too late for the tide. So we are anchored in it, awaiting a high tide and a tug. On the starboard is Yorkshire and on the port, a bit more distant, with a large tower looming up, is Lincolnshire. It's probably about four miles wide here and looks like the

Schulkyl. It's funny to have the ship so absolutely at rest. I had an idea she was on bottom. . . .

The close quarters with the Yorkshire has been fun, and the men (there is only one older than I in our foc'sle) very decent and genial. The poor devils don't seem to know much in any direction, and even though they make very positive statements and back them up with round oaths, they are never positive about anything. The other night I was up in the bow talking with the look-out, and he (twenty-two years) said "She's *foine,* is 'ull! Big!" I said, "How large? How many people?" "I don't know exactly, but she's up in the thousands."

The mate (i.e., first mate) has been quite interested since he heard that I was an artist—I showed him my stuff last night, all I have with me. . . .

<div style="text-align: right">

Love to you

Sandy

</div>

A wire from Bob Trube awaited Sandy on shore, expressing great pleasure in the prospects of a visit. Sandy spent three days in London with him before catching a boat to Paris.

It was another week before he found time to write of his adventures. When he did, his letter gave his parents such pleasure that Mother sent it to Walter and Edith Bliss in San Francisco to read and then send on to me in Washington.

<div style="text-align: right">

Hotel de Versailles

60 Blvd Montparnasse,

Parix XV

July 26, 1926

</div>

Dear Ma & Pa,

I haven't written to you since Hull as there hasn't been much time for doing so. Hull has something like 5 docks (closed in by locks to maintain the water level when the tide lowers the river Humber). The Humber is a great, broad muddy looking affair with no particular hills visible anywhere abouts.

We were towed and steered into the dock by a couple of powerful tugs, and they also warped us into place more or less and then a gent in a row boat took a hauser from our stern some half block to shore, and we wound it in on a winch and pulled the ship alongside. It was really quite a job as there were lighters all about like maggots loading

ships and the lighters, although not bumped, were packed after us and nearly broke loose at times. The ship marked X [in accompanying drawing] was a Greek grain ship, an immense affair, with Greeks hanging about the foc'sle, but Yorkshire longshoremen and 2 men who were on 3 lighters alongside her had a terrific time keeping them from breaking loose. I worked at the stern when we were mooring up. I think we ran 5 steel cables to the shore and then cinched them up and wound them round "the bits." It must have taken about a half hour after we were alongside and by the time we were through hundreds of longshoremen had swarmed over the gangway and brought ropes and locks and were arranging the rigging and practically all the hatches were off by the time I left. I got some hot water and washed and got into my shore clothes.

By the time I left there were 5 men who had entered the foc'sle and were looking for abandoned gear (clothes).

I may have told you of my baths on deck in the bow. They were great. Hot water and soap and finally you lift the bucket and pour all the rest of the water over yourself. Use a towel a bit and then stand in the breeziest part of the deck and dry off. It takes no time (2 or 3 min.) and you feel like a Rockwell Kent drawing.

There was one fireman in particular who I used to like to watch dumping ashes over the side. An iron bucket a little larger than a nail keg comes up on the hook and must be toted to the side and dumped into the sea. This fellow was 6 ft. 2″ or so and had a fine back and arms, which were shown off to advantage as he lifted & carried his load. His hair was pale brown and mussed and his teeth were like [the Tetons]! Both of them and his expression fierce—well, the last night aboard I passed the galley and noticed him there. So I entered, & found him trying to heat a dinky little flat iron enough to iron a soaking wet collar, over which he had placed some three layers of newspaper. He would try ironing, and then wash it again to get another smudge out. Next morning he told me he had washed and ironed it 4 more times and then had burnt it. Isn't that the height of mildness? . . .

Hull, being the first town I saw, interested me then, but probably wouldn't so much now. There are a few rather fair spots. But its like a quainter, more medieval form of Yonkers. The old moat within the city has been widened into a canal, and there is also some muddy stream, more like a slough, which rises and falls with the tide (15 or

20 ft.). I saw this creek at low tide and the middle third was water and the barges and fishing boats were resting on the mud. There is a very large flour mill there, also on this stream, and it is composed of 2 fine big buildings. Red brick about ten stories with one wall blank and with vertical flutings on it, a tapering roof and a battlement tower. Really quite swell.

I went to a show, took a walk and turned in. Next day I was paid off just in time to catch the 12 noon train for London. All the crew was there, in its best shore clothes, high stiff collars and all. . . .

English country is a bit flat for my taste. New mown hay smelled good.

I spent an hour or more finding Bob's office after 4½ hours on the train. . . . He seemed quite happy to have someone new turn up and we had a very pleasant 3 days together. . . .

Bob was busy all day—so I wandered about alone. Went to the National Gallery and thought most of the Rembrandts, self-portrait as an old man and the Woman Bathing. Also an El Greco with some mustard green yellow and some crimson. I think he's really the boy! Also that Goya of the Donna quelque chose. Didn't think much of the English. John is clever. There was someone—H. Lamb—who had a little stuff. Then I went to the Tate. Liked Blake and Hogarths were amusing. And the modern French wing had some samples of swell things. Seurat's bathing scene. And a study for "le Balcon" by Manet. Practically all the English stuff seems to be of a cheap, "illustrative" nature. Perhaps the rosey cheeks on their country men and women impelled them to shoot that way.

I went into Hyde Park and saw the Epstein. I think it a very rich piece of relief, the same way I thought of it when I saw that cut in the N.Y. Times. . . .

I also did the rounds of Westminster, and of the Tower of London. The latter is pretty much of a frost as they've spoilt the layout with service roads, and parts of it look absolutely new tho they have some handsome 15, 16, 17th century armor there. . . .

I left from Victoria Sat. 10 AM for New Haven, Dieppe, and Paris. . . .

Dieppe was very amusing. It's a small town with some rather large buildings (hotels, I guess altho not a very popular place as a resort) facing the water. The harbor is a little pocket and as it was low tide the wall tops came just flush with the upper deck. . . .

Bob [Trube's] mother and sister Maude are in Suisse, but he had written his dad to look out for me. So I got a room here at 35 f and am on the 7th floor with a French window that gives˙ fine light and air, and a red rug and brown wall paper that would knock your eye out. Also an upright piano.

Mr. Trube was very cordial and claimed he had been languishing for someone to dine with so we went somewhere across the way (we are à côté de Gare Montparnasse) and had a "yum yum" (Mrs. Hayes) dinner. I was introduced to frais de bois yesterday and of all things whose measly looks belie their delicious taste these are it!

Later (still Sat. eve) we walked up and inspected a couple of cafés that do all the student business (a few blocks from here). Whom should I spy but the ubiquitous Soto [a model of Father's, who tried and failed to make a go of it in Paris], having a plate of cream. He sent his regards and added something that was 90% Cuban, so it has escaped my memory.

Bob had been rather embarrassed when I assayed to sketch, so I desisted, but his dad was quite amused. . . .

Bob insisted on being my host. Said it wasn't often that anyone came to London. No word from Sam and Narcissa. They're in Bizy-Vernon. Longmans Green will send some books to Father when the volume comes out. [*The Bison of Clay* by Max Begouen, for which Sandy did the dust cover.]

<div style="text-align: right">Love to all,
Sandow</div>

The Sam referred to is Samuel Chamberlain, etcher, photographer, author, who with his wife, Narcissa, formed a gourmet publishing team. Sam took the photographs, made the sketches, and wrote the text, while Narcissa tested the recipes and translated them into usable English. They were just starting this career in 1926. As it happens, Sam was born in Aberdeen, Washington, where he and Kenneth were schoolmates. Sam's father, Doc, was an old curmudgeon, not only an able physician, but a monarch in his bailiwick. As he delivered her third child, he asked the fifteen-year-old unmarried daughter of Aberdeen's "Kallicut Family" about the father. "Well, Doc," she answered, "I don't rightly know his name, but he had on a white sweater." He tied off her ovaries—an illegal act in Washington in the 1920's.

Sam went to M.I.T. in Cambridge, Ken to the University of Cali-

fornia. They met each summer in riotous reunions. Sam had a ribald, easily activated sense of humor. He also played the piano by ear. Kenneth would sit beside him egging him on by singing "Vamp a Little Lady" and beating out its jazz rhythm on the piano with two unfortunate knives. Sam was one of those friends who made living in Aberdeen thinkable. When the United States entered World War I, both he and Kenneth enlisted, Sam in the French ambulance corps and then in the French army. When the war was over, he returned to visit Aberdeen in a handsome powder-blue French uniform with a red stripe down the trousers. He brought his beautiful young wife, Narcissa, whom he called "Biscuit."

Sam returned to M.I.T. to teach. He became a distinguished etcher and photographer. He and Narcissa were living in New York when Sandy occupied the long, narrow little room west of Fifth Avenue in a Puerto Rican neighborhood. Sandy painted it to look like a jungle, hanging real bananas and oranges on wires. He affixed a sundial to the window sill and made wire racks to hold his equipment. In his *Autobiography,* Sandy describes the sundial as his first animal made entirely of wire.

Narcissa posed for him sitting on an orange crate, which may account for her belligerent expression in the portrait. She and Sam made frequent trips to Europe and were in Paris when my parents visited in 1924, just after the birth of their first daughter, Narcisse. When Sandy arrived in Paris, the Chamberlains were traveling around France in an early Fiat. Sam was sketching and etching castles, chateaux, barns, rivers, village squares. Besides taking charge of their small daughter, Narcissa was collecting the recipes that were later published in *Bouquet de France* and in the calendars the Chamberlains published annually. They invited Sandy to join them on their sketching expedition.

Kenneth's sister, Jean Partridge, was also traveling in Europe in 1926. She had joined Cody McMicken, W. J. Patterson's cousin, at Etrétât, a little seaport town. Sandy wrote them suggesting they too join the Chamberlains at the Auberge du Vieux Puits.

<div align="right">

Auberge du Vieux Puits
Aug. 8, 1926

</div>

Dear Ma & Pa,

I am at last at the above spot with Sam, Biscuit, Narcisse and the nurse. I joined them Thursday at a place called Mailleraye sur Seine,

a very cute place where they wanted very much to stay, but which had no room for us after that first night I was there. Friday we crossed and went a few miles to a grand ruin of an abbey (12th Cent.) which Sam says is one of the oldest in the country. It was really swell. The ruins, grand, simple and open to the sky behind it. It was really stunning. We wanted to remain longer, but the hotel was a bit too grimy to keep the kid in so we moved out and wandered about till we found the Auberge, which is really quite swell, and which has slick food. The trouble is that I eat all of it.

We aren't very far from Etrétât, so I am dropping Jean and Cody a line for them to stop in and see me.

I borrowed a French primary grammar from someone and am pounding it, and hope by the end of the week to be able to speak more or less grammatically.

I took a trip down to Fontainebleau from Paris on Tuesday to see some friends who were at the League, and stayed over to a party on Wednesday evening. Wed. A.M. I arose at 6 and rode a bike for 2 hours, and accumulated considerable mal de bicyclette which has since worn off.

The party was good fun and I took a 2 A.M. train for Paris and cleared out for the Chamberlains at 1 P.M.

Narcisse is a peach and cute as tacks, as you know. There is much livestock aboard the farm, 2 dogs, one a fox terrier puppy with short torso and large head—a Mr. and Mrs. Siamese cats with 6 2-day old kittens, guinea pigs, fish, rabbits, and a goose, which latter wanders about the yard and takes baths in the fish pond. The buildings of the Auberge are timbered and just meat for Sam. . . .

The hotel where I stayed is operated by a very nice American chap, who finally moved me to a room at 15 f per day. très bon.

Went to the croquis class at the Grande Chaumière twice and had a pretty good time, but am going to try Colorossi's when I get back as I understand they've more interesting students there. There seemed to be none of note at the G.C. Also will look about for a garret or something of the sort. . . .

Bon nuit, Mes Chers . . . Love to you both and I hope you had a good time south.

Sandy

Sandy rode his bicycle everywhere. He wore a red shirt and plaid

stockings that reached to his knees; his mustaches were long and black: a flamboyant young American giant, at whom the French stared and smiled.

Another postwar sojourner in Paris was John Whitton, a friend of Kenneth's from the University of California who had enlisted in the American ambulance corps and later in the French army. After the war he studied International Law at the Sorbonne and married a Frenchwoman. He taught at the Sorbonne for some years before going to Princeton, where he became an Authority.

Hotel de Versailles, Paris
Wed AM Aug 18-1926

Mes Chers Mama et Papa,

I came up from Etrétât yesterday with Jean. When we arrived at Audemer, the Chamberlains and I, I wrote Jean a letter at Etrétât and had a wire in a few days asking me to call her by phone at a certain hour. . . . She was not in traveling spirit and wouldn't I come on up. As Sam and Narcissa seemed entrenched in Pont Audemer, and I had seen all and wanted to move, I aurevoired and took the charabanc back that evening to Etrétât, arriving about 9 PM. Cody's house is quite big and she has two maids. There were Bobby [Cody's son], a schoolmate of his, a girl of 13, the English governess, Cody, Jean and myself. Quite a noisy household.

We have been fishing twice. Each has a net, an iron hook and a bucket and you roll up your trous and walk along the edge of the water, which is at extremely low tide just now and push the net around the bases of the rocks, and jab under them with the hook, and sometimes (rather rarely) one finds shrimp, crabs, eels, octopi, fish, etc. It is very exciting catching them sometimes—and the whole party surrounds one little fish.

The beach is composed of large pebbles 1″ diam up and is very painful under the feet, but I took to slippers as far as the water's edge and went in twice a day. The water is fine and exhilarating and I wish you were there to take a dip with me. All the kids went in too, in the morning.

The beach isn't very long (less than ½ mile) and has a steep incline, grass covered, leading to a bluff (chalk cliff) on either hand. The golf course is on the top of one bluff and a cute little church like those in the toy village Peg used to have, on the other. The water front

We have been fishing twice. Each
has a net

an iron hook and a bucket

and you roll up your iron

and walk along the
edge of the water, which
is at extremely low tide
just now, and push the
net around the bases of
rocks, and jab under
them with the hook, and
sometimes (rather rarely)
one finds shrimps, crabs, eels, octopi,
fish, etc. It is very exciting catching
them sometimes — and the whole party
3/ surrounds one little fish

is lined with awful buildings, tho not as bad as Atlantic City. The part back from the water is older and better. On entering Etrétât in the charabanc they went for 5 or 10 miles thru a small valley (tho there seemed to be no stream) which was very petit and lined with patches of fields in different shades of yellow and green—really very cute.

Jean wanted to come up to Paris so I came up with her, and we return on Saturday. I am going to take some paints and canvas down, as the place offers more for landscape than any other place I've seen lately. I probably won't stay very long.

Just had a letter from John Whitton. He has married a French lady and will return to Paris in September to lecture on the Monroe Doctrine. I suppose I shall hear from you when I get down to the Guaranty Trust—so will leave this open.

Later—Just received your letters and checks. Thank you very much Mama. I can cash the Govt. check [for matured Liberty Bond] upon its endorsement by the Consul—so it's pretty safe to hold it for a bit, but I'll cash yours now.

Au revoir, Love, Sandy

Sandy wrote from Paris the day after his birthday.

Hotel de Versailles
60 Blvd Montparnasse, Paris xv
August 23, 1926

Dear Mama,

Yesterday having been Mama's and Little Boy's day for you and me, I dedicate this letter to you. . . .

I got a second hand box and palette at the Chaumière and some paints and brushes all for about $11. Also a couple of canvasses. But I haven't painted yet. I decided that I could work better up here than by going back to Etrétât, so am remaining here, and will try to get a studio of some sort at once. . . .

Yesterday I went up on the Eiffel Tower—all the way. It was a bully day. Fine, sunny, with clouds, moving and casting shadows. It was really great fun. . . .

Love to you both . . .
Sandow

A few days later, Sandy had found a studio—and a job.

[August-September, 1926]

Dear Ma & Pa,

This A.M. I at last found a studio, 22 rue Daguerre. It's a small hotel run by a Swiss and cost me 450 f a month—which is a bit higher than I had hoped but I had one all lined up for 350 last week having decided to get along with the maroon burlap as best I could—but the landlady wouldn't let the tenant sublet. So they gave me back my money. This one is rather nice—a sort of inoffensive gray with a little balcony with a bed on it. It is almost cubical with a skylight and window in 2 walls near the same corner (north). I've been in one or two studios and it has less of that cloistral effect than most places I have seen. . . .

I spent nearly every afternoon this past week at the Grande Chaumière drawing the croquis. Its pretty good fun, and runs from 2 to 7 and as the last two hours are 10 and 5 minute poses, one is all in by 7 o'clock.

I have a good deal of fun picking up French and think I am progressing. When I get settled in the atelier I shall arrange to study the Français more assiduously. The studio by the way is near the metro station Denfert out toward Italie from Montparnasse. . . .

Friday

I moved in that night and find the place quite comfortable tho I haven't painted there as yet. But the light seems pretty good. So I think I'm lucky.

Saw Mrs. [Frances] Robbins last night and we are all going out to Robinsons where the people live in trees and one rides a donkey. It may be fun.

Perhaps you remember that American hangout the DOME on Montparnasse at Raspail. There are some Algerian boys there who peddle peanuts and I arranged to have the largest come to pose for me. The others all wanted to come too and I wasn't quite certain how many dozen would turn up. However, nobody came.

Just got a job lined up with the Holland American Line sailing on the *Volendam* on Sept. 8 to make some sketches en route. Back in Paris by Oct. 1. I think it takes 8 days, so we'll be in about Sept. 16.

Love,
Sandy

Sandy's job with the Holland American Line was to illustrate a promotional brochure for its Student Third Cabin Association. The job entailed a round trip on the line's ships so Sandy could sketch from first-hand experience. Two months after arriving in Europe, he would return, very briefly, to New York. Mother considered this a triumph of some import. Kenneth and I felt quite deprived to be stuck away in Aberdeen while my adventurous brother zipped across the Atlantic, almost as if for lunch. We consoled ourselves with a long rhymed telegram to him in New York.

September 25
on board the S.S. Volendam

Dear Ma & Pa & Peg (for I request that this be forwarded) and Mr. Hayes and all the other Hayeses, Mes Saluts! . . .

Thank you family H, for the telegram. It was very agreeable and mother spent most of the day trying to dope it out. Thus far, and its Saturday, one week out, we have had marvellously smooth weather considering the season. Monday things were just a bit wobbly but the rest of the time she's been steady enough for a Prudential Life ad, and Wed. and Thurs. were particularly calm and sunny.

There are ten passengers in this section—which at times carries 500. We have become quite congenial and now have quite a gay time, especially at meals, as we all eat like horses (esp. one you know) and kid each other about it.

The first on the left is a Suisse governess from an American family whom she abhors. Long and attentuated. Perfectly safe. The next an old gent who runs a hash house in New Haven and his bulbous wife, who has been liquored in their cabin for 2 or 3 days straight. "A little whiskey keeps off the seasickness! Hic!" 4th a Dutchman who talks and argues a lot with a very serious expression. 5th a dark horse. 6th an Austrian Doctor who has been living in St. Louis for 3 years. He is really Roumanian now, as the territory where his home is was acquired by Roumania at the end of the war. He's 32 and really very good fun. 1 and 2 on the right are a gent who ran a hash house in Miami until it was blown down and his recently acquired wife, from Philadelphia with bobbed hair and dirty neck (not the town but the femme). #3 is a Dutch farmer who raised hogs in Iowa. He's very amusing and knows his stuff, I don't doubt, as he had charge, at one time, of the Canadian experimental farm near Halifax, and was there

at the time of the explosion. He told us about it the other day. The last is a rather colorless Dutchman, who has had jobs in at least Miami, and Passaic, N.J.

So we have assorted nationalities and the Dutch language to cope with. Dutch is guttural and choppy, like low German and seems to be made up of German and English, many words being just as, or almost as in English. "Milik" is the usual white stuff, but I don't know whether it is English, Hollandaise, or Dutch! I have a grand room for 4 all to myself, and last night the wind was on my side and as I have an upper with a port next to my head, I got a good nose full. But at 5:30 when they were hosing down the deck, they apparently accidentally stuck the hose thru my port.

The feed is remarkably good. Fortunately, there are no choices, for we eat everything and probably would in that case, too, and I have gained at least 5# this week, I'm certain.

Exercise consists of shuffle board, jumping rope, and walking. I hope to see J. B. Whitton in the near future, and box my 5# away. He said he'd be back in Paris dishing out Monroe's Doctrine dope.

A ship is passing so I must out and reconnoiter. See you later.

 Monday 5 P.M.

We get in at 7 tonight, the Roumanian Doctor and I are all set to hop a train to Paris. (1 and 2R) are set for London from Boulogne sur Mer. They were the only passengers for Plymouth so we didn't stop there, and their passage over is being paid.

We passed the Mauretania the other morning (Sunday). She was north of us so that the sun lit up her four red funnels in a very gay manner. It was almost like a bunch of fire crackers. . . .

Paradoxically, after showing us the boat deck and the bridge on the poop, we were informed that we could not use either as there was a contagious patient in the hospital (which is located there). It turned out to be a Dutch sailor who is being returned to Holland by the U.S. as he is insane. . . .

This trip has been pretty good fun, and it is the sort of solitude I think you would like. The Doctor has proved to be the only kindred soul, with possibly the exception of the Dutch farmer (R 3). . . .

 Love to you all,
 Sandow

After he got back to his Rue Daguerre studio, Sandy wrote describing the end of his trip:

22 Rue Daguerre Paris
[October, 1926]

Dear Ma and Pa,

 . . . The weather on the trip was serene until we got abreast of Dover (we didn't stop at Plymouth as we only had two passengers for there, and they were given their carfare) and then it got rainy and rough, and by the time we were outside of Boulogne-sur-Mer the waves were 10 to 15 feet high, and the pilot must have had to make a long jump to get aboard, tho I didn't see him. Anyway, he wouldn't take us into the breakwater with the sea in that condition. So we waited about and finally entered at 11 P.M. It was 7 when we arrived— and all the time there was talk of taking us to Rotterdam. It was really very melodramatic. A dark night, lights ashore, 3 or 4 light houses flashing, waves running 15' (and a luminous green), the cessation of the ship's motion, and finally the approaching tender with its multi- colored lights. We got off without any trouble, tho it was drizzling, and I stood on the rear of the tender and watched the big ship recede, all lighted, and at first over-towering us, then sliding astern as we pulled away (she was anchored, of course) and then growing smaller and smaller as we came in to the little locks which shelter the smaller craft, and finally disappearing as we rounded a pierhead. It was drizzling all the time and every now and then a wave would go smack against the tender's side and the bilge keel would throw it back in spray.

It was midnight when we landed and the customs agents tossed up and decided which of 20 trunks they would open. There was no train till 6 A.M. so they had to put us up at a hotel—very comfortably, too. The Roumanian Dr. and I shared a room and got quite collegiate kidding each other as we turned in. He came up to Paris with me next morning and we had a grand time talking to all the customers in our 3rd class section.

I discovered upon my arrival at 22 Daguerre that everything was KO, and my pajamas still on the hook, altho I owed them some 3 days rent. Also found that there is a hot water radiator in the room which is good for warming my hands on, and a small but effective gas stove which is going to work nicely—and will also help to dry water colours, should I do any, as my landlord remarked. . . .

I have painted, started, at least 2 canvasses since returning and expect to get underway and do a lot of stuff.

The Citröen (Auto) Co. financed an Expedition into Africa, and have a show in part of the Louvre which Frances Robbins and I saw a week ago, together with some film which was very good. They have the whole film on at some movies now and I expect to go this week. It's called the "Croisière Noire." . . .

I had a letter from Nana Bliss with $25.00 in it, to say nothing of the kindly reading matter. Also found one from Jean of 2 weeks before asking me to go touring in Normandy for 3 weeks in a car she had bought.

<div style="text-align: right">Love to you all

Sandow</div>

While Sandy was living with the Blisses in San Francisco, he had often visited with "Nana" Bliss's warm friend Nina Kent. Now Nina, too, would be spending the winter in Paris. Mother was delighted to hear that she would keep an eye on her bairn for her.

<div style="text-align: right">22 r. Daguerre

November 7, 1926</div>

Dear Ma & Pa,

Just got your letter. Glad you are to have a studio, Mother. However, I think you may find it hard to work with anyone at all, even Jane [Davenport], who to my mind is one of the most congenial. I wish you good fortune.

Got you some hankies today altho it took some thought to be certain what "hdkfs" meant.

Will send tout de suite. Also use those in my drawer.

I have plenty of cash for some time to come. Will give you advance warning. Thank you.

I guess I told you I saw Johnny Whitton once and met his wife, a very nice French lady.

Saw Nina Kent Sat. and had lunch and tea and a walk and concert with her on Monday. She said she'd keep an eye on me, and is coming over to see me soon. She seemed quite well and chipper, and we had a long talk. Lives near the Tour Eiffel.

Heard from Renwick Smith Fri. and almost every day since. He is publishing a couple of sheets of music and has so far wanted me to do the covers for him, but seems to be getting cold feet. Asked for you both, and sent his kindest regards. . . .

The Salon d'Automne opened this afternoon and Meg Bossi who was going to take me couldn't find me as I was wandering about town expecting it to be in the evening. However, she said that all one could see was all the old fogies one sees at the cafés, and one couldn't see pictures at all. I shall go in a day or 2, alone. People with one always hinder. . . .

<div align="right">

Love to you both,
Sandow

</div>

<div align="right">

22 r. Daguerre, Paris
Friday, Nov. 12, 1926

</div>

Dear Ma & Pa

Soto came in saturday and said he was returning, sailing Wednesday. He had bought a ticket for about 3 weeks ago, and I had seen him just before he was to sail, and had been thinking he had gone. But he had gotten them to postpone his sailing date, tho they wouldn't let him out of it altogether. He wanted to know if I had anything I wanted to send you. I said no, but asked if I couldn't give him some money. Sugges'ed 20- and he said that was too much as he wanted to pay me back. So I gave him 300 francs, which was about half that. Then he said he wanted to get a present for you. And wanted to know if I didn't think you'd like a houkah (water pipe). I had a notion that you wouldn't be exactly thrilled with one (although perhaps I made a mistake) and suggested a few French magazines. He switched to cigarettes, which I thought a good bet, and then departed. He came in Monday for a final farewell, and said he had bought a lampshade, pseudo bronze, with beautiful landscapes like stained glass on it. I shudder to think of it; and laughed all afternoon, it sounded so marvelously terrible.

I have had 2 French lessons with a Mme. Le Texier, going with Mrs. Robbins. Mme. Le Texier is a grand old lady, who taught Mark Twain 40 years ago, and coached Whistler, when he was preparing to defend himself against suit by Lord Elgin. My French had not increased in a utilitarian way to any extent altho I had learned a good deal, so I am now out for much conversation, and think Mme. Le Texier will be a good spur.

Some of the room interiors at the Salon d'Automne are good fun, altho most are not. And some of the window displays are very clever too. But very little of the art is any good at all. It's very fortunate

that they have the commercial stuff to keep up the tone of things.

Johnny Whitton and I went swimming Tuesday morning and of course enjoyed the water.

Yesterday, being Armistice Day there were brass bands and brass buttons about the Etoile and I went out for an hour of it in the A.M. and got something to paint. One would see a whole family on a step-ladder, indeed within an inch of its life, and hawkers of all sorts calling out their wares. . . .

> Love to you—and bon chance—
> Sandow

> 22 R. Daguerre Paris
> [November, 1926]

Hallo Ma and Pa
Comment ça va?
J'espère très bien,
Aussi Peg et Kien
Et avec les petits,
Est'ce que vous avez toujours "dry feet"?
Je suis très bien gai
Avec ma Français.

Jean came out Sunday and we went to the Salon D'Automne and then to a Beethoven concert. After all of which she blew me to a lot of swell food and loaned me a book on Normandy.

Last night Nana Nina had me to dinner and took me to see Ciboulette, a musical comedy (French)—very good fun, tho it was close as the devil.

Yesterday at our Leçon française, Frances Robbins said she thought of staking a few of us to 3 days in Switzerland, over Christmas! Wow! won't that be swell if it comes off! !

Il faut que je m'achète beaucoup de laine, parce que j'aurai toujours le derrière mouillé.

I have been looking for some jobs now and then, and think I may land some in the near future. Its quite a spur to learn French.

> Love to you,
> Sandy

Wednesday, December 1, 1926

Dear Ma and Pa,

. . . My French is the most exciting thing on the slate. I am getting so that I can read programs, notices, etc. and eat without fear. And Mme. Le Texier said I wrote a very good exercise last time, and I just pounded it out. She is great fun, quite a live wire and seems to have had many pupils of note.

I assayed a couple of places here for work, chiefly travel bureaus, wagon lits, etc. and seem to have some chance, altho I have no idea what sort of price they will pay.

Finally I got tired of dragging along with Renwick Smith and told him I didn't want to do the job, at any rate, for nothing—it had resolved itself into simply lettering, after my having made two swell drawings. He got sore, but I couldn't help that. I'm thru with these "friendship" jobs. They're worse than the others getting things accepted, 'cause they think you're slighting them, and the only reason for doing commercial stuff, anyway, is to make money. . . .

Love to you.
Sandow

Dec. 19, 1926

Dear Ma and Pa,

Thank you extensively for the money and for the "augmentation" of the 25. Part of that will be for French lessons, the which are doing me a great deal of good. Your baby is beginning to talk a bit, all over again. It's swell fun and I carried on a (somewhat choppy) conversation on the phone with a Frenchman the other day, and thought I was doing well. Pronunciation is the tough part, not in general, but the accent, and certain words. All of which you know all about.

We are going to Gstaad, Berne Suisse, for Xmas and I just heard from my landlord that is his hometown (or near it, anyway). And of course he says its beautiful but I really don't doubt it. It's surrounded by mountains and full of snow and only a hamlet, anyway.

I have borrowed a French-German grammar from the landlord, and am now endeavoring to reheat my high school German for they speak German at Gstaad.

It promises to be a swell adventure. Moi, I will go for some woolen underwear, but it's a good thing to have in this cuckoo climate anyway.

Went to Sampson & Delilah, which wasn't much, but they did "an Enchanted Evening" a ballet of toy dolls, with scenery, and music by Chopin which was great fun. They also have some very interesting movies at a few certain theatres. At one they had pictures of the Kaiser, and of the Czar of Russia, taken before the war. At another, we saw an octopus catch and eat fish, a cruiser breaking ice on the Baltic for some freighters, the "raid" (movies made from air plane) made by an Englishman who crossed Africa from Egypt to Cape of Good Hope, and a short Charlie Chaplin all in one evening. Will write more fully later. . . .

> Joyeuse Noël et Bon Jour de L'An
> Sandy
>
> January 10, 1927

Dear Father and Mother,

. . . I spent a day at Chamonix in France, at the foot of Mt. Blanc at Christmas due to the generosity of Mrs. Robbins, who developed grippe shortly before and spent the holidays at the Am. Hospital but insisted that I have some winter sports. I have been back in Paris since the 27th. Some dozen of us had a large party planned for New Year's, but it went a bit flat. I have been drawing and painting, and studying French and Italian. Tonight I am going to "L'Amore" at the Odéon. Saturday and Sunday, I went to Pasdeloup Concerts. Yesterday being all Berlioz—and very splendid.

I can sit on the floor in the prominoir for 3 F and then the lights don't shine in my face.

> Sandy

Sandy's association with toys had been continuous and pleasurable. They were never something to put on a shelf to contemplate or collect, but something to manipulate, to use imaginatively. He had almost always improved on his own playthings and mine, and made toys for his nephews. He had even turned Mother's cat, Soufflé, into a toy lion, by adding a tuft to his tail and slipping on a paper bag head with shredded string mane to make him look fearsome.

When doodling at the table over coffee, he never failed to produce some object made of the soft insides of bread or a cork. Nana Frank had been impatient with this disposition to play when he had undertaken to set up the Tidelands School in Aberdeen. Father had advised

in no uncertain terms, "Stop fooling and improve your mind!"

But now, Sandy returned to his studio in Paris and made toys. A lion with a wire body and tawny head of velvet and wool led to a cage on wheels. Each creation suggested another. Soon he had assembled a small Circus. He was intrigued by the engineering problems of making his creatures move as he desired, which posed interesting challenges to his ingenuity. The animals and actors he made were of wire, corks, bits of wood, leather, odds and ends of silk, velvet, or cotton, articulated so they could perform in character. Horses carved of wood with shredded-string manes galloped around a ring propelled by an eggbeater. A spring released a bareback rider, who landed across a horse's back. Dalmatian dogs ran in and out the spokes of a wheel as the gig rolled along with a big-bosomed lady, onto whose shoulders a flock of white-paper pigeons descended on wires.

As he worked out the mechanics that made his animated dancer twist, Sandy thought of how to weight the tightrope artist's feet so he would stay on the wire, and how to get the acrobats to hang by their heels or arms and flip over to catch the opposite bar. As his acts multiplied, Sandy sat in the middle, manipulating strings and cranks. It was the extra little jerk at the end that sent the acrobats to catch each other, releasing the trap at the proper moment that landed the lovely lady astride her galloping steed. The movements were delightful in part because they were so ridiculously lifelike. He selected special music for each act, which signalled the coming event just as in the big circus.

At first, Sandy showed these marionettes to just a few friends. They persuaded him to give a performance for others. When he decided to send out written invitations and charge admission, he made a linoleum cut.

In Aberdeen, meanwhile, Kenneth and I were discovering the other side of what it meant to have our fortunes tied to those of a banking magnate in a frontier town. W. J. had built his success on winning gambles, but now the very pragmatism he had urged on Kenneth played him false. He overextended loans to several logging operations, including one in which he was co-owner. The town was in an uproar in early 1927, when Hayes and Hayes, established in 1885 and the second oldest bank in Washington, was closed by the state banking department. Even though the shortfall of funds was slight—ultimately the bank paid out 98 cents on the dollar—and though there was no

question of dishonesty, only poor judgment, W. J. had made numerous political enemies on his way to the top and they seized the opportunity to bring him down.

My parents took the news very hard. They had put their savings in Hayes and Hayes because they had thought they would be in especially good hands there, and for a while they feared they had lost everything. Further, they had thought that whatever the future held for them and Sandy, at least their daughter and grandchildren were financially secure. What would become of us? What would we do? When they wrote to Sandy in this vein, his response was far more sanguine and, as it proved, correct. In February, he wrote:

Chers Maman and Papa,

Thank you werry, werry much for the check. It has bucked me up considerably . . . not that I had ceased to dine well, for my landlord had lent me some money, but that it's more fun to pay as one goes. But I really did feel like a bum digging in for cash, when you pictured Peg and Ken so unhappily. However, I am sure that you exaggerate a bit, and I'm very sympathetic towards them, for altho they have rested in Aberdeen quite placidly all this while, they are really glad of a chance to move, and a jolt like that is so very stimulating.

Mrs. Kent was rather funny about it. I guess she called me up as soon as she heard about it, and we had lunch a few days later and she wanted to weep for Peg and Ken and I objected that they were glad of a chance to get away and to their friends. And then she picked out Ken's mother and I said it was just the sort of stimulus she needed to make life interesting and exciting for her. So she turned to Jean and I had to admit that it was a calamity as far as she was concerned. [Jean was divorced, and had no training for remunerative work.]

But I think it impossible to feel for them, at this distance, except in a very general way (I mean that I am very fond of Peg and Ken and hope they come out with colors flying), but as far as feeling angry with anybody, it's impossible for I haven't enough information to judge at all. Apparently Bill was a very sloppy businessman, but he was consistently so which is to his credit in a way. . . . Meaning he was certainly generous and kindly hearted.

But they're all that way in the logging country. It's all just a cut and dry method of business and living. If you want to get some trees off a hill you try one way, and if that doesn't work you try another,

and if that doesn't work you say, "Oh Hell, guess we'll have to leave them," all without sitting down and really doping it out in advance. . . .

I have made a lot of swell toys and am underway to find out what to do with them. I suppose I could get more for them in America, if they would sell at all. But rather doubt whether or not any American would show much interest in them, because they're the sort that have always been manufactured in Europe heretofore. So I had better try here first and widen out afterwards if I get going here.

We are having glorious weather and I am going to paint (outside) soon. When I'm in my chambre all I can think of is toys. . . .

<div style="text-align:right">Sandow</div>

Sandy was right about Kenneth and me. Although Kenneth had better prospects of employment in the northwest, he and I decided to seize this chance to live where we really wanted to—in Berkeley, which held so many happy memories for us both. So Kenneth left for San Francisco to find a job, while the boys and I wound up affairs at the Tidelands School, sold our house, packed our belongings, and drove to Portland. From there, we proceeded to San Francisco by boat. Kenneth's sister Jean, with her son John, went also. My mother-in-law had gone ahead and was already manager of the Western Women's Club in San Francisco (later the Marines Memorial).

With our funds very short, I cast about for ways to augment them and found myself turning naturally to art. Fortunately, I had started drawing seriously, with my parents' enthusiastic encouragement, a year or two before. Now, everyone helped. From Paris, Sandy sent a box of paints, a sheet of lettering done in his best mechanical engineering style, and an ink drawing showing "how to make things look solid." Friends ordered my hand-drawn Christmas cards. Edith Bliss paid for a life drawing class at the University, and later, when Dorothy Liebes taught me to weave, helped buy a loom. In January, 1928, Father wrote me, "Your work is surprisingly good, Peg, showing taste and fine feeling for your subjects. I know what application it means to get it out. Don't get into it too deep tho. Hold it at arms length as it were, and be master."

Shortly after this, an opportunity to assist Margaret Schevill, an art teacher, led to several years in two private schools, reigning over the Arts and Crafts Room. Here, those early years during which Sandy and I had been encouraged to "make things" and association with my

ingenious brother bore fruit in musical instruments, puppets, marion-
ettes, kites, costumes and masks for school plays, paints, firing clay,
batiks, and linoleum cuts. I then decided it would be more satisfactory
to conduct an Arts and Crafts Workshop of my own, where I would
be free to refuse to tell the children what to make, only help a bit
with techniques. The workshop in our Berkeley basement held forth
at least once a week for over twelve years. In order to be more helpful
to my small friends, I took a course in "The Problem Child in School."

Sandy sent a pair of Bernard pliers and several coils of wire, and
revealed why he steadfastly refused to teach: "If you teach, you tell
'em how, then you have to do it that way. I want to be free to do
what I want." Father said he found teaching "something of a drag
after the first year or two. It takes it out of you." He was right. Teach-
ing does take it out of you. One must find compensation in warm
friendships and in the reward that comes later—on finding that so
many pupils have been brushed with the flame.

So there we were in the late twenties: Sandy in Paris, making toys
and giving Circus performances to earn his rent, helping me via letter
halfway around the world in California; and our parents in between,
modeling and painting on their own and encouraging us both.

Sandy sent an ink drawing showing how to 'make things look solid.'
Photo: Antonio Violich

9

Mother had a vision of lifelong, day-to-day intimacy with her two grown children, a vision I unwittingly helped foster by incessant, almost daily, correspondence. Although Sandy was never out of touch with her for long and indeed was remarkably loyal to his family all his life, his letters inevitably became less frequent as he became more fully engaged in the Paris art world. Moreover, he grasped far better than Mother or I the need to concentrate one's energies.

Across the top of Sandy's next letter Mother wrote, before forwarding it to me, "What would you think if this was written to you? It has hurt me."

April 27 [1927]

Dear Mother,

I got your letter this evening, and it is very sweet. Believe me, truly, I do feel that I am one of the Calder family, our Calder family (immediate). I always feel that I love you 2 and Peg, and I always feel sure that I can count on you to continue to love me.

You want me to give news of myself, I suppose the reason I don't feel impelled to write more often is that nothing particular seems to happen, except perhaps the toys or drawings I make, and they come along so slowly, comparatively, I mean in such small increments that they don't seem very important. I don't feel inclined somehow to detail (I'm not crabbing—just explaining myself to you) all the little possibilities of what I might do with the toys, it doesn't seem to matter, unless I've got it done, and I haven't done anything, yet. I sent some drawings to the Police Gazette and to the New Yorker today, but

that's of no import unless I make some money out of them. The other day I made 4 frames, all for 300 francs and that is interesting, and I intended telling you. But you see doing drawings that don't especially excite me is a bore, unless they sell. And if they don't sell one has them on his hands long enough and gets quite sick of them (without daring to destroy them because they *might* sell), so that he feels foolish to have talked about them. Even the toys are beginning to annoy me, because I have shown them so much, although I am quite certain— just as much as ever—that they are very clever. I think you've developed a habit from reading Peg's letters, of thinking that it is necessary to have recounted all the daily events—*please don't take this amiss!* but Peg doesn't recount all the colds, etc. so that you feel when you read one of her letters, just as if you were in the midst of the family. And its fun to feel that way. But it takes *a lot of* time and routine, even for her, and if I wrote that much it would take me twice the time. And in addition I should think one would get one's sense of the importance of one thing as compared with another, a bit mixed up. . . .

As to my mind and body, they're absolutely in the pink. I've had a couple of colds (all over) but I think that's really part of a Parisian winter. Don't fear about my not telling you if I get in a real pinch. . . .

. . . I don't feel any necessity for chasing money. I can't see any real sense in doing so, for you don't put your best effort into it unless you've got to, I mean as far as money and I are concerned. . . .

Love to you 2
Sand

Despite the doubts he had expressed about selling his toys in America, Sandy brought them with him when he returned to the United States in the fall of 1927, and arranged to have them produced by a manufacturing company in Oshkosh, Wisconsin. Similar in design to those he had made for us in Aberdeen, these runabout animals leapt or wobbled, waggled a tail or blinked an eye, all in the most comical manner. For these he was paid a royalty of 2½ percent.

In New York that winter Sandy arranged for his first show, held at the Weyhe Gallery in February and March, 1928. For this exhibition of wire sculpture, he made the first *Josephine Baker,* designed to be suspended over head, as well as other portraits and animals in wire. Some of these were shown at the Whitney in 1976; they had lost their power to astonish, but none of their power to amuse and delight.

Sandy with one of his wire portraits. Weyhe Gallery, 1928.

In a room he rented in the winter of 1928, Sandy made the wire *Romulus and Remus* and *Spring,* exhibited by the New York Society of Independent Artists in March, 1928. He then returned to Monteath's for wood, and spent the summer at the Drews' farm in upstate New York carving wooden objects, including the horse now in the Museum of Modern Art. He arranged for a showing of them to be held at the Weyhe Gallery in February, 1929. On his return from the farm, he received a commission for five wire sculptures advertising the strength of a particular brand of eyeglass frames. He made athletes pulling at the lenses. For these wire sculptures he finally, at age thirty, received his first check for $1,000. Armed with the money and with the tightly bundled *Spring* and *Romulus and Remus,* he returned to Paris in the fall of 1928.

I, too, was finding gratification in combining art with the chase for money. In July, 1928, Father wrote me in a somewhat ambivalent vein:

Dear Peg,

. . . I am glad that you are getting a kick from your growing power to draw. Your Art School out there would have photos of the drawing of some of the strong old boys like Michelangelo and Dürer whose technique it is helpful to realize even if you disdain it like Sandy. . . .

Cézanne was a searching scientific painter working quite like a scientist alone in his laboratory with a problem that he alone saw clearly and to which he devoted his life, that at the time was thought a failure. Read if you can Zola's *L'Oeuvre.* . . . Cézanne there figures as Claude Lautier, the painter who finally hangs himself before his great canvas of madness. This was Zola's dramatic invention not in Cézanne's real life. He lived alone and died naturally.

Man may be the most cruel animal in nature, but he is only part of nature. I conceive the whole organization of nature to be cruel from the great beasts of prey to the domestic cat.

When one considers the system, for it is a system, through animals, birds, fish and men it would seem that our sentimental ideas of education which we have been taught are false and in the effort to improve ourselves, to lift ourselves still further toward what is called the better life we have weakened our power as fighting animals. "Compensation" Emerson would say. . . .

<div align="right">Pater</div>

The year 1929 began auspiciously for Sandy. In Paris, he had rejoined his friends, a group of artists that included Foujita, Man Ray, Breton, Kiki, Desnos, Léger, and Pascin. When the Galerie Billiet agreed to hold a show of Sandy's work in January, Jules Pascin, who had met Father in New York, wrote an unconventionally irreverent preface to the catalogue. It aroused considerable comment, and particularly puzzled Father, who found himself included: "But at any rate, I swear that Mr. Stirling Calder, who is one of our best American sculptors, is also the handsomest of our [artists'] society. When I returned to Paris I met his son, Sandy Calder, who at first sight disappointed me. In all frankness, he is not as handsome as his father. But now, having seen his work, I know that he will shortly make a name for himself despite his ugly mug and that he will exhibit with smashing success alongside his father and other great artists such as I, Pascin."

Sandy reassured his perplexed father: "About the preface by Pascin —practically all the prefaces used in that manner are rather lengthy

treatises in a serious manner, telling how good the guy is. Pascin didn't care about doing the usual thing (I think it was the first preface he ever did) and he didn't want to commit himself in any great measure, so he did it facetiously. And it was quite a success for it stood out quite signally from others."

He enclosed an enthusiastic notice from the French review *Cette Semaine à Paris,* which ended:

> Le fil de fer de Calder fuit rond et pur comme un passage d'aile ou, quand l'ingéniosité le rapetisse, comme les courbes aériennes des jongleries. Son adresse miraculeuse opère des loopings ahurissants. Maintenant, en dehors de son procédé, seulement du fait de la qualité de son esprit, Calder est le sculpteur critique par excellence.

Late that same month—January, 1929—*Spring* and *Romulus and Remus* went on exhibit at the French Salon des Indépendants, where they met with considerable acclaim. The enthusiastic description of *Spring* quoted at the beginning of this book continued: "Before her one can be astonished, admiring, shrug one's shoulders, or pass by without taking notice. Everyone knows that the right to criticize comes with the price of admission. This visitor [referring to the accompanying cut of a gentleman staring adoringly at the seven-foot statue], caught unawares yesterday by our photographer, is obviously an admirer."

Sandy was then at a stage in his career familiar to many young artists: his work was beginning to receive favorable critical notice and public approval, but sales were slow. The results of the simultaneous Weyhe show of wood sculpture were equally disappointing. Sandy swallowed whatever disappointment he may have felt and went skiing.

[February-March, 1929]

Dear Mama,

It was swell fun in Mégève and skiing is *the* most glorious sport. For one climbs mountains, and sees wonderful sights, and feels the presence of something like God—especially when one is solitary as I always was, being left behind by the others who knew more about skiing (but perhaps less about God).

I had planned on staying two weeks, but altho I enjoyed the sport— I really got a bit bored with the people in general (altho there were

many swell people, too) for there were a lot of those tight-mouthed, ratty piggy little French—who can't even say 'Goodday' to you after you've been dining in the same room for a week . . . and the general atmosphere was not really congenial. And I felt rather impatient to start work on other things as well. To begin with I am going strong after exhibitions in London and in Berlin, and if they come off I will go to each place in turn so will you send me uncle Jack's address [Grandfather's brother].

I sold 6 things at the show, 4 to two Englishmen who promised to lend me the things should I have a showing in London, and the other two to Bernheim, Paris dealer, for his own personal use. This is to be considered quite a success—for in many of the shows they sell almost nothing. And of course, the publicity has been profuse, which is one of the main issues. I am wondering if anything has been sold at the Weyhes. You didn't say anything so I suppose not. And also from the London and Berlin shows, if I get them, for there is more money there. I took in almost 7000 francs here, but as I had put up 3500f for the Galerie, that wasn't such a remarkable profit.

There was one significant advantage in being on Rue de la Boëtie— that of my being able to get higher prices than I could have elsewhere.

Got 2000f for one thing. I think that the things I did recently, in wire were much more sculptural than most of those things shown last year at Weyhes. . . .

Am going to see the Riccolli (Italian marionettes). I saw them once. They are gorgeous. . . .

I'm glad you think the [Weyhe] show looked well, for I was a bit afraid that they would clutter it up and detract from things.

I know the price for the cow was high but as it was such a favorite I decided that there being only one, I might as well sell it dear.

 Sand

I brought back my stuff from the Salon des Indépendants (French) today [Sandy reported to Mother and Father]. They were a grand success, but I wish someone had bought them for they are the dickens to house. However, I have slung the wolf up near the ceiling and its quite amusing to see it from below.

There is a Galerie Zak, opposite L'Eglise de St. Germain de Prés. I have just left several things there—and Mme. Zak seems highly interested, so I think she may do something for me.

In another letter he wrote:

> I don't know about not being sufficiently academic for Guggen-
> heim. I think there may be a pretty fair chance of getting it. What
> they want chiefly, I think, is the drive and push, as well as the
> ability to carry on a work or research *alone*. I gave them fourteen
> references when they asked for six, tho I had no idea what results
> that may have produced.
>
> This rather faint possibility for receiving the scholarship is
> really quite amusing—for I don't take it at all seriously—and I
> see no way in which it will alter my plans if I do get it.

Sandy's philosophic attitude stood him in good stead, for he was
turned down by the Guggenheim awards committee. He packed away
Spring and *Romulus and Remus*. For thirty-five years they remained
bundled up, until in 1964 the museum founded by a different branch
of the Guggenheim family mounted a comprehensive Retrospective of
Sandy's work—when, as Sandy says in his *Autobiography,* the wire
sculptures of 1928 proved to have "all the freshness of youth—of my
youth."

In the winter of 1928-29, on the suggestion of a New York friend,
Elizabeth Hawes, Sandy called on the Spanish surrealist Joan Miró in
Miró's Montmartre studio. Miró, a very amiable man, showed Sandy
some of his work, and for once it was Sandy's turn to be astonished
by the materials an artist worked with. One creation Miró showed him
was a sheet of gray cardboard with a feather, a cork, and a picture
postcard glued to it. Soon afterward, Miró attended a performance of
Sandy's Circus at Sandy's rue Cels studio. The two men began to
exchange their work and became lifelong friends. They were com-
patible not just temperamentally, but artistically. In 1961, the Perls
Galleries in New York held a joint exhibition of Miró's paintings
and Sandy's mobiles. The show was an outstanding success; the im-
pishness and vibrant colors of the paintings were a perfect complement
to the mobiles' airy grace.

Sandy had no sooner unpacked *Romulus and Remus* than he left
for Berlin. He wrote home en route:

Berlin, Deutschland,
Sunday, March 17, 1929

Dear Ma & Pa,

You will be surprised to see a German stamp on this letter, for it was only three days ago I saw [Sacha] Stone who had just returned from Berlin and who made a few inquiries among the Galleries. He said there was a very good gallery, Nierendorf, that was interested in the photos, both of wire and wood, but that the man wanted to see more photos, clippings, etc. and he himself suggested that I go to Berlin and take some actual objects along. So as Stone was returning in 2 or 3 days (he is a photographer) I said I would go with him. And it certainly was a lucky hunch as we have been in 3rd which cost $10.00 and is much more comfortable than I ever was in 2nd in France. They actually open the windows on both sides of the car.

I have one or two friends in Berlin—whom I met in Paris and shall get along very well, I feel certain. . . .

I got your letters last night containing the Guggenheim sad news. But it doesn't bother me in the least, as it would have been a gift, and one should get along without them. And I never thought I'd get it anyway; only how funny it would have been if I did.

I did expect Weyhe to sell something, but I guess they don't know much about blowing a horn. I had a note from Zigrosser last night too, saying that he still hoped to sell the cow. He seems to have dispersed the collection pretty soon, but I suppose and hope that he has kept the more popular articles at the Gallery, because all the publicity seems to come along rather late. Isn't it funny that the Boston paper copies the Times verbatim? . . .

This is a Polish car we are in. It goes on direct from Paris to Warsaw. It is very nice and clean, tho that is partially because it's new. But anyway, my compliments to the Poles. Their language is all over the place. The W.C. is marked "O.O."!

. . . I'll be home about the middle of the summer as I may take a trip with [Rupert] Fordham on his boat in the Mediterranean.

I heard from Cody [McMicken] that all the London Galleries were booked up, altho one of the smaller ones seemed a bit interested and their man is coming over to Paris in a week or 2. I expect to return in 4 or 5 days—this trip is just to arrange things in advance. I have 3 wood carvings and 4 or 5 wire figures along. . . .

Don't mistake me—I appreciate the joy of being all together with one family and I enjoy it too—*and will be there*—but it's impossible to work under those conditions and if one wants to stay that way forever, one is anchored, and has to forget all the places one wants to see and most of the things he wants to do.

<div align="right">
Love to you

Sandy
</div>

Sandy's next letter, reporting on his stay in Berlin, was sent to my parents in Pittsfield, where Mother had joyfully resumed painting after a long hiatus and Father, having made a rapid recovery from his latest illness, was modeling a group called *Cruel Nature*.

<div align="right">
Berlin, Deutschland

April 6, 1929
</div>

Dear Mama and Papa,

I have given this address just as a bit of topical interest, as I shall probably be back in Paris before the mails can make a round trip. I have let all correspondence slide for several weeks, owing to the exigency of the case. . . . Sunday, the morning on which we entered Germany was a gorgeous day, bright and sunny, and altho there were pools of bright water, and spots of snow on the ground, it did look as tho spring had come. Germany is very flat, and really wasn't very fertile looking at that moment, tho I may not know much about it. Anyway, one eventually comes on Berlin, as tho by mere accident. The train crews are for the most part quite fat, and a conductor's life, squeezing up and down corridors must not be a very happy one.

Berlin, the great mass of it, is quite old-fashioned and ugly, except that the rooms are large, and there are a great many balconies, which is a good idea. I have one, and enjoy breathing exercises on it every morning. The streets are well kept, but mostly the buildings are of a rather oppressive grey. Of course it is still winter (we had snow 2 days ago and some bitter cold, tho today was slightly milder and had a glorious sun).

The Tier Garten, and several more important streets are good, but the place abounds in the most idiotic sculptures. There are numerous fine museums and exhibitions of things, assembled at considerable cost and with a great deal of care. They just closed a show of Chinese art in Unter den Linden, which I regret very much having missed— for from all reports it was a knockout.

The people are very polite and I wish I could know what it was like before the war. The first week I saw absolutely no one whom I deemed good looking, but lately I have changed my mind, and think there are a lot of good lookers, men and women, both. The older generation contains a lot of birds that remind me of Kraushaar, even a good deal fatter, but I think the younger generation is avoiding this excessive obesity.

There are 1 or 2 sections where there abound buildings built in modern style. Some of those are quite telling, and some, altho telling, are not especially pleasing. However, they all show an inventiveness and a willingness to try new things which seems fine to me. . . .

The Show opened, in really not a bad manner, on April 1, which being Easter Monday, was a holiday. Westheim, Editor of Kunstblatt, bought his portrait. As this is the first of the catalogs we really haven't made much appeal to the public as yet, tho there have been 4 or 5 things in the paper, several of them illustrated.

I have been working on the American correspondents here and think something ought to come of it. There ought to be a pretty good article in the *New York Evening Post* Saturday edition, in a week or two, tho I can't be absolutely certain that it will get in at all.

. . . They seem to take things too easy here to permit of any really "high balling" (high pressure) and the catalogues won't be out in quantity until tomorrow, and at times I feel furious, but then things are really screamingly funny when viewed from the right side—so when I am not at a peak of embêtement, I can laugh quite heartily.

Have to scrape my face and then off to the Gallery. They open from 11 to 1.

<div align="right">Sandy</div>

His nephews and I were already in Pittsfield when Sandy joined us there in the summer of 1929. He came bearing gifts of Rodier material for the ladies and showed us pieces of his brass wire jewelry for the first time. Father thought their design very handsome.

Although Sandy had been working with wire and carving wood, he devoted most of his visit to playing with the boys and giving all of us a good time. (This was especially self-denying because it was on this trip to the United States that he had met Louisa James.) He gave a performance of the Circus, and allowed the boys to turn the eggbeater that moved the horses around the ring; to release at just the right

moment the lever that propelled the bareback rider onto her mount; and to figure out the timing necessary to send the acrobat through his hoop and allow the trapeze artists to catch their heels on the opposite swing. The slack rope artist, made of wire, was elegant in his black dress suit with a diamond glittering on his bosom. His coat tails streamed out behind him as he slid down the slack wire on his lead feet, grooved so they held to the wire and kept him upright.

After we had been together in Pittsfield for a week, Sandy's friend Bill Drew and his cousin Bill Murphy came to take Sandy, the boys, and me to New York for a few days. There we visited Father's Fourteenth Street studio, and I fell in love with *Little Dear with a Tiny Black Swan*. Father promised to have it cast in bronze for me when he had the money to do so. Knowing that my boys were ardent baseball fans, Sandy took us to a game at Yankee Stadium. Besides a very exciting game, we saw Al Jolson, royally drunk, seated with members of his troupe in a box across the grandstand. To the crowd's delight, Jolson rose and sang *Where Did Robinson Crusoe Go with Friday on Saturday Night* and *Mammy*. We were still in New York when Kenneth wired from Berkeley to assure me that our fortunes would not be seriously affected by the stock market crash, that he would continue at the Bank of Italy, and that we should finish our trip as planned. Not knowing exactly what he was talking about, we spent the next day serenely at the Bronx Zoo.

Sandy stayed on in New York until March, 1930. He worked in Father's studio, gave several performances of his Circus, and cultivated his acquaintance with Louisa James. In December, 1929, he held a show at the Fifty-Sixth Street Galleries, in which he exhibited paintings, wood sculptures, wire sculptures, toys, jewelry, and textiles.

The catalogue cover displayed the wooden horse carved at the Drews' farm the year before. The horse's legs, carved separately, are fitted into the body. The horse thus marks a bridge between the articulated animals of the Circus and the other wood carvings, all made from one piece. The back of the catalogue showed a wire sculpture of a lady on stilts astride a galloping horse. Above it, Murdock Pemberton of *The New Yorker* is quoted:

> Calder is nothing for your grandmother, but we imagine he will be the choice of your sons. He makes a mockery of the old-fashioned, frozen-stone school of sculpture and comes nearer to life in his creations than do nine-tenths of the serious stone-cutters. Some

of his wood elephants and tin animals are masterpieces of motion and balance; his cow is a cow with all of her pathos left in.

Louisa's name occurred with increasing frequency in Mother's letters that winter. As the families became acquainted Louisa's father liked to tell wryly how he and his daughter had set forth the previous summer for a chummy voyage to New York and how instead he had seen less and less of her as they progressed, until at the last moment they had to scramble to get ready to go ashore. On Christmas eve, Mother wrote me:

Dear Pegus,

. . . Mrs. James just phoned again. . . . Louisa's other sister, Olivia is coming and bringing her boy, four years old. He is quite cute from the tales they tell.

Frances [Gould, a singer and music teacher], had us to breakfast— 10:30. Fred Hart, Gwladys [Sills], your Dad, me, Sandy. Louisa and Sandy brought her sister Mary who did not know it was an arranged party, but we scrambled around and made room for her. I wore my red dress. Your father said, 'An evening dress in the morning?' but after it was over, remarked it was the best color there. When we got started with sausage, waffles and Calif. eucalyptus honey, I forgot about dress. I wore your gift of hosiery and Sandy's medallion on my chest. Hosiery on legs and glad to have them as I have bought only dark ones. We played around and sang. There were trifles for each one and balloons to blow up and Sandy put two in Mary's sweater to simulate breasts.

Then we went to the Drews for dinner of Goose . . . and champagne . . . your father would not go.

Sandy made a clever girl riding on horseback out of the champagne wires. He and Louisa rushed off to Olivia's for the tree. . . . It seems the youngster is already in knights, and a French village Sandy brought him, which he called a castle . . . so Sandy made a drawbridge and portcullis whilst we sat around and talked at the Drews. . . .

Mother

On Christmas morning Sandy arrived, Mother wrote,

laden with gifts like Santa Claus. He made me a fish tank of brass wire, with two fish that wiggle as you turn a crank made also of

One wire beginning at his tail, running along the backbone to the head, where the eyes and mouth are faultlessly placed

wire. Waves are indicated along the top. For your Dad a large fish that is now hanging from the electric light. Peggy, it is remarkable.

One wire beginning at his tail, running along the backbone to the head where the eyes and mouth are faultlessly placed. Then the wire loops around the back bone as it travels back to form the other half of the tail. This is hard to describe, but it is really wonderful as is the fish bowl in which the fishes bend as tho swimming.

He is giving his circus tonight at Mrs. Bernstein's, somewhere on Park Ave. We are invited. He certainly has a large circle of friends, but he seems to be faithful to Louisa James.

He blushed a few moments ago when I called her his "inamorata.' . . .

Sandy sold $550.00 worth of stuff at the Gallery. I will get $300.00 (return on loan). Our room looks gay as I turn around. He loaned us one of the Chinese prints you sent him. The room is partly dark and dull grey, so all the pinks and blues and greens look fine.

Sandy brought me a swank scarf, oriental in spirit, beautiful green dominating. . . .

Mother tried to keep me informed of my brother's comings and goings. In January, 1930, while Father was working on sketches of Leif Ericson and commuting to Washington, Sandy went to Cambridge to install a show at Harvard's Contemporary Art Gallery, astonishing the powers-that-be by arriving in his mustard-colored coat, pockets bulging with pliers, a coil of wire slung around his shoulder. While in Cambridge, he went to see Donald McLaughlin, whom he had met at the Walter Blisses' in San Francisco. Don was teaching at Harvard. Sandy was let in by a good-natured maid, who explained that the McLaughlins would be returning shortly from a dinner party. Sandy promptly went to sleep on a couch.

"One of your friends, I presume," said Mrs. McLaughlin icily, surveying the mountain on her sofa. Then Sandy unrolled, and after introductions, explanations, and laughs all around, he was given a real bed for the rest of his stay.

Mother wrote me:

Dear Pegus,

Sandy came in this morning, bigger and blowsier than ever. He will be off to the other side as soon as possible with his gatherings in Boston and elsewhere—even can give me the $200. He said one woman bought a necklace and wore it and after that his jewelry went— He sold the camel for $500, I heard him tell Bill over the phone.

Your father is about ready for the train for Washington and says he feels dull—rather disagreeable. . . .

Sandy seemed happy and that is good to be near. We are waiting for him to come back. He went up to his former residence but did not know if his bed was not occupied by an old acquaintance. Somebody Morgan who has just returned from Paris having buried his chum who died in Nice. . . .

We dined with Albert and Marie Sterner and talked and talked. Albert challenged me to paint minus all earth colors—that means white, strontian or cadmium, crimson, blue permanent and cobalt . . . c'est tout . . . and I did it!!

. . .

After an afternoon with Sandy—the first in many moons. First we went to the station with your dad. . . . Then we had luncheon at the sit up counter. Then we saw the animals in Central Park Zoo. There

are two lion cubs about 6 weeks old. The mother licked while we gazed, then catching one leg in her mouth she turned him over and licked his belly. So maternal. . . .

. . . We went to an Italian joint for dinner and then he left me after to call on ????? He would not disclose himself but I know where Louisa James lives. They were together in Boston. [The James family home was in Concord, Massachusetts.] He dined with Donald Mc-Laughlin twice.

He vouchsafes no information and I had to drag this from him. I wonder why?

So here I am alone tonight and I am going to read some more Islandic Sagas. . . .

Bless you and Good night,
Mother

After New Year's, Father wrote to thank us for the gifts we had sent from Berkeley:

Dear Peg,

. . . I remarked to your Mother . . . that we had been most fortunate in our children, and she seemed to think we deserved it.

I am not so presumptuous myself. I remember well my antagonism for my parents and when I recall my antagonism and impatience with them, I realize it the more and feel undeserving.

Instance of the perverse cruelty of the nature into which we are born. Where I feel that I have deserved better I get it in the neck. When undeserving, I am rewarded.

Pater

Mother had a chance encounter with her increasingly elusive son: "On the bus last night coming down 5th Ave., I heard a [nose] blow that sounded like Sandy's. I partly turned around and the next I knew Sandy was sitting beside me. He was on his way to get Louisa James and I was on the way to the Brevoort to meet your father." She wrote again:

Dear Pegus,

Sandy had tickets for Frances [Gould] and me for a most unusual performance of music. It was plus ultra modern music. Sandy's friend Varèse had the most noisy one with two sirens (auto) to make noises.

Sandy brought me home at midnight with Varèse, a wee man who was born in South America. Mr. and Mrs. Salzedo, the harpist, and two sirens were in the back seat. They went on to a party at Varèse's but I decided that was not for me. Salzedo had some splendid compositions. He played the harp and wind instrument. Wonderful performer, had been teaching and playing many years. Wish you had been there to hear the din. I was amused at Sandy who said the sirens were the best notes in the Varèse music. I am glad he did not hear him. Sandy has rhythm because he dances but otherwise so far, I think music is not in him. I fear I have not given him any.

Frances posed for me one day last week. I made an Arabian of her, your Father says, and though I can still handle paint, my eyes are playing tricks. . . .

Muz

Having earned enough money to live on for a while, Sandy made ready to return to Paris. Before sailing, however, he had one more project to complete: he was to "do" a room for the New York apartment of W. R. Hearst, Jr. Mother saw the room a few days after Sandy's departure, and wrote me a detailed description:

[March, 1930]

Oh Pegus dear,

. . . I wish you could see it. The kids would be crazy about it. There are no doors left nor any door stops—the stop is the head of a long curly black snake —nor electric light buttons. Everything covered . . . I'll try to tell you. Opposite the door at which you enter is a huge elephant coming at you and rubbing against its side is a little one with his back to you . . . further on is a large deer with twisted horns, beautifully done and sitting in the pasture, low down near the baseboard but large in drawing. Then he covered the light pusher with a yellow lily like plant which has great leaves. With a wire to hold it was a yellow grapefruit—a real one. The door next is two beautifully done palm trees; on the wall at right angles, first is a mass of large colored leaves and to the right two zebras, one red, white and blue and the other black and gold. The R.W.B. [red, white, blue] is almost side view but the B.G. [black and gold] is full on and I perceived he did not have such an easy time drawing it. On the horizon line is a list of animals going 〰〰 as one sees them in the movies. All the walls and ceiling were gilded first and he has used

it splendidly. In his meadows, covering with paint enough to give distance. At right angles to wall is a . . . magnolia tree. . . . Everything is done bigly and in the most simple way. There is a pond on that sill. I really forget about the animals. Further on, including the door thru which we entered are enormous palms that go over the ceiling and I think he wanted to hang a real pineapple. I saw the attached wire and the pineapple on the table, also a bunch of bananas, both of which I think he found too heavy for his wire. On the other wall are two windows in the first corner he has painted some bully giraffes, trees and accompanying surroundings between the windows he has again attached wires with leaves painted. On the wires are real oranges. Under the second window is a radiator with a glass top and over it one sees the upper half of a hippopotamus. There is a yellow wild cat leading to one of the beams and a black one crouching on one beam. That last is the only animal I feel is not achieved, and I do think it is a very modern and to me, cheap though amusing idea, to put a small wire holding a peanut below the elephant's trunk.

Mrs. Hearst who was a Miss Walker is in Calif. and the housekeeper let us in. She did not know the young man had finished. There was his palette, 20 brushes and lots of paint. I told her I would stop in and get them, so I will have another look also. He has a grand funny bone and is a devil for doing it and letting it go at that, not mincing matters. Anyone else would have gotten $1,500.00 instead of $500.00 for it.

So now he is after that reputation that he thinks he must get over there [Europe] first. I have my doubts about that as here is where the money is being spent. It [the painting] is certainly powerful.

Mother

In the end, Sandy did not get even the $500 he had been promised. Several months after he returned to Paris, Hearst wrote saying that he had had a mantel originally priced at $500 installed in the room. The seller had agreed to settle for half; Sandy should do likewise. Deeply engrossed by then in the exciting new world of abstract art, Sandy did not press his claim. A short time later, the Hearsts redid the room. Thus Sandy's Africa in New York, considered powerful painting by his critical mother, exists today only in her sharp-eyed description.

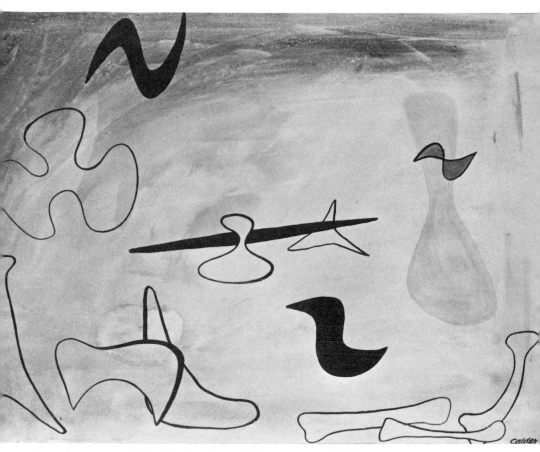

Deeply engrossed by then in the exciting new world of abstract art

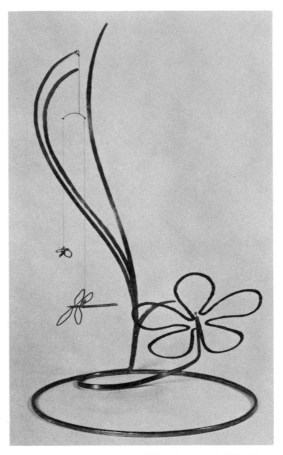

THE DRAGON FLY AND THE BEE, a mobile (around 1944)
Photo: Colin McRae

10

As the paintbrushes he left at the Hearsts' apartment indicated, Sandy sailed from New York in some haste. He was the only paying passenger on the Spanish freighter *Gabo-Mayor,* and returned to Paris by way of Barcelona. He had not yet hit his stride in the spring of 1930. He was still experimenting, still looking for work that would bring in money and yet be something he wanted to do, when he wrote home:

7 Villa Brune, Paris 14
May 23, 1930

Dear Ma and Pa,

. . . About doing textiles for Miss Harbeck—I think that it would be much better to drop all thought of doing that stuff—for her at any rate, as it seems obvious to me that she isn't interested and it's impossible to expect to cram something down her throat. You see—she actually can and does buy designs over here for such sums as $8— and these people have all the technical knowledge of how to do the thing—and it's a hell of a lot of work—the way the regular things are done at any rate. Do believe me—I'm sure it will be just a lot of waste labor—and she's a nice person to know as a friend so it would be foolish to make it uncomfortable for her.

I ran my circus once and Vogue (here) asked me to come to their studio and let them make photographs—so I did and then I ran it again in their studio. But since then I have shut up the show and am going to leave it there for a long time as it hinders my work.

The Hayes family devotes June 27, [...] to its most favorite pastimes to celebrate the 14th Anniversary of its inaugur[ation] This disturbs only one cow + 3 fish and proves a joyous occassion for all rest of the world Dedicated this 10th day of June 1930 by its loving brother Al Calder 7 Villa Brune 14e Paris, France

Sandy's Anniversary
letter to the Hayeses
June 27, 1930

There is a very fine bronze foundry at the end of Villa Brune—so I am going to delve into *cire perdue*.

I have been carving and painting a bit, and am really getting underway.

Rupert Fordham has definitely invited me to go on his boat in July—I am to join him in Palma, Mallerca [Majorca] Balearic Isles. It is Spanish there. Joan Miró, the Spanish painter, Babe's friend and mine is down there now.

I have a couple of wire things at the Salon de L'Araignée at the moment—but that is all I have out. . . .

Sandy

Sandy à la famille Hayes

As we saw earlier, Sandy's experiments with *cire-perdue* were short-lived. He returned to more congenial materials and accepted Rupert Fordham's invitation to sail around Corsica and the south of France. Just before leaving on this jaunt, he sent Kenneth and me the following letter for our anniversary:

The Hayes family devotes June 27, 1930 A.D. to its most favorite pastimes—to celebrate the 14th anniversary of its inauguration. This disturbs only one cow and three fish and proves a joyous occasion for all the rest of the world.

Dedicated this 10th day of June 1930 by its loving brother.

Al Calder
Paris, France

Sandy's letter recounting his adventures with Fordham begins on an uncharacteristically misanthropic note:

Welcome Hotel
Au Bord de la Mer—Plein Midi
Villefranche-sur-Mer
July 27, 1930

Dear Ma and Pa,

I started to write to you last night but didn't get very far. I hope that you will have had a joyful birthday Mama, in spite of our distance apart. . . . However, I think we are more in sympathy, perhaps, when we are some distance apart. (I don't mean we should always be so) but it removes the friction caused by personal contact which always seems to exist altho I seem to be considered "good natured."

I seem to become bored by people in fairly short order—after having embraced them quite warmly to begin with.

I suppose I see the pleasant side of them first, and really am in accord, but get annoyed with their little habits that keep repeatedly appearing.

For instance, L— who, tho not much of a painter is a very congenial and likeable fellow, was so anxious that I enjoy his country that he said, 'Isn't that beautiful?' some 100 to 200 times in a week—and I, being quite certain of my powers of appreciation, got annoyed and finally cleared quite brusquely—thereby having a grand sense of freedom the minute I was on the trolley going to Amsterdam (we were out in the country).

Then I got tired of F—'s ways, altho he is a nice fellow. Too short a memory. Never can remember where he has left a thing, nor what disasters happen to books, jam, victrola records, etc., when one puts to sea without securing them.

Then D—. He's really quite unbearable, tho I had either forgotten it or never really decided about it. He has no resources whatever—except those in the bank.

We put out from Calvi—where we had rested during a 3 days' blow from the south, and wanted to head south to Girolata. But the wind was coming stronger from there so that all we could have done would have been to cruise about and put back to Calvi. But I insisted that we do some cruising, so we turned toward France. . . .

We sailed all day and all night, getting wet with spray and taking watches. Next A.M., however, the boat ceased to respond to the rudder, so we tried various makeshift devices for steering and finally got her to respond to a sweep (a large oar). The weather was gorgeous and I always enjoy mechanical problems, so I enjoyed it to the full. We had to reduce sail so she would steer, so we didn't get there till 9 P.M. or nearly 30 hours out. The eggs I had packed were about the only perishable food that wasn't swishing around the cabin floor. That disgusted me—so I cleared out, stayed at the Decherts a few days and then came here.

I suppose you know Villefranche, and it must be just the same as ever, all up and down the hill, *dirty* and gayly colored. And the hotel is right on the Quai and I am awakened by sunlight and the voices of fishermen and the swishing of nets at 5 A.M.

I have made some quite swell joolery since my arrival, having toted some wire all the way from Paris.

<div align="right">Love,
Sandy</div>

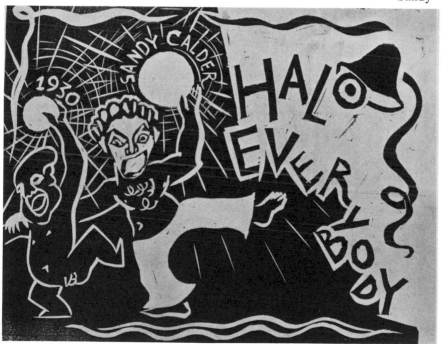

GREETINGS FROM FRANCE. Linoleum cut by Sandy. 1930 *Photo: Colin McRae*

Next Sandy wrote directly to the Hayeses in Berkeley:

7 Villa Brune, Paris 14e
Nov. 11, 1930

Dear Peg, Ken and Brats,

I should have written you long since, at least to thank you for the check, which, being quite in order—(from my standpoint at that moment—tho I wish you wouldn't do those things)—I cashed immediately. Thank you extremely but please don't do it again—a nice letter is quite as fine as anything you can send me.

It seems funny, when I stop to think about it—that I am living in the town where you were born, but which you have never really seen. It's quite a grand town, I assure you! I think I sent you a map once—for I think the map alone quite handsome—and when one passes the Arc de Triomphe and sees that its on the summit of a gentle hill, and then later passes by the "Carrousel" (the small arch in front of the Louvre) and is able to look straight up the Jardin des Tuileries and the Champs Elysées, with all the swell lights, one knows its a swell town. Another thing—the lights are all gas—and at times very profuse —and they are *very* white, and mostly the buildings are very black, so that one gets some fine black and white color effects. It's funny for me to rave about things like that—most people take such things as a matter of course—but it isn't the effect of each individual building, for many, and all the statues are awful, but the coordination and *designedness* of it that is handsome. Every phrenological feature of the terrain has something imposing, if not beautiful, and well placed and surrounded.

As you know, I spent a week in Holland, 2 in Corsica, and 2 in Villefranche (near Nice) last June and July. That seems a long time ago, but I seem to have had no empty spells between then and now. Corsica was marvellous, and although I regret not having seen more of it, perhaps my memory of Calvi is more accurate for not being diffused. Villefranche was fun, chiefly for swimming, and its colour and shape, tho Nice was awful.

I had a bit of worry a month ago when I had to raise my rent, which is high—$150. a quarter—but decided, with the aid of some French broker friends to run 4 regular séances of my circus with a charge attached. We raised $100, and as a check arrived in the meantime from Mr. Wm. Randolph Hearst, Jr. for half of what he owed

me for a room I painted in N.Y. I had no more worries for the nonce and the circus indicated a way out of any possible future difficulties. For we figured that by hiring a place, and running for a week, I can raise my rent money for a year. That is certainly excellent news—as what I need is an unbroken stay in Europe for some time. It's absolutely essential to stay, and put oneself across for all one's got, to get anywhere as far as Paris is concerned. And as it is the merchandising centre for Art, besides other features, it's here I want to be. I am arranging also—and am sure it will go thru—for an exhibition in Stockholm for the spring. Also, a week ago, I sent a great batch of wire jewelry to London for a show in a gallery.

I haven't closed on anything here in Paris as yet—it being a tough job to get the swanker dealers to even come to see one's stuff. However, I am quite confident about it.

Also have reserved room for a sculpture show at Weyhe's in New York for this winter.

Since the hectic 4 nights of circus a few weeks ago—when I managed to get all the neighbors down on me—I have been painting—and now have 5 or 6 canvasses that please me—as well as my other stuff. So I think I can finally do something with it. Have one set of neighbors in the building—there are 8 ateliers—who are very agreeable, which makes it nice.

This seems to be all about me, but I guess that's natural. I sent you a bundle recently with some nonsense for the kids, and a brass necklace in it. Let me know if you don't get it. Love to you all,

Love to you all,
Sandy

Sandy's box of gifts included a tin and wire weather vane in the shape of a fish, which blinked its eye when the wind whirled its tail; a hammered brass napkin ring with his initial for each of us; and a brass wire necklace that I still enjoy wearing.

But in retrospect, this letter of November, 1930, is most remarkable for what it does not say. Louisa had visited Europe at the end of the summer, and she and Sandy were considering various wedding plans. The Circus performances he mentions giving to pay his rent had by then drawn the élite of the Paris art world, notably members of the Abstraction-Création group, which Sandy later joined: they included Arp, Hélion, Pevsner, Van Doesburg, Léger, Breton, and LeCorbusier. To one later performance, a mutual friend had brought Piet Mondrian,

and had taken Sandy to see Mondrian's studio. This visit gave Sandy, as he says in his *Autobiography,* "a shock that started things." Mondrian's airy studio was lit by windows on each side. The walls were white. Between were areas occupied by moveable red, blue, and yellow rectangles, which Mondrian re-arranged at will. Sandy's spontaneous reaction was what fun it would be if the rectangles moved of themselves. Mondrian was not receptive to the idea, but out of this crucial encounter was born the Mobile—abstract form in motion.

Sandy's first reaction, however, was to paint abstract oil paintings. The colors of these first abstract paintings is surprisingly subdued, for Sandy had not yet turned to gouache, the opaque water-based paint that dries quickly and comes in what are now called "Calder colors."

Within a few weeks, Sandy returned to sculpture, but now his sculptures were abstract objects made of wire, small wooden balls, metal shapes. He painted the bases and wires white. Arp later dubbed these abstract sculptures Stabiles. Once during a television interview Marcel Duchamp, then past eighty, described his conscious search for a new way to paint a familiar subject, the pressure he felt to find a new approach, a new method. With Sandy, by contrast, the idea came first, with the problem—and the adventure—of realizing it following from the idea. Now his work with toys and the miniature Circus, frowned on by Father as childish, came into its own, for it had taught Sandy the possibilities and limitations of such materials as wire and wood, and enhanced his capacity to devise artful solutions to mechanical problems. Soon his love for color, especially red, asserted itself.

One object stemming from this period (late 1930), called simply *Une Boule Noire, Une Boule Blanche,* is an assemblage of nine red saucers of differing size above which swing two wooden balls suspended from eight feet of wire. As the balls swing, they strike one or another of the saucers, producing pleasant sounds that vary with the size of the saucer. The effect, both auditory and visual, is one of a peculiarly mesmerizing patterned randomness. The assemblage was reconstructed for a Retrospective at the Fondation Maeght in 1969, and shown again at the Whitney in 1976, where it drew large crowds of children and adults, who, finding it mysteriously hard to tear themselves away, clapped and cheered as one of the balls struck a saucer. How can one explain the continued power to fascinate of this construction, so much less sophisticated than Sandy's later mobiles?

Of course at the time no one but Sandy knew that the Mobile was incubating. Rumors of Sandy's impending marriage, however, had reached my parents, and through them, me. William Hayter, the etcher and printmaker who later held forth at Atelier 17 in London, undertook to find out if they were true. After visiting Sandy, he reported:

> Sandy is to be married. I saw him yesterday. I found him with a clothespin on his nose to which he had fastened a piece of cotton as he has a cold and couldn't take time off for his hands to wipe his nose. He had bread and salami attached to his Bulletin Board by strings. When he wanted either he cut off a hunk. I tried to find out about Louisa, but he was noncommital. Finally I asked, "What does she do?" "She's a philosopher," he replied.

Sandy sailed for the United States in mid-December. From Mother's repeated mentions of Louisa, it became obvious to Kenneth and me that she would be a permanent part of our lives. Hating to be so far from the scene and exasperated when Mother ignored my repeated pleas for a more detailed description of my future sister-in-law, I sent her a sheet of questions to be checked "yes" or "no":

Is she tall —— short —— slim —— thin —— fat ——
sober —— lively —— sedate —— like to dance ——
other interests (besides Sandy) ————————————————

Mother finally answered after Christmas, 1930. By then, the wedding date—January 17, 1931—had been set:

> Well, Maggie Hayes,
> I thought of sitting down to a long letter to you and this morning along come all your questions . . .
> The James girls dragged Sandy out early yesterday morning to purchase a proper hat. His was ancient, unfitting and greasy and he looked like a big bear fooling with a small hat atop. He is after jobs and money and his Circus affairs. He has hopes of making a thousand in the next few weeks! ! ! !
> I think Louisa rather likes his erratic ways but expects to keep a proper menage and her husband looking proper. . . . Here goes for answers. . . .
> She (L) is not enormous, nor fat, medium I should say, athletic somewhat. Fair, blue eyes, bushy brownish hair (the Drews say she

looks Irish). Your father made a bust of her last year and thinks she is very pretty. So she is.

Her speech is Bostonese. As she lived in Paris seven years when the girls were little, their French is good also. They wear large felt hats like poke bonnets, very good coloring, pretty silk dresses, a little different from most of those I see. Louisa takes singing lessons and when we sang Christmas carols at Frances', I stood next and think her voice is good altho she declares she is only in the stage of learning to breathe and can't (kaant) sing yet.

She is neither bold nor shy nor merry, but loves Sandy's jokes and Sandy's mauling. Has, I think a very clear head.

They have travelled a great deal. Spent a year in Rome. I had no knowledge that the affair was anything but companionship and tho I have not asked, surmise things might have come to a climax when Louisa went to Paris this fall after cycling around Ireland. I think she would have stayed and married him then, except for consideration for her mother and for her sister Mary, with whom she was to share an apartment.

You should see the wedding ring! Yum. . . . He gave me a bully ornament, one which I will love to wear, a big circle of flattened wire with a stone in the middle.

She will root for him and already has a buyer for something. She is self possessed, having taken care of herself and gone her own way for years. Though she has not earned the money. I think the Indian ring or the turquoise might be nice to send her although she wears a diamond and two sapphires and I think may have conservative taste, but I really think a Chinese silk kimono would be the best gift from you. . . . I wonder will she ever fall for the gay colors and exotic things we like.

She is determined to have a little home that is comfortable and pleasant and expects to rent it in a quarter where the hoi polloi can't come in for a drink.

Am I happy about it. You bet! And I am eager for the wedding. But I wish they would not make us go to Concord. It is really hard on your father, though he is very pleased with Louisa. . . . She has nice manners and speech and a good head; is 25 years old. . . .

 Mother

On January 12, 1931, the day after his birthday, Father wrote me

from 56 Washington Mews, where he and Mother were living for the winter:

Dear Peg,

I was much affected by your fine letter that came pat on the eve of my 61st birthday. I found it waiting for me, on entering our cosey little place here before dinner. We had arranged to dine out at an Italian speakeasy with the young couple, and your Mother had not yet come in, so that it was quiet between us, and I got the fullest effect of your good thoughts.

Whatever else fate has dealt out to me, I certainly have drawn luck in wife and children, for I can claim no forethought or merit in it. . . . You will be glad to know that Sandy has presented me with a Palm Beach violet ray sunbath and I shall try it out.

Bun's amusing thanks letter came today. Between ourselves I thought his Xmas prints the most original and stimulating of the many we received. His line, 'Merriment to you boy' is inimitable and the other was well drawn. Another in the Arts perhaps? Better let it go 'just as it falls.' ["Bun" became a physician.]

. . . Your Mother suggests that I tell you of your sister-in-law to be. In character, directly different from Sandy, who fascinates her with his rough playfulness. She is rather reserved and undemonstrative— told me so when I embraced her as our new daughter. She is physically attractive and speaks very prettily, with an accent derived, she says, from an early English governess. Also speaks French well enough to be able to laugh at Sandy's. I think she is a very nice girl and should do your brother a lot of good. . . .

Pop

I had to be content with these descriptions of Louisa until my visit to Pittsfield in the summer of 1933, when I at last met my beautiful sister-in-law. We all went swimming in the quarry every day. Louisa pinned her hair back and swam the breast stroke with smooth, even strokes so that her oval, patrician face with its blue, blue eyes floated above the water like an exquisite cameo. Her wavy chestnut hair was tinged with copper, as though brushed by a turkey's wing.

Not only did Louisa prove to love "gay colors and exotic things" as much as we did, she also had a similar sense of values, of what living is all about. She took to strong color and an artist's life with a skill for enjoying and enriching it that uncovered many talents of her

own. When I met her she was quiet but gay, with a keen sense of fun. She loved to dance, to play baseball, basketball, and hockey, and was always ready for a trip or new adventure. She proved a perfect companion for Sandy, accepting his unusual ideas, the twists and turns of his development, with appreciation of his talent, humor, and ingenuity.

Like many reserved people, Louisa has strong affections and feelings. Now that she is older, she expresses them more freely, but when she was a young woman the only outward sign of inner emotion was a red line running up her neck. She was stoical when, in the first year of marriage, she had a miscarriage. It was Sandy who wept over the loss of a little boy.

In spite of the great differences in their circumstances and upbringing, Louisa took to the unconventional life of an artist with seeming ease. She became an accomplished cook and at one time was heard to say she would like to have a restaurant! Like her parents she was not afraid of holding uncommon ideas, espousing unpopular causes, or living in unconventional ways. Her father, Edward Holton James, was a nephew of William and Henry James; he held strong opinions on ethics, religion, and mysticism. For two years, 1910–12, he published *The Liberator,* a news sheet that, among other things, questioned the legitimacy of Edward VII (his London distributor was jailed for two years for selling it). His nose was broken by the police as he joined with many others on the Boston Common to protest the conviction of Sacco and Vanzetti. After studying Jewish history in Jerusalem, he wrote *Jesus for Jews,* for which Sandy did the dustjacket, and, after traveling around India, *The Brown Man's Burden,* which included a photograph of an Indian carrying his trunk.

Louisa demonstrated the same spirit when she took a handsome full-page advertisement in the *New York Times* of January 2, 1966, calling for a New World in the New Year, for an end to hypocrisy and self-interest. The advertisement ended *Reason is not treason.* She and Sandy, who was Chairman of Artists for a Sane Nuclear Policy, flew to the United States from France to take part in the March on Washington.

Mr. James suffered from asthma, and spent many years searching for relief. He drove to Colorado and other reportedly beneficial places in a well-appointed Pontiac that had an Oriental rug and a space for sleeping. He cultivated the Gandhian attitude toward others, and one night was awakened at 2 A.M. by a policeman who ordered him to take

his watch and other valuables from the dashboard and put them where they would not tempt thieves. He and his wife lived in separate houses on their Concord estate. He built his house over a little brook that ran through the property, where without disturbing anyone he practiced the violin for hours.

Louisa Cushing James, Louisa's mother, was a tall, stately woman, rather detached from the mundane aspects of housekeeping and child-rearing. She allowed her three daughters, each of whom had inherited an income from their Grandmother Cushing, to go their own ways after their governess years. She was a Christian Scientist and a member of the American Friends Service Committee. In the 1930's she invited Mother to accompany her to one of the Institutes of International Relations the Committee was conducting in an effort to prevent the on-coming world war by educating people about the underlying forces. When I met her in 1933, she had white hair and looked superb in the purple clothes she loved to wear. She kept busy doing needlepoint as a discipline for her hands, which had developed a slight tremor.

Although the James household was so very different from hers, which pivoted around Father's needs and comfort, when the wedding day came Mother rose above Father's fretting over the possibility that his Leif would freeze and above Sandy's casual manners to enjoy it all. In this she was helped by Sandy's best man, the thoughtful and affectionate Bill Drew.

Sandy and Louisa were married on January 17. Sandy took his Circus to Concord and put on a gala performance the evening before. Two days later Mother wrote me:

January 19, 1931

Peg dearie,

. . . Here goes—Sandy and Mrs. Sandy are out with the Harrises at Cold Spring Harbor. . . .

En route to the wedding Bill [Drew], your Dad and I had a drawing room and we were cosey, quiet and chatty. Bill attended to this and I am glad he did for your dad would never have thought of a drawing room and privacy—hang the cost!

Sandy in a blue shirt and red tie met us at Back Bay station with a Mr. Prescott who owned the car.

The Jameses have two houses. In one they do not cook. There is a very large living room with the first floor and bed rooms above.

When we arrived Louisa in all her glory of a new blue frock, long train and tiger lilies, white with red spots, was having photographs taken by professional people who came out from Boston on their own responsibility. It was awful and funny. They did not want Sandy around. He would say 'Chin up' and they would say 'Head down.' . . . There was an aunt, Mr. James's sister, [Aunt Mary] Vaux from Bryn Mawr who was bossing and told them they had 'two more minutes, Hurry up!' . . .

Then Louisa went up to one of the bedrooms. She was sweet about two gardenias I brought her and had them tied to her lilies.

Then they began to coax Sandy to dress. I went over to our quarters—2 rooms and bath in the house where they have food. Father put on his dark blue suit and I my yellow silk . . . sounds gay and when I again went over to the house where the ceremony was to be, forty-eleven old dames were assembling; there was Kath Bangs . . . I blessed her for being there. It seems Sandy phoned her the night before. . . .

The last I saw of Sandy he had on a nice new blue suit, a red and white tie and was tieing his brown shoes. I congratulated him that he had had them shined. But Bill tells me Louisa sent him word he was to wear black shoes. He had on his dancing blacks when he marched in with Bill as best man. The minister in white robe was waiting. Candles lighted and someone at the piano playing anything but the proverbial wedding music. Rather nice, Bill tells me the minister asked Sandy what kind of ceremony he wished and he said 'anything you wish will be all right with me.' They left out the blessing of the ring, but the 'I take and I will' were dutifully spoken. . . .

After the ceremony they had the usual tea food—plenty of good ice cream. Then six couples went off to a wedding party—Mr. and Mrs. Calder, Mr. and Mrs. [Charles] Prescott, Mr. Drew and Miss [Helen] Coolidge, and we got left, for after all had departed . . . for the night train to New York, we were alone with Mrs. James who had provided nothing [for supper]. Your father asked for some tea and after half an hour or so, there was cheese, bread and tea. Mrs. James has no interest in housekeeping and as she is going to live in N.Y. this winter has no servants. Only someone who came in for the wedding.

After I was in bed there was a telephone message for Mrs. Calder. She called me and I went to the phone. It was a telegram for Mrs.

Just before Sandy and Louisa's wedding. *Sandy would say* *Photo: Bachrach*
'Chin up!' They would say 'Head down'

Sandy Calder. I guess she was pretty tired and woebegone after so much excitement.

In the morning we were up, bathed and dressed but as she had engaged someone to come in and get breakfast, I was not allowed to prepare it. Finally we had it and were sent to Boston to catch the 10 o'clock. . . .

Bill met us and gave us the history of their doings. He gave me two terrible photos of the six, but Sandy said HE wanted to send you the photos so I won't. . . .

Maybe Sandy will write some more to you. He behaved beautifully. But I wager he never paid the minister, not even $2.00 [a reference to June 27, 1916].

. . . Most of Sandy's gifts, in fact all, are checks and much of Louisa's. They won't starve the first year.

I was quite pleased to see her carry away with her the two gardenias I had given her. I did not like either of her gowns, though they were up to date and stylish. She usually has something plain and out of the usual. I took the necklace from the Near East I had for her and forgot to give it to her. . . .

Louisa's mother is handsome, very nice and has a hesitancy in her speech which is caused by paralysis which also makes her forget easily. But she is *very* kindly, has always had plenty of money and not being obliged to cook, and not liking it, does not think much about the housekeeping which is so much a part of life for most of us.

Mother

Sandy and Louisa stayed on in the United States, visiting friends, till late January. They spent a few days at Cold Spring Harbor visiting Jane and Reggie Harris, who had just returned from Yucatan. There Reggie, an anthropologist, had studied the white Indians while Jane modeled them. Jane later wrote about the newlyweds' visit: "We decided to go out for dinner and dancing. . . . I told Reggie he was asleep on his feet. When we returned to the table Sandy and Louisa were not dancing. Louisa said Sandy was an exhibitionist. So we changed partners and had a lovely evening together."

A few days before they sailed for France, Mother wrote again:

Dear Pegus

Sandy and Louisa stayed at the Harris's until last afternoon and then all four came in for tea. They were a hungry crowd. . . . We

went to the Italian restaurant and then to the Italian marionettes. We went back stage and it was most interesting.

The Calders are now at the Brevoort. Everybody has been most kind and there were checks. Ken's Mother's pewter duck is appreciated and your Father wants them to leave it but they won't, they love it so much. Gwladys and Bill are sending checks "so Sandy can hold up his end of their house purchases" for Louisa has received a good sum from her Grandmother's will and from her Mother. . . .

Sandy is rushing after some business in the interim. Louisa cut his hair when they arrived yesterday. Reg says they made him feel young. He has fallen in love with Louisa.

Mother

A few days later Sandy wrote from shipboard:

Sunday, Feb. 1, 1931
S.S. Farmer

Dear Peg, Ken and Brats,

This seems to be your natal day and we're going to your natal city, so you really would deserve a letter on either of those counts alone. But your unstinted attention and enthusiasm has been marvelous and delightful and it seems really a great dommage that we're off in the wrong direction instead of passing your way to pay you a visit. But of course, this trip to Paris again is not a visit abroad, but a returning home for we have elected to live there for a while.

So—I've got to get home and get to work.

Your checks have been highly appreciated, too and your instructions about buying ourselves a gift from you shall be carried out to the letter. And we thank you.

Mrs. Pat's pewter duck is very handsome and was courted in vain by father who seemed to think it would be very difficult to transport. . . .

This ship has been very pleasant with only 30 people aboard out of a possible 80. The food is quite *American,* but really very fair, and swell pastry and plenty of deck space and small and built like a ship and not like a lousy hotel on a barge.

The weather has been remarkably mild and smooth for this season, except for yesterday (Saturday). It got quite choppy during the day and quite interesting at night. We waited four hours to enter Plymouth breakwater. Medusa (this is a general descriptive name, due to hair

part, may be used by anyone) and I spent several hours around midnight standing in the wet on deck right under the bridge watching the waves go under and the spray break over the ship. It was really very exciting to watch the light houses and the lights of the other ships and the men crawling up the ladder into the crows nest.

Plymouth Harbor, where we found ourselves anchored on waking, was very handsome and bathed in sunshine and quite balmy and they were busy unloading some 3000 bags of mail onto a tug alongside. It was like being on the Mediterranean. We sail up the Thames tonight or tomorrow and expect to spend a night or 2 and go to the theatre.

I know a very nice English boy whom we hope to see. Then we're off home to Paris and work. . . .

Sand.

Louisa's inheritance, along with wedding checks from friends and relatives, now made it possible for Sandy to experiment freely, without regard to what would sell, to follow his imagination wherever it might lead. But the gift of money, which brought with it the more precious gifts of time and space, did not free Sandy of either the need or the determination to make his own way, to "put himself over." He was returning to Paris, as he said, to establish a home and to work.

For the next few months, the letters from Paris were taken up primarily with house-keeping details, partly because Sandy and Louisa were happily engrossed by them, partly because they knew that Mother would want to picture the scene as vividly as she could. Unfortunately for the young man who had written so disparagingly of obese Berliners, the letters are also filled with requests for recipes and happy reports of new, usually fattening, dishes added to the couple's cooking repertory. Sandy never failed to inquire affectionately after our parents' health and the progress of Father's work on Leif Ericson; to avoid boring the reader, I have deleted most of these inquiries.

7 Villa Brune, Feb. 16, 1931

Dear Ma and Pa,

We have been so happily busy getting arranged that I feel very mean not to have transmitted a word of it sooner. . . .

Thank you again for being so enthusiastic about my wife. She's quite a peach and also seems to be a good COOK. We have already taken a house that Pauline Cauchie [Louisa's former governess] had seen while looking for a place for her family. Their rent is the same as

for my place here 15000 francs except that we have to pay a reprise of 16000 fr. . . . The address is 14 Rue de la Colonie XIII but right near the edge of the XV and right off rue de Tolbiac, which is a continuation of rue d'Alésia. It's down in the direction of Porte d'Italie. There are 3 floors, the top being mainly a studio. All the rooms seem quite light. . . .

I am to illustrate 50 of Aesop's Fables for "Harrison of Paris" who are friends of mine here. There's not an awful lot of money in it, but it's not bad as a job in Paris—and it's a very swell job, anyway.

. . . Have to read to my wife now so God bless you both.

Sandy

7 Villa Brune March 3, 1931

Dear Ma and Pa,

My charming wife is opposite munching a cheekful of bread, my back is leaning against the open window and the *bonne* is clearing away the repast. We have been running a fire in the grate ever since arriving—and ceased after a few days to bother about the *chauffage* central, as that is so stuffy a system anyway. We eventually discovered that we could burn anthracite in the grate, and I have extended the cowl downwards with a piece of tin so that it burns beautifully.

Our place at 7 Villa Brune is very cheerful (I found two smaller Arab curtains like that one you have just before sailing for N.Y. and they're both up). The walls are white, the fireplace black—a black head and some mimosa on the mantel, a colorful toy or two, a group of necklaces of mine tacked on the wall, a few books, in a corner 2 'poufs' (Arab cushions), a very gay, gay red rug, red blanket, a couple of pieces of tin, painted, for manipulating the fire, and a little table, all in a room about 14 x 8 ft. (and a good big window on the SE). The studio, etc., is below. It is all fine and gay, but a bit too tiny.

The gent is coming to tell us something about the house in an hour or so, so I'll tell you that afterwards.

We bought a bureau and another smaller device—both very nice, the other day with father's check. We are being very careful to attribute nice and permanent objects to each of the donors of checks.

In dining, we put a large plank on 2 boxes, quite low, spread a cloth etc. and sit on the Arab poufs right before the fire. And it really is lots of fun with all the giddy colors about. We have a *bonne* each day for 2 or 3 hours at noon.

Medusa has proven a very good cook—nothing very complicated so far, but very O.K. We inquired in an Italian restaurant how Zabaglione was made and have been making it 2 or 4 times a day, ever since.

The gent did not show up so I am scribbling away to get this on the Olympic.

Last week we saw a French lady called Marie Debas—she was very amusing with songs and gestures. . . .

Am still working shows here and in Stockholm, with nothing very definite in sight. Nobody in Paris wants to do anything just now.

A bientôt,
Sandy

Sandy's efforts to arrange an exhibition finally bore fruit. He and Louisa were to move into the house at 14 Rue de la Colonie on May 1, just after the preview Vernissage and Opening at the Galerie Percier. Louisa wrote Mother about their affairs:

Sunday
Dear Mrs. Calder,

Sandy has just about finished the Aesop illustrations and everybody is very pleased with them. They really are excellent and very original (naturally) and amusing.

Then he is going to have a Show in April, the 27th–May 9, but he will probably write you more about it in detail.

. . . We are both in good health only I have another cold and Sandy has had three nose bleeds in the last two days. We went to a party or two where the atmosphere was dry and smokey and that probably started it. He gained a lot of weight so we don't eat potatoes or bread at home, but it's difficult to keep on that diet when bread and potatoes are always being shoved under one's noses in restaurants; they always look so delicious. . . .

Sandy is working downstairs and talking to Varèse, the composer, whose music corresponds to Sandy's wire abstractions, so he likes to watch him work. We bought a nice portable Columbia Victrola with Mother's birthday money and have already been enjoying it tremendously.

We both go to gym three times a week, not of course, to the same one and I love it. I never get enough strenuous exercise except when Sandy and I have tussles and he knocks me down and I try to knock

him down which is a more difficult proposition. . . .

I'm afraid our Moroccan trip will have to be postponed till next year, on account of the Exhibition and later on in the spring it will probably be too hot, and we also have our house to settle. We'll be moving in on the first of May and I hope I will have nothing more to do than to paint the walls. It seems very clean and in a good condition now and the garden, I am sure, will be a lot of fun. . . .

<div style="text-align: right">Medusa</div>

Sandy wrote next time, giving their new address:

<div style="text-align: right">14 Rue de la Colonie,
Paris 13e</div>

Dear Ma and Pa,

What with all that's to be done in the house and all the sociabilities of having people to lunch in the garden and going to see them for tea—things are pretty busy. So I haven't undertaken any new work as yet. All the house excepting the staircase, kitch & bath are to be white. The kitchen and bath are a pale blue and we are having them washed, simply, by the painter. The staircase is to be white, with all the woodwork black—and we have an old yellow carpet for a runner. We are going to attempt a lawn in the garden which at present, is gravel. But the garden will not compare with yours at Pittsfield.

I wish we were already there to enjoy it. The front room on the second floor we are going to use as a gallery, for my stuff and for some 7 or 8 others, who paint or work in the same direction, as there is no place where they can be seen collectively.

We have just heard from Mr. James that his book *The Brown Man's Burden* is being published in Geneva, and that he expects to be here in about 3 weeks. . . .

<div style="text-align: right">Love to you, Sandy
Much love from Medusa</div>

<div style="text-align: right">Fri. 20 March</div>

Dear Ma and Pa,

. . . I have arranged a show at the *Galerie Percier*—38 rue la Boëtie for April 27–May 9. It's a small but very good gallery, and the season is quite one of the best, especially as the Colonial Exposition opens May 1st . . . which is the day we move into 14 rue de la Colonie (Amusing?).

The *Aesop* is just about finished as far as I am concerned. I mean the work I have to do with it, tho I am much interested in the outcome. 'Munroe' was Munroe Wheeler. He and Miss Harrison comprise *Harrison of Paris* for whom I am doing the book. They seem much pleased with the drawings and the 17th century English is swell. . . .

Sandy

Fables of AEsop According to Sir Roger L'Estrange was published in August, 1931. The two hundred fables with fifty drawings by Sandy were based on the 1682 edition of AEsop retaining the Elizabethan spelling and inconsistencies. It was printed in a limited edition on Guarro's Spanish pure rag paper with colored silk threads.

This was the first of the five books Sandy illustrated. *Three Young Rats and Other Rhymes* was published in 1944 by Curt Valentin, then Sandy's dealer. *The Rime of the Ancient Mariner* was published in 1946. This volume contains an essay by Robert Penn Warren and a line drawing by Sandy that reads "For Malcolm Cowley." Our copy, which arrived on February 1st, had a freely drawn map of the United States covering the first two pages. Across the continent a naked Sandy, his foot in Connecticut, stretches out to hand the volume "With love to Peg on her Feb. 1. Sandy."

Selected Fables of Jean de la Fontaine, a large and joyous book, arrived at Christmas, 1948. The illustrations for Richard Wilbur's *A Bestiary* (1955) are drawn with great gusto and humor. Although not as elaborate as *AEsop,* the four later books are all deluxe editions, printed on heavy rag paper. Sandy's line drawings reflect his abundant amusement in their contents.

12 Rue de la Colonie
Tuesday Apr. 21-31

Dear Ma and Pa,

My show starting in 6 days I naturally have a few things on my mind. I think it will go over very well among the artists, some dozen of whom have seen the things and are very enthusiastic. . . . These things are abstractions in wire with spheres and blocks of wood painted in some instances. I got Fernand Léger to write me a very nice preface. [In forwarding the letter to me Mother added, "One of the present abstractionists. So severe and steely. I could not stay in the room where they were."]

The catalogs will be out in a few days, and you'll get one directly. I am also showing portraits in wire, and drawings. I haven't decided on prices as yet, but will do that when I get the stuff to the Galerie, in conjunction with the men there. I really don't expect to sell much, but may do something with the masks and drawings. . . .

Medusa bought a bike, and I borrowed one Friday a week ago, and took a late train for Chantilly, getting there at 9 P.M. Then we lighted up and biked to Senlis (where the Chamberlains live) in about an hour and rang violently at a hotel (everything was black) and finally a garçon came and got very sassy thru the grille—and wouldn't open up! So there was nothing for it but to go to the Cauchies' little house. We got there in half an hour or so—after biking thru the forest of tall slender black trees, where occasionally a few birds let out exotic cries. It was really quite exciting. Once arrived chez les Cauchies we had some difficulty in arousing them and thought for a few minutes that we were out of luck and would have to sleep in the forest.

The following day, Saturday, we went to a stag hunt on our bikes. There were also crowds of people watching from autos, bikes, etc., and afoot, with baby carriers often—and we all saw a good deal more of the animals than the hunters.

We biked over to Senlis and saw Sam and Narcissa for a minute before lunch.

Sunday we went out and dug a lot of primroses (for our garden) and brought them back in a knapsack. Sunday evening we came back, biking thru the forest to Chantilly direct, more or less. They had fenced off several parts of the wood, on account of the hunt—so, to even reach the signposts to see where we were to go, we had to lift our sacks, our bikes, and ourselves over picket fences. But we got here ok. and all the flowers are growing beautifully.

This Friday and Saturday we set the Circus up in the [Karl] Einsteins, our neighbors, apartment and had a double header party. . . .

Sunday we went and saw the Fratellinis in their travelling show (these gymnast clowns used my dog this year . . .) and then stayed till 2 o'clock to watch them strike the tent.

Sandow

Sandy and Louisa moved as planned on the first of May although the workmen had not finished and were still underfoot.

[1931]

Dear Ma and Pa,

. . . Mr. James just wrote and asked us to see Brentanos about handling his book here. The manager to whom I talked is an Englishman, and most of the employees seem English, and when he said he'd like to see the book, I almost started to tell him that it hit hard at the English, but caught myself, and didn't say anything committal. However, when the book arrives . . . he will have to see it, and of course, you know what it's about. . . .

Our Corsican *bonne* (for 2 hours a day) is amiable, but really not very bright. There's an Italian shop around the corner, which has corn-meal so I got some and undertook to make polenta. She corrected my system for making the pulp, and after that, of course, it was simple sailing. I know we asked you more than once, but will you tell me again how to make a *rice pudding,* a chocolate pudding, a *gateau de riz,* please. We have been living chiefly on salad, and strawberries and cream.

The garden is really good fun to sit in, altho at the moment it is just a bit too hot and still to be comfortable anywhere. We had some 9 or 10 people dining out there about the light of one candle, stuck in a glass for protection against the wind.

There are 2 large rose bushes out there which go up about 6 ft. and then branch out with the aid of a wire frame, one into a sphere and the other into an umbrella. The bumbershoot is covered with probably hundreds of buds, and the sphere has 40 or 50 brilliant red roses on it in a lump about 8 ft. off the ground. . . .

We have been expecting Mr. James to arrive shortly, but it seems as tho he would stay in Geneva somewhat longer. . . .

Love to you, Sandy

[1931]

Dear Parents Calder,

Sandy was so overcome by the effort of writing to his sister that I said I would write to you. The weather for the last two days has been sweltering and so our garden has been of little use to us except that in it now we have a baby crow. A friend of Sandys found it in the country by the roadside and gave him to us yesterday. He's terribly cunning and although he's at least three times the size of a large robin, he cannot fly or eat by himself. He's probably about two months old and has a perpetual hunger, opening his large red throat and cawing

loudly for food to be dropped down it.

I am anxious to get another turtle to keep him company.

We went last night to the Exposition Colonial and found it quite nice, although we didn't see nearly all of it.

We may be able to find some nice rugs which seem to be quite expensive now, but will undoubtedly be cheaper at the end of the summer.

. . .

A day or two have passed unfortunately and this is a very sad day because the crow is dead. We have no luck. He must have tried to fly and hit his head or broken his neck because we looked all over for him and found him on a ledge against the wall. We had gotten so devoted to him those few days we had him and now he's buried next to the turtle. It's a sad life. I hardly have the heart to accept any animals because something always happens to them and then you feel so sad.

The house is being completed very rapidly now. We bought, yesterday, a large sofa and five small arm chairs but we have to wait a month for them to be made. We also bought a table which may be the dining room table. It's long and slender made of cherry wood and I suppose about a hundred and fifty years old. It cost 550 francs which isn't expensive, and for 200 francs Sandy bought from some French friends a sideboard. It's long with three square doors and quite low. So you see we are gradually getting furnished.

We have already had many guests for meals, mostly in the garden, and last night we were six and Sandy made a delicious polenta.

We expect Father any day now, but I'm afraid his visit will be very short. . . .

<div style="text-align: right;">

With much love to you from both of us,
Medusa

</div>

After the Leif was cast in bronze, Father asked Sandy and Louisa if they would be interested in overseeing its installation in Iceland. They had planned to go walking in Majorca, but were willing to change their plan. In fact, they became enthusiastic as they read of the macabre, spectacular country with its almost medieval dwellings and just ponies or small horses for transportation. A "very nice" young Icelander, "long, gaunt, and blond," told them there were boats every two weeks out of England and Norway and advised going in July

when they would see the northern lights. But Father decided to send
instead a young sculptor from the foundry who could also accompany
the statue on the ship across the Atlantic.

[1931]

Dear Ma and Pa,

. . . The painters are soon to leave—they are at the moment doing
the banisters—which are a shining black against the flat white wall—
and they are going to be quite swell.

Medusa came in yesterday A.M.—looking rather foolish and said—
"I've bought a dog" so now we have a small Briard (I think he's only
half Briard) about 2 feet long, 9 months old, fluffy hair, white body,
gray head, long black ears and very playful. We had just planted grass
yesterday when he arrived, tore around the garden 20 times and dug 3
holes all in 10 minutes . . . whilst we all laughed violently.

Einstein, my erstwhile neighbor at 7 Villa Brune, is off to Russia
in 6 more days. Mary, Mrs. Einstein, is in Ville franche until he
returns in 3 months. He and Hélion, a young Frenchman are going as
'students' that classification giving them much greater entreé into places
and things.

I thought I'd told you that Mr. James arrived last Sunday morning
and stayed till Monday evening. We saw various people about handling
or reviewing his book. Also he took us in to see the "Conciergerie," in
the Cité which was one of the first places built in Paris and which had
dungeons and cells in the interior—which were used during the Reign
of Terror and even within the last 100 years.

We had some people to tea on Sunday, and others to dinner on
Monday, and he got into very strenuous arguments on both occasions.
. . .

Sunday it was very funny because Léonce Rosenberg insisted that
Judas had NOT betrayed Christ for money but because of some higher
motive. However, he admitted that he had taken some cash "but that
was just a blind." . . .

Love to you,
Sandy

Meanwhile, Sandy's show in the Galerie Percier, called "Volumes—
Vecteurs—Densités—Dessins—Portraits," was winning the praises of
critics and friends of art. In the window, there were drawings of the

Circus. High up on the walls, there hung wire portraits. And around the room, on boards and boxes painted white, were stationary abstract sculptures of wood, metal, and wire—Sandy's first Stabiles, though the term was not invented till the following year.

Critic Don Brown wrote in the *Paris Tribune* on May 2, 1931:

AMERICAN ARTIST WINS PRAISE FOR HIS WORK IN WIRE

Calder Amuses in Show by Use of Unusual Materials

Work of art executed in wire, wood, tin cans, sheet zinc, whitewash, housepaint and other materials, which Leo Stein, internationally recognized art critic, yesterday characterized as being far more interesting and successful than the recent productions of two of the most famous French moderns in the world, are being shown by Alexander Calder, young New York artist, in the Galerie Percier, 38 Rue la Boëtie.

Blasé amateurs, artists and critics, wearily wandering up and down the Rue de la Boëtie in search of something new and refreshing, dropped into the Percier gallery by ones and twos yesterday afternoon while the *Tribune* reporter was there. After one glance around, they took off their hats, fanned themselves, looked at one another in pleased surprise, and appeared refreshed.

Many of the works shown by Calder are extremely witty. . . . Calder's work obviously amuses and refreshes those who see it, but he is not being taken as a joke in France.

The show was a critical and popular success. But once again, nothing was sold.

14 rue de la Colonie, Paris 13
May 25, 1931

Dear Peg and all Allies,

Thank so much for your swell long letter.

The show has been over quite 2 weeks. I didn't sell anything, but it was a very handsome show, and was a real success among the artists. Of course, if we had sold a few things it would have been very much more exciting, but I am not disappointed. Things are *very* slow just now, and everybody said it was not the year to do it. But if I had waited a year to put it on I would have lost a year, and it takes some working and showing and waiting to arrive at all. Probably all the present day headliners *"ont mangé de la vache enragée dans leur*

temps." I will send some photos bientôt. (There were many guys who showed in bigger, snappier galleries, with lots of advertising and who didn't sell anything either.)

Since May 2 we have been living in our new house. It's really very nice, large, squarish rooms with big windows; 3 stories high . . . and a small garden derrière with many plants and small trees. . . .

The Ville de Paris is building a 2-story salt warehouse next door. They have been working on the basement a year and intend taking 2 years more. And they get out at 6 AM Sundays included and yell like bloody murder, and Medusa sleeps right along.

The house is in a section we are little accustomed to. Toward the south and east—on the edge of the 13th Arrondissement—near the 14th—and is really very near the *bâtiments*—(the ancient fortifications) which have been demolished in most places. This is very nice as it is very simple to get out of the city. . . .

<div align="right">Sandy</div>

With summer approaching, they began planning a trip, on which Louisa's sister Mary was to accompany them.

<div align="right">July 1, 1931, Paris</div>

Dear Ma and Pa,

. . . A friend of ours gave us a card to the Matisse vernissage a couple of weeks ago. We got all dressed up and went and had never seen so many Americans together before. Even A. C. Barnes was there with a bunch of old Philadelphia hens. Also Birnbaum, once of Scott and Fowles. And rafts of others from New York, Chicago, etc. . . .

I am now a member of the new group called "Abstraction-Création"—composed solely of people who do abstractions—and who will show in the fall (November). They are also going to publish a journal.

<div align="right">Love to you 2
Sandy</div>

In the Abstraction-Création group were many of Sandy's new friends, serious artists searching for new forms of expression. Members of the group drew encouragement from the support of one another, though each of them pursued an independent course. Mondrian, Hélion, and Miró seem to have most directly influenced Sandy's thinking, but he soon worked out his own ideas, his own style and idiom. From the beginning, his constructions related to the organic world;

it was to nature that he turned for elements of abstract form. The gaiety and spontaneity of so much of his work give it a deceptive air of simplicity. In fact there is always an integrated underlying structure. He did not work in a haphazard, unpremeditated way. Although later he came to be called the "Father of Kinetic Art," his interest, unlike Tinguely's, for instance, was never in gadgets that spin and fly for their own sake. Mechanics were always the means of realizing an idea. Much of Tinguely's work ends in self-destruction; Sandy poked fun at deadly seriousness in art.

Louisa accepted Sandy's new alignment as though she had expected it all the time.

Despite their awakened interest in Iceland, she and Sandy went instead on the trip to Majorca originally planned. They went by train to Barcelona and then by boat to Majorca, where they stayed at first in the Hotel Mediterráneo. In Palma, they visited with the family of Joan Miró's wife, Pilar, a numerous and pleasant tribe.

After a month's stay in a smaller hotel, they packed their knapsacks and set off on the road that circles the island. In some places this road rose high above the sea, in others dropped down close to it. From the highest peak in the north, the terraced slopes ran down to the ocean, ending in a series of small coves and larger harbors which scallop the edges of the land at water's edge. Where the road neared the sea, they found fishing villages that offered quaint, unusual, and often uncomfortable shelter. They became addicted to espadrilles and played a game in which one or the other would sight some novelty ahead. This carried them eagerly forward, much as Last Tag lures the players on and on.

They found that although the villages differed in many ways, they suffered a common deficiency—water. So they kept on, wearing out their footgear and sending postcards to their families. Louisa lost her heart to the baby donkeys with their bulgy foreheads and turned-up noses. Sandy found it hard to persuade her that one would not fare well in their Paris garden. But they did send me a donkey hobble, with suggestions about whom to hobble.

Life seems to have been so full for Sandy until the fall of 1931 that, although he doubtless thought a lot about his visions of color in motion, it was not until he and Louisa had returned from Majorca that he retired to his studio on the top floor of 14 Rue de la Colonie to work out his ideas. "We are having a terrific amount of rain, almost continuous," he wrote, "but my shop is gloriously light."

11

After their trip, Sandy retired to his top-floor studio-gallery and spent hours in working out his vision of colored forms floating in space, the vision that had leapt into his imagination in Mondrian's studio. Working with the energy and efficiency that later became legendary, he drew on his knowledge of engineering and on his experience putting together his Circus. His first moving objects, such as Mother's fish bowl and the horses of his Circus, moved by hand-turned cranks, but now he turned to small motors.

By early winter he had completed a sufficient number of moving sculptures that satisfied him to begin thinking about exhibiting them. In this he was encouraged by some of his and Louisa's guests, of whom there were many, for he and Louisa continued to give performances of the Circus, once staging it for three nights running and entertaining over a hundred people.

Marie Cuttoli agreed to exhibit the new objects in her Galerie Vignon from February 22 to 29, 1932. Sandy always felt great affection for Mme. Cuttoli, and remembered with gratitude her warm interest in his innovative work. Later he designed rugs for her to have made, and in 1964 he and Louisa visited with her in Morocco, staying "in the lovely hotel Momonnia." Fifteen of the sculptures shown at the Galerie Vignon were driven by motors; the other fifteen had moving elements. It was at this time that Duchamp suggested the name Mobiles for those which moved, and Sandy made the sign of wire proclaiming

<div align="center">

CALDER
Ses Mobiles

</div>

He defined the new art form: "A Mobile is an abstract sculpture made chiefly out of sheet metal, steel rods, wire, and wood. Some or all of

these elements move, propelled by electric motors, wind, water or by hand." It seems a straightforward enough concept, and, now, almost an obvious one, but viewers who saw these first mobiles tended, like me when I saw them first in Pittsfield a year and a half later, to be intrigued but nonplussed.

<div style="text-align: right">14 Rue de la Colonie
[1932]</div>

Dear Ma and Pa,

I am working and starving. Working in a gymnasium—and starving myself as well as possible at mealtimes. I have stomach trouble— (it's too big)—so tout est malheureux—mais ça viendra.

My wife is yodelling more strongly than usual. It carries all the way up to the studio. . . .

Joan Miró, the Spanish painter who lives near Barcelona, is in Monte Carlo, doing the decors for a Ballet Russe. He knows my stuff so I wrote him and sent him photos and perhaps I will be able to do a ballet next year. The Russian who used to do them, Diagileff, died two years ago but one of the McCormacks has put up some money for their continuance. . . .

When were the Léger's there—this winter, or some years ago— I like some of his earlier things, but didn't at all like his show last year at Rosenberg's (here). . . .

<div style="text-align: right">Love,
Sandy</div>

In April, 1932, Sandy and Louisa visited their families, friends, and dealers in the United States, and in May his motor-driven Mobiles were introduced to the public at the recently opened Julien Levy Galleries. The invitation to the preview added a descriptive term to the previous announcement:

<div style="text-align: center">Calder
Mobiles
Abstract Sculpture</div>

Again there was a foreword to the catalogue, this one by Léger, who classed Sandy among "those incontestable masters of an inexpressive and silent beauty."

The reviewers were not so sure:

> There is something absolutely new in sculpture at the Julien Levy Galleries . . . where "Mobiles" by Alexander Calder were

placed on view yesterday. . . . "Mobiles" are abstract sculpture set in motion. And these pieces of plastic composition are, like all the sculptural work Mr. Calder has produced in recent years, made of wire. The bits of wire, now and then colored, weave strange patterns when a motor is turned on. . . . At first it all seems merely bizarre. You smile at the created antics of this big boy Calder whose hair is beginning to gray. When that small red ball, pursuing its arc-rhythm, focuses for an instant precisely in the center of the circlet of wire that moves also, with a rhythm of its own, there is a balanced universe unresting and yet irrefragably sure in its minute, reciprocal calculations. . . . Amazing you agree, but is it Art? . . . After all, what is Art? We have here, somehow more than just an idle diversion . . . more too than borrowing from the machine.

Critic E. A. Jewell finished his review for the *New York Times* with some observations about Sandy's father, "Alexander Stirling Calder whose latest work the Government is presenting to Iceland":

Although he has resolutely kept himself out of an academic rut, [he] is what is generally termed an "artist of the old school." . . . While motors zoomed and wires and colored balls executed their animated arabesque, the elder Calder remarked, "Well, we should all keep moving in a world so full of wonders." He was manifestly proud of his "Big Boy" who has startled Paris with his abstractions that really work!

According to his own recent *Memoir of an Art Gallery,* Julien Levy was not at all enthusiastic about these early mobiles. When their motors blew the fuses in his new gallery, requiring workmen to breach the unmarred walls to install new outlets, Levy became so intemperately angry that Sandy took his next show elsewhere.

Before returning to France, Sandy and Louisa gave a gala performance of the Circus in Pittsfield. Mother wrote me about it:

Pegus dear,

It is a grand Monday morning. The party went off very well on Saturday. There were about 50 people and Sandy in a pink shirt and white trous. Big and husky and big boy gave a fine performance of his Circus in two acts. In the entre' act, the people strolled outside where

there was a table full of doughnuts and lemonade. Inside were two baskets of peanuts. . . .

Louisa knits and crochets. She has done a swanky pair of gloves for me for this winter. She is a sweet, nice person and she and Sandy are cosey together and dog. She is rather a tomboy and likes to be going about. She runs the victrola with appropriate music for the circus and is very sedate about it and very observant of people. I wonder into what she will develop with Sandy as a companion.

Mrs. White and Miss Delehanty came over in the afternoon with praises for our party. They took us—father and me—for a ride. Mrs. W. and I in the rumble seat. She talked of Sandy, said it was wonderful that he must have no inhibitions. I wonder. He is fat and hairy, does not care a damn who sees him, wears underdrawers only and goes about barefoot—making the grass short and raking up dead grasses. We now have a lawn almost to the apple trees.

All the Trurans were here. Mabel asked for Sunny. I sat next to her and heard her laugh at some of the naughty stunts, like dogs urinating against lamp posts and elephants dropping chestnuts, etc., Sandy covering the droppings with sawdust. . . .

I don't know when Sandy and Louisa are going to Cape Cod, soon, as they sail Aug. 23 for Barcelona, Spain, on a freighter which carries passengers. They can have their dog with them and are visiting Miró, a Spanish abstractionist, in Barcelona.

<div style="text-align: right">

Blessings,
Mother

</div>

After her birthday on August 4 Mother wrote, "Sandy made a pair of sconces for you and they are all ready to mail. Jane Drexel paid him fifty dollars for some, five in all. He also made two for Mary Masiero [Mother's cook in Pittsfield]."

Sandy took the Circus with him on the boat, and while he and Louisa were visiting Miró in Spain, gave a performance for all the children, relatives, and neighbors. When he had seen the Circus in Paris, Miró told Sandy that he liked best the bits of white paper that fluttered down onto the big-bosomed lady's shoulder as she rode in a horsedrawn gig. Meant to be doves, these were small pieces of paper, each with a tiny hole and weight, that on a jiggle from Sandy descended along thin steel wires. (At the same time, dalmatian dogs went in and out between the spokes of the carriage wheels.) It was ideas such as

these, worked out for the Circus—where their charm lay in their comically lifelike qualities—that were now helpful to Sandy in working out his abstract concepts.

As the atmosphere in Europe became more ominous, Sandy and Louisa decided to return to the United States, hoping to find a farmhouse with a barn that Sandy could convert into a studio, a place with plenty of land around it where they could entertain their friends and raise a family in tranquility. After searching for several weeks, they found what they were looking for in June, 1933. Sandy and Louisa drove Father, Mother, their dog Feathers, and me from Pittsfield to Roxbury in Sandy's beloved LaSalle to picnic and inspect their find.

The well-proportioned old farmhouse in Roxbury looked forlorn that day, with windows broken and paint peeling. Father walked all around, inspecting the adzed floor and roof beams, and pronounced the basic structure sound and handsome. Mother, appalled at the clean-up job ahead, was won over by the forsythia and lilacs that screened the house from the road, and by the apple orchard, which needed only pruning.

The marble living room fireplace had a crane to hold a kettle fastened into the back wall. The floors were uneven, the ceilings low, and the two staircases to the second floor very steep and narrow. An ice house, built into the hill alongside the main house, was occupied by rusting wheels and three hundred mice. A rather high stone wall held the hill back, forming a courtyard between it and the house. Climbing some very steep steps made of marble blocks, we came out on a meadow dotted with apple trees. Sandy waved through broken windows, threw open the front door with a flourish, and clowned a lavish welcome. He and Louisa bought the house the next day.

The transformation of the battered and neglected old farmhouse on Painter Hill Road began immediately. The ice house, after a short interval as a studio, was transformed into the living room; windows were installed across the whole side that looked out over the adjacent fields. In a window box along its entire length, climbing plants, begonias, and browallia were installed. Citrus plants stood in pots in the bend of the grand piano. Sandy made a table with an aluminum top and chairs with rope seats covered with cowhides. The table, used for the evening meal, seated ten or more on benches covered with sheep hides with the fleeces on. The walls were painted white, making a fine background for paintings by Sandy, Mother, Miró, Salemmie,

Sandy and Louisa in Roxbury

Picabia, Léger, and Vieira da Silva. By 1938, when I visited again, several mobiles hung overhead; one of aluminum, unpainted, reflected the candlelight from the table; another had a gong that sounded as it turned lazily in the air. The piano was piled high with books. Along ledges hanging or leaning against the wall were an effigy from the New Hebrides, Father's bust of Louisa, several wood carvings by Sandy, jade beads from Mexico, an embroidered oriole nest from South America, and embroidery inlaid with mirrors from Katmandu. The rugs, colorful saddle blankets from South America, were later supplemented by others of Louisa's own handsome make.

Besides the flowers Louisa brought inside, which were washed lovingly leaf by leaf when necessary to remove aphids or scale, she developed a riotous garden across the drive under some grape vines: peonies, Chinese poppies, delphinium, canterbury bells, and candytuft. Scillas and daffodils carpeted the ground under the fruit trees.

Meanwhile Sandy, bored with the repetitiveness of the machine-driven mobiles, continued his experiments with movement. The answer, like the shapes that came to characterize his gouaches, was derived from the universe, where large bodies are suspended in the atmosphere. He thought of the air, of wind, and of the response of perfectly balanced objects to the slightest *courant d'air*. As this idea unfolded, he worked for the suspended balance he sought until he obtained it. The same fluidity that had characterized his line drawings and wire constructions prevailed as he guided the destinies of the forms, and of the spaces they made as they swung freely in the breeze. The all-important question of balance was resolved without ever being considered a problem. "I begin at the small ends," he told me years later, "then balance in progression until I think I've found the point of support. This is crucial, as there is only one such point and it must be right if the object is to hang or pivot freely. I usually test out this point with string to make sure before bending the wire. The size and angle of the shapes and how to use them is a matter of taste and what you have in mind."

Sandy, as always, had a great deal in mind. He created such a rich variety of mobiles in the forty-five years he made them that even to describe the various *kinds* is difficult. They range in size from simple two-inch objects that pivot on their stands to great hanging beauties over forty feet in diameter. The last, and largest, of Sandy's hanging mobiles, installed at the Federal Reserve Bank in Philadelphia in October, 1976, is one hundred and forty feet high and has an eighty-foot sweep. Other large mobiles—e.g. *Lollipops* and *Hello Girls!* at the Los Angeles County Museum—stand on their bases. *Hello Girls!*, a water sculpture, is propelled by sprays of water as well as the wind. For the largest mobiles and for the great stabiles, products of his later years, weighing many tons each and cut from steel over an inch thick, Sandy made maquettes several feet high, which were then enlarged at a foundry under his watchful eye. For the gigantic mobile in Philadelphia, Sandy had the village carpenter in Saché build him a wooden frame in the proportions of the Federal Reserve Bank, and within it he tested and perfected the smaller mobile from which the final one was enlarged in the Biémont foundry in Tours. The dustjacket of this book shows Sandy at Biémont, instructing one of the workmen who enlarged the small original of the Reserve Bank's mobile into its unprecedented proportions.

One early type of mobile with which he experimented consisted of a brass wire circle, within which he hung a horizontal rod by thread or string and from it other, smaller rods. From these he hung pieces of colored glass found on the beach, painted metal buttons, the bottoms of wine glasses, and almost always some shape reminiscent of fish—those torpedolike creatures that come in so many variations and are so perfectly adapted to their element. The rods, strings of different lengths, and dangling objects were all arranged so that they swung clear of one another, making patterns in the space between them that changed continuously.

Almost from the beginning he introduced bold colors: pure reds, blues, and yellows.

Sandy's first show of completely air-propelled mobiles was held at the Pierre Matisse Gallery in New York in April, 1934. James Johnson Sweeney wrote the foreword to the catalogue, which ended, "Calder personalizes his 'mobiles' with a lyricism entirely his own—a freshness, gaiety, and charm." Mother reported to me:

> Sandy's Show opens today. Good luck to it. It is raining but I am going up to Matisse when I finish this. . . . *Later.* I have just returned and had my luncheon. Sandy and Matisse working away to get the opening for this evening. The Gallery is too small, and the background not good but the work is most entertaining. I met Mr. Sweeney whose notes accompany the invitation, and also Mr. Goetz, who said they always had more fun at Sandy's exhibitions in Paris than any others. With the machinery going, people were amused and friendly. His [Sandy's] ideas, the proportions, forms and colors ought to do something for him. Here is a press release for you.

The enclosed press release described Sandy's mobiles as "fresh and provocative"; "one may venture to guess that you will not find, in all the town, a display more novel and amusing than this." Mother paid several more visits. After one she wrote me again:

> I went again to Sandy's Show! ! I wish you could see it. It is the most complete and colorful one yet. There are a few gigantic specimens, and so many possible small ones. Evidently he has been much affected by birds in his thinking. One called "Swizzle Sticks" is all bright red in back, with small long pieces of wood leaded at the base and suspended by wires which allow it to move when the air is disturbed. Another with a form like a flying bird.

During these years before Sandy was well known, I tried to arrange an exhibition for him at the San Francisco Museum of Modern Art. I thought a Mother and Son Show would be interesting. Father's work was too large to move about, but I optimistically decided that the aura of the 1915 Exposition still hung over San Francisco and would help with the publicity. It was hard going, and I wrote to Sandy in dismayed asperity. He answered, "Funny thing about Museums. They all have very nice rich people who enjoy being connected with them, and receiving the social uplift, or whatever it is they get, but they never seem to be able to afford even a modest sum to buy what to the artist seems to be the main reason for having Museums!"

Finally Grace McCann Morley, then Director, arranged to exhibit several of Mother's paintings, Sandy's big Circus painting done for our tenth anniversary, and several mobiles. At my request, the dirty burlap walls were whitewashed. When the show finally opened, we discovered that the last section of one mobile had been attached backward! We hunted down Miss Morley, who hunted down a ladder so we could rehang it, to the great interest of visitors to the show. Another mobile was hanging in an end room, far from the entrance. As we rounded the corner into the room, a man deliberately took his hat, reached up, and gave the mobile a hard swat. Kenneth yelled and gave chase, but the vandal disappeared into the crowd of visitors. Again the ladder was sent for and again we were able to straighten the mobile, although this time the wires were bent. The whole experience left me rather sour on efforts to raise the artistic sights of the community. Several of my friends, however, wanted mobiles for themselves, so I wrote to Sandy. Here is his reply about an order that finally went through:

Dear Peg,

As to Mrs. S——, for that variety I ask two to three hundred, but will take what I can get within reason. But I could make her one especially for whatever amount she'd be able to afford, starting at one hundred. Ask her if she'd like one to *hang* or *stand* and if she has a particular spot for it. Will she please make a drawing showing shape of room, alcove niche with accurate dimensions and note the color of the wall. . . .

You keep the two objects I sent and I'll make another for Mrs. S. Tell her to write me direct.

If you put these Mobiles up, do so one at a time or in very separate

spots. This one should clear the floor about a foot or less. . . .

Sandy

There was great excitement in the Calder-James-Hayes clan when, in April, 1935, the first daughter was born to Louisa and Sandy. Louisa had gone to stay with her mother in Concord, which proved to be a fortunate decision. The baby arrived normally enough, but shortly afterward Louisa hemorrhaged so severely that emergency measures, specialists, and numerous transfusions were required. Sandy slept in his car outside the hospital the first night, and stayed with the Jameses afterward. He wrote me, "They had five men come up to the hospital for blood transfusions and three tested correctly; they were all policemen."

There followed weeks of dashing back and forth between Roxbury and Concord, for Louisa and the baby stayed with her parents for six weeks while she regained her strength. "He made me a daisy for my Easter hat," wrote Mrs. James. Sandy reported, "The infant is fine, and very cute. Dark hair and beet-red all over when in a fury (hungry or wet). As yet she has no definite name, but various terms used to designate her." While Louisa recovered, Sandy took time out to plant their garden. On May 16 he wrote me:

> Your niece takes things very strenuously and yells like hell for food and falls asleep as soon as she gets it. . . . You will be horrified to hear that her name is Sandra. We were up in the air for a bit but it seems to go all right, as I have sent her a couple of post cards to try it out. . . . I had a very nice letter from Nana Frank and sent her a giddy brass and glass pin from her [honorary] granddaughter.

Sandy's numerous gifts of jewelry to his West Coast relatives led friends to ask if he would make them some to order; I relayed their inquiries to Sandy, who replied that he would make jewelry on order, although no two pieces would ever be identical. "Measure the lady's neck for a necklace," he instructed me; "is she tall or short? What kind of neck? which of mine did she prefer? What material? I charge the same for brass or silver." When he had completed an order he wrote again:

Oct. 12, '35 Roxbury

Dear Peg,

I am sending you 2 buckles and a set of 6 buttons. The rectangular

A rampant starfish for
a birthday gift
Photo: Nanette Sexton

A brass wire necklace still enjoyed by the author. *Right* necklace—
a gift at a later date.

Some jewelry by Sandy—often full of whimsey, as above where Muriel Cowley's initials become a bunny's head; *left,* H with E and S suspended, and HE.

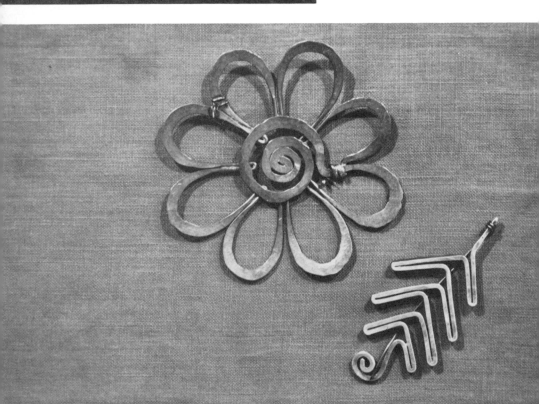

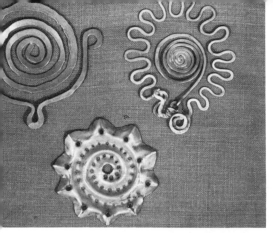

More jewelry by Sandy
Photo: Nanette Sexton

Below: A silver necklace to celebrate the author's 25th wedding anniversary
Photo: James Stipovich

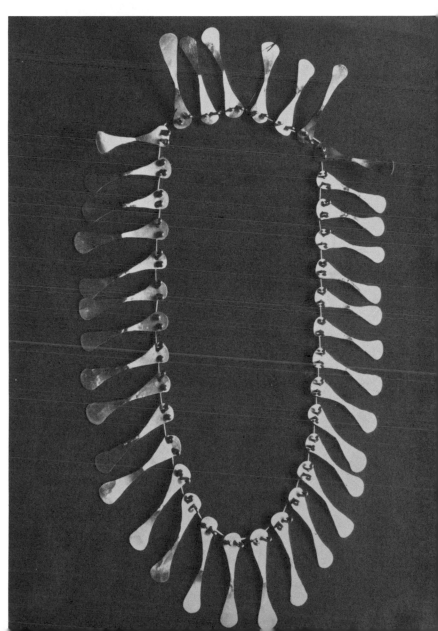

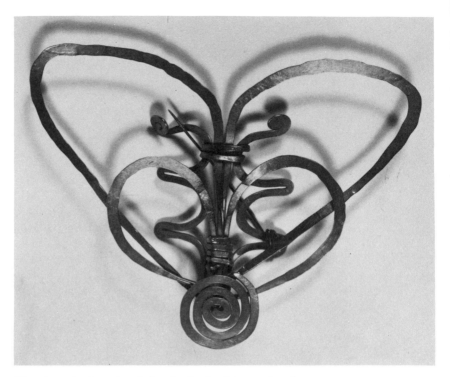

'*Here's a fly, buzzing by.*'—A pin for his mother from
Sandy, about 1930

Photo: Colin McRae

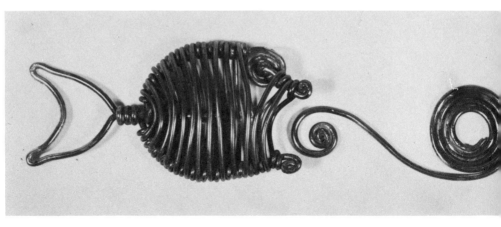

A fish becomes a buckle for the author's birthday.

Photo: Coli

buckle should be sold for 15.00, the oval for 12.00, and the buttons for 5.00 per six.

If it's a shop you may give 25% commission and I'll split the rest with YOU 50-50.

This may seem exorbitant, at first bloom, but remember I'm not *manufacturing* them—and besides, I know from experience that comparatively few will be sold, so one might as well get good prices. And its much more interesting to sell them gradually and get fair prices, than to put out a great mass—à la Woolworth and swamp the market. (Please don't think I'm trying to lecture—I just wish to explain my theory of merchandising.) I don't care to make a great many—but if you wish I'll send you a few more things if you'll let me know what you'd like.

I made a lot of stuff for Dilkusha (a couturière) in Paris and don't think there is much to be done with that ilk (buttons, etc.).

The idea is that *they are not manufactured* and so there are comparatively few of them. . . .

If nothing comes of the Button and Buckle business, please accept these with my love. . . .

> Sandy

Sandy's jewelry was as diverse as his other work. Pins were often initials, or an H on which e.s. were playfully hung. "Elodie" is spelled out in a small airy mobile. MC becomes a bunny. A pin could be a lazy daisy, a pea pod, a fly or butterfly, or a piece of a Chinese dish, obsidian, ivory, or glass mounted on hammered brass or silver. The pin used to fasten it is often piano wire wrapped about the head and reaching across behind to lock into some part of the design.

Sandy seemed to put his feeling about a person into the jewelry he made for her. I was very pleased to receive a rangey silver starfish clearly on the go, as well as a beautifully designed and executed gold pin.

Sandy's dislike of sham influenced the design of his jewelry. Once, while wrapping a stiff piece of steel wire about a hammered gold pin, he replied to a query about welding, "I always meant to learn but it never seemed convenient." Of course, this was not the whole story. The challenge was to use the original materials in a way that was both efficient and beautiful. His proficiency with the running line made it seem unnatural, hence unacceptable, to stop and stick on another element. That is why even his gold and silver necklaces, except for those

whose components lock into one another and eliminate the need for stringing parts separately, are apt to be strung on stout cotton twine.

Some of the shoulder and neck pieces shown in the Perls Gallery jewelry exhibition in New York in 1966 displayed his playfulness. A necklace called *The Jealous Husband,* shown at the Whitney in 1976, arches over the shoulders with a mobile on each; others hang in concentric circles, entirely covering the chest. They would be superb worn in plays, but certainly must present problems for someone trying to make dinner.

Sandy's earrings run the gamut from the gold-pounded coils for pierced ears, which he made for Louisa and which she always wears, to silver "winged victories." He also made combs, hairpins, barrettes, rings—more varied and original than most people could imagine, let alone produce. "Only A. Calder can make a Calder," some wag has said. This is as true of his jewelry as of his mobiles and stabiles. In 1958 he sent me several necklaces made to order for friends that were slightly large or small. They could be adjusted, but how? Sandy replied:

<div align="right">11 May 1958</div>

Dear Peg,

Here is a collar I pounded out. I have made it somewhat curvical . . . if you want it flatter beat it on the *horn* of an anvil where the *red* marks are. If you want to make it larger (longer) beat at the *blue* marks, as well.

. . . The cuff links are made *cold.* If the wire gets hard, heat it and quench it. But *move* the flame, or the wire, so as not to burn or melt it. . . .

I am interested in what you say about Ken's business. One usually assumes that other people are approximately as well off, or as poorly, as oneself. And I have wondered how you and Ken were making out, without feeling that I had the right to inquire; . . . if you're ever really strapped, don't hesitate to say so—and I will do what I can.

<div align="right">Love again,
Sandy</div>

It was in Roxbury that Sandy and Louisa's daughters—Mary was born in 1939—grew up. Sandy held to the resolution he had made before marriage not to take on household chores. Indeed, had he done so, he could not have produced the phenomenal amount of diverse sculpture and painting that he did. Louisa, a "philosopher" in Sandy's

Sandy and his daughters. *A good deal of good-natured teasing went on.*
Photo: Antonio Violich

apt description, accepted this division of responsibilities without question as she had his art. She took full charge of the girls' upbringing and education, although Sandy exerted a definite influence on the color and styles of the clothes Louisa and the girls wore, as well as on their taste. With his studio adjoining the house, he was home for lunch as well as breakfast and supper, so he spent more time with his children than most fathers can. His all-embracing love and good humor poured forth in glorious romps, in the many toys and other articles he made for them, in his enjoyment of their amusing observations, and in good-natured teasing.

Sandy did not believe that taste could be learned. He insisted that a person is born either with or without it. This denies the whole learning process, and I could not agree. I observed that the tastes of whole sections of the world or country seem to run in a similar pattern. This suggests learning from one's surroundings, from neighbors and community—sometimes the wrong things, to be sure, but learning nonetheless. I recalled how as children we had loved Maxfield Parrish's illustration of "The Dinkey-Bird Is Singing in the Amfalula Tree" by Eugene Field, and insisted that it was possible to progress, to learn. Neither of us ever convinced the other.

Consistent with his views, Sandy refused to have anything around that was not well designed, saying "bad taste boomerangs." So even their pots, pans, and skillets had distinction. As they lived in the house and devised conveniences, Louisa painted the steep and narrow stairs brick red, with an amusing design in yellow. The kitchen, where meals were eaten when the family was alone, had two tables. One, of polished cherry wood, was built in simple straight lines. On it were Italian bowls full of fruit, Chinese bowls of figs or nuts, a straw cheese tray from Lourdes for letters, packages, toys or flowers to invite the passer-by. The high kitchen utility table became the center of family meals and gab fests with friends, who sat there sipping wine and discussing life, freedom, war, Art. Louisa swept the piled-up objects and people aside when she prepared a meal. In the corner of the kitchen, shelves piled high with casseroles from France and Spain, sconces from Finland, a classical mask from Greece, pewter dishes from China, baskets from everywhere, waited to be used. On the mantel over the kitchen fireplace was a tiny mobile made from a teaspoon, fetishes from Africa and South America, a dog made of a champagne cork, a silver wire sieve made for Louisa by Sandy the same Christmas she, attracted by its amusing design, bought a Chinese brass one for him.

The inventive and amusing objects that they had made and gathered for their home made me discontented with some of our more conventional appurtenances. Kenneth and I hated our andirons—he because they fell to pieces when he tried to polish them and were brutes to put together again, I because they were mere shells of brass, shaped for appearance only. Besides, the iron rods that held the logs were so flattened by heat they were no longer useful. I asked Sandy how I could make some, or have some made, of more modern design. He replied:

Dear Peg,

Up in Roxbury there are some old carriage axles lying about. I have long projected making andirons. But if there are no axles at hand, that wouldn't be worthwhile. In Paris we had a pair of large dumbells. But that is only good for small fireplaces, I guess. Here are some sketches.

Or *best,* go to a junk dealer and try to find two objects which will serve, even if you have to cut part away. And if they are *not* a pair that would be more amusing, REALLY *sans blague!* The real idea in modern furnishing is *economy* and if you can substitute an old piece of *junk* and make it serve as well as something more costly, you win. . . .

Much love to you all,
Sandy

The respect for materials carried over to tools as well. Once in Roxbury he allowed me to use his cherished equipment. Not realizing how fragile the surface of the anvil was and not striking in his deft, competent way, I put marks on it. As he sanded them off, he told me that visitors often took up his hammer and idly struck the anvil, and of how dangerous this could be when there was no buffer, such as a piece of brass or silver wire, to absorb the blow: "The hammer can bounce up and hit you in the head, and the ends of the wire, being bent, can whirl around and deal a mean jab." He had fine tools and used them with care and expertise. He usually bought several of a kind—Bernard pliers by the box.

Work finished or stored, or begun and not yet finished, accumulated rapidly, together with all sorts of stones, rocks, and coils of various kinds of wire, destined to be made into something beautiful. To the

'I have long projected making andirons.'

11 May 58

Dear Peg. Here is a collar I
pounded out

I have made it somewhat

conical

← if you want it flatter

want it flatter

beat it on the horn of an anvil where the red marks are

If you want to make it larger (longer) beat at the blue marks, as well.

How fragile the surface of the anvil.

uninitiated, it seemed a great mess, but Sandy always knew where everything was and moved about with great efficiency. His tools were where they could most conveniently be reached. Brushes for each color paint for the mobiles, their bristles down in a can of turpentine, waited to be used straight from the paint cans that were lined up and wired in place along the edge of the table. Sketches were clipped to the edge of Sandy's "desk." Benches were strewn with tin snips and saws, rasps and files; a hand drill stood waiting. Jewelry he had made between times was wrapped and stored for giving or selling at the right moment. Overhead, mobiles suspended by pulleys floated in the breeze from the open doors like trapeze artists. Along the walls, old masks made of an inner tube and cans, a wire hat, and endless other relics of bygone efforts or parties, leaned or were fastened. My parents never ceased being amazed that beautiful, meticulous work somehow emerged from the chaos.

During one visit to Roxbury in the early 1960's, I went to see Sandy in his studio. He was so absorbed that he just grinned at me from under his home-made visor and continued working. The doors of his studio—large, wide, and high—stood open to the meadow. From waist height to the ceiling, the area completing the wall to the right of the doors was made up of small panes of glass. A flycatcher, which had flown through the open doors when no one was there, was desperately trying to get out through the glass panes. I made a move to shoo him gently toward the open doors. The corner was stacked high with easels, wood, aluminum. The benches and tables were piled with cut-out shapes and machinery, rolls of paper, plans, and scraps.

Sandy growled from under his visor, "*Don't* go over there. If it hasn't sense enough to get out, let it die."

"Let me just shoo him over to the door," I pleaded. "You can't expect a bird to know about glass. The poor thing is frantic with thirst and fright."

"Fool things do it all the time. *Don't* go over there." He kept working.

Unable to bear the bird's torment, equally unable to contest Sandy's absolute rule of his domain, I left. As I walked back to the main house, I realized I had been treated to a rare flash of the inner strength that underlay even the clowning. As John Russell has put it (*Calder's Universe,* p. 26), "you don't get to do what he has done, or to be what he is, without an inner intransigence. In the man, as in the work, iron

is the metal." But iron becomes flexible when subjected to heat, and so was Sandy. The cold iron in his character was used only to protect the integrity of his work and his ideas.

Father's studios were very different—always a large room with skylight, the floor covered with fine powdered clay dust that stuck on one's shoes, leaving tracks behind. He bought dry clay by the barrel and mixed it in a bathtub. There were also large packages of plasticene, a chest of modeling tools, armatures, modeling stands, and many old rags and sheets. The last were soaked in water and then put around the work in progress each night to keep it moist. He had only a few objects about: a bronze Etruscan deer, a Greek mask, a Chinese theater poster or Japanese print. He was very particular about faucets that might drip. After turning one off, he put his hand under it to be sure there was not one drop. He did this not once, but a dozen times or more, snatching his hand away as if to trick the faucet into misbehaving. Till the end, he worked with live models. Sandy was scornful: "You'd think he'd know how the arms and legs fit on by now." Sandy did not seem to need such direct inspiration. He told of a reporter who, searching for a bit of sex interest for his article, asked leadingly, "Josephine Baker must have had a beautiful body?" His reply: "Dunno, never saw it."

Although Father continued to go to the studio each day until his final illness, working on busts and fountains for private homes, his last large commission was a marble memorial statue of Bishop William White, who became the first Episcopal bishop of Pennsylvania in 1787. The statue was unveiled at Valley Forge on November 6, 1937, by the Bishop's great-great-grand-daughter.

An ardent Anglophile, Father was deeply moved by Churchill's oratory and was greatly disappointed when no one bought the outsized bust he modeled of his hero.

When the Museum of Modern Art in New York dedicated its new building in May, 1939, both Father and Mother, Sandy and Louisa, were invited to the opening. Mother wrote me about it:

[May 10, 1939]

Dear Peg,

Father and I went to the opening of the Modern Museum last night. We went early and had a look around before the mob arrived. Many canvasses we knew but many more—all very interesting.

But the mob was terrific when we were ready to leave nearly eleven o'clock. We missed Sandy and Louisa. I wanted to see Louisa because Mrs. Julien Levy lent her a very handsome gown that she had made. Not many we knew. What a motley crowd! Such hideous clothes and such hideous women. I wore the red Chinese silk but your Father was in his tux. A very few in street costume. It was the occasion for every white haired woman to put on evening attire. Such sights! The building is really interesting with a large open court on the ground floor for sculpture.

<div style="text-align: right">Mother</div>

Sandy and Louisa arrived later that evening. As it turned out, Louisa did not wear Joella Levy's dress, but she did wear a lacey hat of brass wire, crowned with real flowers, that Sandy made for the occasion. The same Museum hosted Sandy's first one-man show in 1943. Thus established, his standing in the art world began a steady, crescendo-like rise, culminating gloriously in the Whitney Retrospective of 1976.

Father died in January, 1945, after a miserable illness and drastic operation that must have been deeply distressing to so fastidious a man. Mother had left the hospital for a few hours sleep, and when she returned he was unconscious. The doctor offered to try to revive him, but Mother, remembering his suffering and mental anguish, shook her head no. She stayed with him until he died late that night. His ashes were buried in the West Laurel Hill Cemetery plot that Grandfather thoughtfully provided for his entire family, marked by the Celtic cross he brought back from Scotland. Now he, a sculptor, and his son, a sculptor, lie buried beneath a cross of unknown origin, created by an unknown sculptor. In later years when she thought of Father, Mother found solace in the lovely song by Robert Louis Stevenson that ends:

> Here he lies where he longed to be;
> Home is the sailor, home from the sea,
> And the hunter home from the hill.

Mother herself lived on until 1960, first in "Grandma's house," a pretty little cottage that Sandy and Louisa had built in the meadow about a hundred yards up hill from the main house in Roxbury. A huge catalpa tree grew at the door. When they were in Roxbury, Sandy trudged up the hill to see her each morning, and her grand-

daughters Sandra and Mary visited her almost daily. Her last few years were spent at the home of Stephen and Vera Golembeski, who loved and cared for her. She was ninety-three and a half, and had just been taken to the hospital in New Milford, when Sandy returned from Rio. He hastened to her bedside, and as he was standing there, a nurse primly pulled the sheet up over her legs. Mother opened one dark eye, winked, and said clearly, *Honi soit qui mal y pense.* Her ashes were buried next to Father's. Dogwood and azaleas bloom joyously each spring around the CAWDOR cross, as do the violets transplanted from Mother's garden in Roxbury.

Sandy supported Mother for the last fifteen years of her life, and treated me, too, with the utmost affection and wondrous generosity. In the fall of 1957, when I was recovering from a nasty operation, I found myself longing for a mobile for the corner of the room in which I was forced to spend much time. I wrote Sandy about it, at the same time mentioning how much I liked *The Forest Is the Best Place,* a mobile that had been shown in San Francisco. I asked where it was, and if it had been sold. Sandy replied, "I will be delighted to make a Mobile for you. The 'Forest' is in Europe and is occasionally shown somewhere or other. [It was subsequently bought by the Moderna Museet in Stockholm.] Would a Mobile 50″ in diameter, many small leaves, all black be what you would like? Just tell me. You are a funny one about being embarrassed about asking. Just send me instructions."

My instructions, although they seemed explicit to me, were inadequate. Apparently I was not thinking big enough. He wrote again: "Did you really mean *diameter,* or perhaps radius? Make me a drawing of the place you want to put it." Almost before I had a chance to reply, he wrote again: "I have made a Mobile (as sketched on the reverse) for you. Let me know if it is too wide—but it is very flexible. I thought of making it all *black.* Or would you like it all red? Do let me know."

I expressed a preference for red. A week later Sandy wrote: "I sent the Mobile to you yesterday. It is all bright red. I made a wire hook and a little point to make a hole in the ceiling. The best way is to assemble the Mobile, and tie it to the end of a stick. Then someone can hold it up to the ceiling and you can decide just where to put the hook. I left the soft wire rather long (on the hook) but cut it off after installation. I trust you have a plaster ceiling."

And so for twenty years, long after the pain that occasioned it receded, I have had the fun of living with Sandy's bright red mobile, now imposing and arrogant, now naughty and playful, depending on its position in the air and my own mood. It joins many other gifts from Sandy. As I write here in Berkeley, surrounded by the work of my brother's hands, of my father's and mother's, I recall some lines Father wrote more than fifty years ago:

"Beauty is something wonderful and strange that the artist fashions out of the chaos of the world in the torment of his soul, and when he has made it, it is not given to all to know it. To recognize it, you must repeat the adventure of the artist."

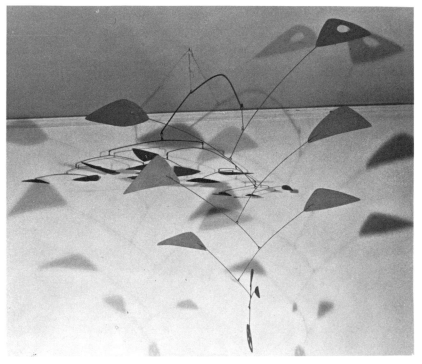

'I sent the Mobile to you yesterday. It is all bright red.'
Photo: Nanette Sexton

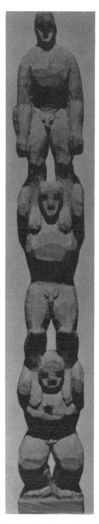

Three Men High

PART IV

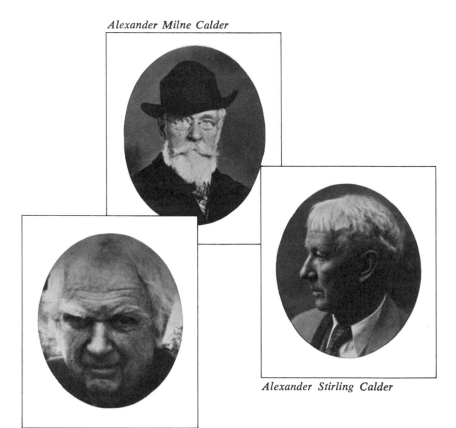

Alexander Milne Calder

Alexander Stirling Calder

Alexander Calder

EPILOGUE

The three Alexander Calders were united by kinship, name, and profession. Apart from a remarkable similarity in their signatures and a capacity for sustained hard work, that is about where the resemblances end.

The three men were very different in looks. Grandfather, about 5' 9", was spry, never overweight. He became bald in his late 50's. Father, an even six feet, was always trying to gain a few pounds. His hair turned white while he was in his thirties; he was never completely bald. Sandy, about 5' 11", began to fight his weight in his early thirties. With a home in France and a wife who became a gifted cook, he soon gave up the struggle, unregretfully. He had a head full of rumpled white hair when he died at seventy-eight.

Both Father's and Sandy's hands were chunky, Sandy's with thickish fingers at the end of short arms. He was much stronger than the other two, with more powerful shoulders. Father's first finger and thumb became flattened with the years spent rolling and pressing clay into shape, as did Grandfather's. Sandy was always trimming hang-nails, keeping his hands in working order.

A characteristic the three men did share was the ability to work hard for long hours. Grandfather worked for twenty years in what is now Courtroom No. 2 of the Philadelphia City Hall, and during that entire time attended night school at the Pennsylvania Academy of the Fine Arts, studying among others with Thomas Eakins, who became a warm friend. Father could become so absorbed in what he was creating that he would forget to eat and became utterly asocial. Sandy could arise at 6:30 in the morning and, once he had perfected his

technique, complete a medium-sized mobile or a maquette for a stabile in a day. Afterward he might unwind by painting in the gouacherie for several hours.

All three men had distinctive styles of dress. Grandfather was something of a dandy. He wore his hat at a jaunty tilt and suits made of homespun tweed that smelled of peat. He smoked a pipe. Father also wore Scottish tweed; he had Mother remove the thick shoulder padding then in style, so that he looked like a tall, handsome country squire. My mother-in-law aptly called him "the Earl of Fourteenth Street." He smoked a pipe now and then, and one stogie after dinner. Sandy, too, evolved a distinctive style of dress, if only out of indifference and a desire for maximum comfort and convenience. His red flannel L.L. Bean shirts and baggy blue jeans became his trademark. Once on a visit to us in Berkeley, he had but one shirt left. After some vigorous dancing, the shirt got very wet. When I asked what he would wear the next day, he replied, "Oh, turn it inside out. It'll soon dry."

Grandfather was a gleeful man, and although his work was symbolic in a rather heavy-handed way (woman at loom, man at lathe, beehive for industry), sly little touches abound in the Philadelphia City Hall that attest to his good humor and enjoyment of life. More sensitive, Father had a less sanguine outlook on life and this was reflected both in his temperament and in his work. He loved jokes and plays on words, but his humor tended to have a cynical twist: "Is life worth living? It depends on the liver." He loved the theater but was himself undemonstrative, moody, and often withdrawn. Obviously responsive to sensual beauty, he was at the same time preoccupied with the cruelties of Nature, of life. His work is full of introspection. Art is serious: *Death and the Maiden, Tragic Figures,* a headless figure holding its head turned with the face toward him, *Brooding Head.* When Grandfather put a cat chasing a mouse, and finally catching it, in and out of a City Hall frieze, it was for him a joke. For Father, it was another instance of the cruelty of Nature.

Sandy rebounds from all this with joyous gusto. His humor can be outrageously broad, as in *Three Young Rats* ("Eaper Weaper, Chimbley Sweeper"), where a naked man stuffs his naked wife up the chimney. But it is always good-natured, and in a world where violence is the daily diet, he has given us gaiety and joy, with hate, greed, and envy left out. He approaches the Universe with reverence, but can paint a seven-footed "animule" on a Braniff nascelles that might have

made Grandfather laugh, but would have nonplussed him. Father would have laughed, too, but would have considered the whole thing something less than Art.

The three Alexander Calders all seem to have become sculptors on the second bound: Grandfather started out in the garden, and, with some experience cutting stone, was inspired when he saw a piece of sculpture; Father wanted to be an actor, but was too shy; Sandy trained as an engineer, but out of distaste for the work available to him and in response to an inner urge, turned to painting and sculpture.

It was the experience of Paris at a crucial, formative stage that put its seal on the way each of the three men approached his work.

Grandfather's Paris was that of the 1860's. The ambitious public buildings of the Second Empire were going up everywhere—the final additions to the Louvre, for instance, had just been completed. The buildings Grandfather saw rising around him were in the Neo-Baroque style, with complex sculptural and architectural ornamentation that was meant to educate as well as to gratify the eye. When he went to work on the new public buildings in Philadelphia, under architect John McArthur and commissioner Samuel Perkins, their project—which underwent many revisions and took thirty years to complete—was similarly ambitious in both form and content.

When Father went to Paris in 1890, the expansive mood of the Second Empire had given way to the restlessness of the fin-de-siècle. The atmosphere of the sculpture ateliers was predominantly Neo-Classic. Father became interested in integrating spirit and character with the whole composition. He sought feeling and design rather than likeness. Back in New York after the years of involuntary exile in Arizona and California, he became an early member of the Society of Independent Artists and supported their efforts from the first. He strove to eliminate the unnecessary, to compose with care, with an eye on the whole. Father contended that sculpture on buildings should be an integral part of the original design, not an embellishment stuck on platforms and abutments after a building is finished. "Sculpture that is only ornament is not sculpture at all. . . . Sculptors forced to frame their thoughts in formal classic spaces become sterile."

His friends and constant associates—Grafly, Sloan, Henri, Glackens, Williamson, Davies, Whiteside, Shinn, Preston, and, above all, his wife—were questioning the goals of the artist. Their discussions and their curiosity toward the avant-garde in Europe, particularly

Paris, led to the organization of the Armory Show of 1913, which shocked the staid and parochial art world of early-twentieth-century America.

Sandy, brought up in the midst of artists and their work, of discussions about art, and with materials for art always available to him, at first used traditional material. His work for the *Police Gazette,* which emphasized the cartoon style of the single line, was reminiscent of the cartoons by Father's friends Henri and Shinn, but in adapting this style Sandy omitted more than the artists of Father's generation would have thought to. Although Sandy grew to ridicule realism, his early animal sculptures, Circus performers, and portraits in wire invoked reality in an amazingly direct way.

Engineering school put Sandy in touch with other materials. He developed a disgust for what he derisively called "mud," the oozy plastic material Father and Grandfather used. He turned instead to the hard, more precise materials he had learned about at Stevens— and which indeed were more characteristic of the industrial world in which he would live and work.

Sandy's Paris was alive with the ferment of Surrealism and Dada, and gave him the jolt that directed his interests toward abstract art. Henceforth he would be preoccupied with objects born in his mind, drawing—not always consciously—on the endless experimentation going on around him, incorporating what he chose in a way uniquely his. His restless, inventive seeking led him to work with an unprecedented variety of materials and media, as bedazzled visitors to the Whitney Retrospective discovered anew each time they turned a corner.

Early in his career, when he invented the Mobile, Sandy set abstract form in motion. *Motion:* an idea that came to him on seeing the bright colors in Mondrian's studio. *Motion,* a basic characteristic of our age.

The hundred and twenty-five years during which these three artists worked brought great changes to the United States and to the world of Art. It is not surprising that there are equally pronounced differences in the work of the three Alexander Calders, who seem to have risen each on the shoulders of the other like the figures in Sandy's carving *Three Men High.*

Mother once said, "The Arts are too educated. One does not feel the living pulse of mere life." Her comment was aimed at the intellectualism that flourished in my parents' era, which in turn was a reaction

to the often ornate grandiosity of the period in which Grandfather worked. She would have found no lack of vitality in Sandy's lusty output. She would have exulted as she went around the Whitney Retrospective at the strong pulse of mere life in the work of her only son. She would have applauded a visitor's response to a companion who complained: "Nine red saucers and two balls that bounce around and hit them. What's so wonderful about that?"

His reply: "That's just the point. It isn't wonderful. But with this guy we can see the beauty and fun in the simplest things around us. *It* isn't wonderful, *he* is."

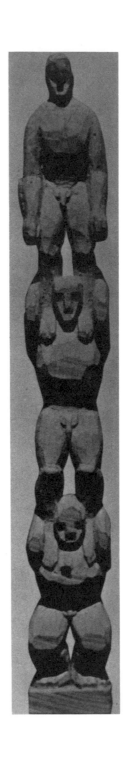

INDEX